GEORGIA

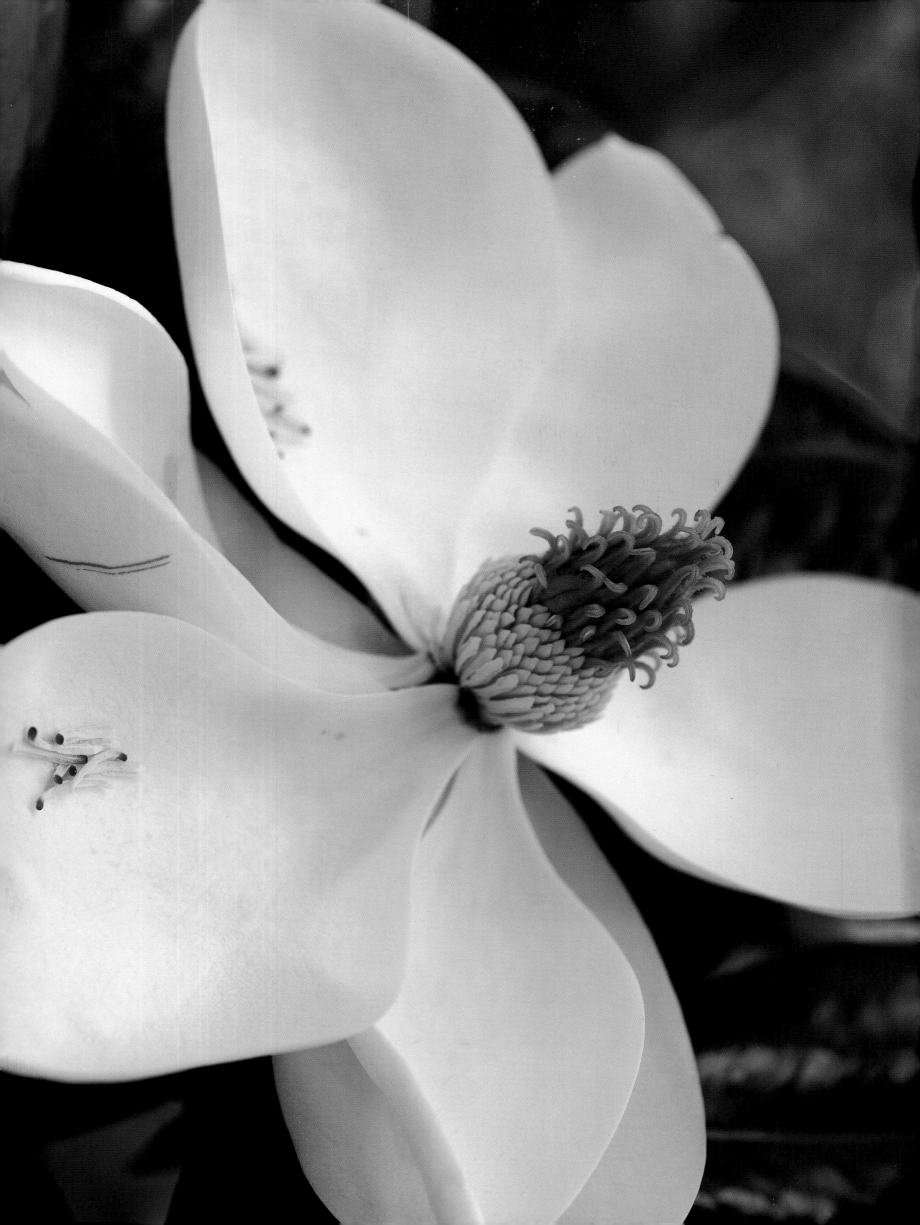

GEORGIA

PHOTOGRAPHY BY CRAIG M. TANNER
ESSAY BY RHETA GRIMSLEY JOHNSON

GRAPHIC ARTS CENTER PUBLISHING®

Photographs © MM by Craig Tanner
Text © MM by Rheta Grimsley Johnson
Book compilation © MM by Graphic Arts Center Publishing Company
P.O. Box 10306, Portland, Oregon 97296-0306
800/452-3032 • www.gacpc.com

President/Publisher: Charles M. Hopkins
Editorial Staff: Douglas A. Pfeiffer, Ellen Harkins Wheat,
Timothy W. Frew, Tricia Brown, Jean Andrews,
Alicia I. Paulson, Julia Warren
Production Staff: Richard L. Owsiany, Heather Doornink
Designer: Robert Reynolds
Cartographer: Ortelius Design
Book Manufacturing: Lincoln & Allen Company
Printed in Hong Kong

Library of Congress Cataloging-in-Publication Data

Tanner, Craig, 1961–
 Georgia / photography by Craig Tanner ; text by Rheta
Grimsley Johnson.
 p. cm.
 ISBN 1-55868-525-1 (alk. paper)
 1. Georgia—Pictorial works. 2. Georgia—Description
and travel. I. Johnson, Rheta Grimsley, 1953– II. Title.
F287.T36 2000
975.8—dc21
 00-024598
 CIP

◁ ◁ The huge blossoms of the southern magnolia, native to the
coastal plain but planted extensively throughout the state, are
a familiar site across Georgia in late spring and early summer.
BELOW: Confederate Memorial carving, Stone Mountain Park.
OPPOSITE PAGE: Ships and docks, Savannah River.

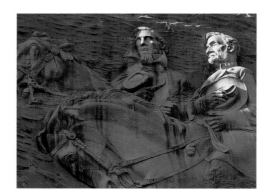

GEORGIA

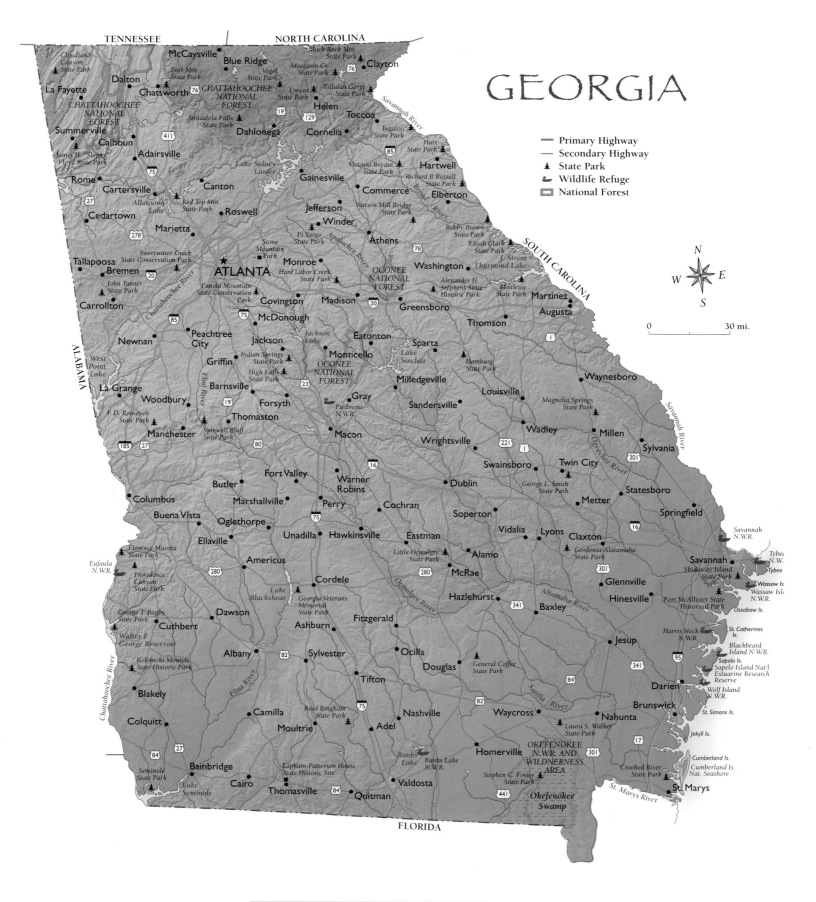

TENNESSEE

NORTH CAROLINA

Cloudland Canyon State Park

McCaysville

Blue Ridge

Black Rock Mtn. State Park

Clayton

Fort Mtn. State Park

Moccasin Cr. State Park

La Fayette

Dalton

Chatsworth

Vogel State Park

CHATTAHOOCHEE NATIONAL FOREST

Unicoi State Park

Tallulah Gorge State Park

Helen

Toccoa

CHATTAHOOCHEE NATIONAL FOREST

Summerville

Amicalola Falls State Park

Dahlonega

Cornelia

Tugaloo State Park

Calhoun

Adairsville

Dahlonega

Hart State Park

James H. "Sloppy" Floyd State Park

Rome

Cartersville

Lake Sidney Lanier

Gainesville

Hartwell

Cedartown

Allatoona Lake

Canton

Victoria Bryant State Park

Elberton

Red Top Mtn. State Park

Roswell

Jefferson

Commerce

Richard B. Russell State Park

Marietta

Winder

Watson Mill Bridge State Park

Athens

Bobby Brown State Park

Sweetwater Creek State Conservation Park

Stone Mountain Park

Monroe

Fr. Yargo State Park

Apalachee River

Washington

Elijah Clark State Park

J. Strom Thurmond Lake

Tallapoosa

Bremen

ATLANTA

Hard Labor Creek State Park

OCONEE NATIONAL FOREST

Alexander H. Stephens State Historic Park

Mistletoe State Park

Martinez

Panola Mountain State Conservation Park

Covington

Madison

Greensboro

Augusta

Carrollton

John Tanner State Park

McDonough

Thomson

Chattahoochee River

Newnan

Peachtree City

Jackson

Jackson Lake

Eatonton

Sparta

Louisville

Waynesboro

Griffin

Indian Springs State Park

Monticello

Lake Sinclair

Hamburg State Park

La Grange

High Falls State Park

OCONEE NATIONAL FOREST

Milledgeville

Woodbury

Barnsville

Forsyth

Gray

Sandersville

Wadley

Millen

Sylvania

F.D. Roosevelt State Park

Thomaston

Piedmont N.W.R.

Macon

Wrightsville

Swainsboro

Twin City

Manchester

Sprewell Bluff State Park

Fort Valley

Warner Robins

Dublin

George L. Smith State Park

Metter

Statesboro

Butler

Marshallville

Perry

Cochran

Soperton

Springfield

Columbus

Oglethorpe

Unadilla

Hawkinsville

Eastman

Vidalia

Lyons

Claxton

Savannah N.W.R.

Buena Vista

Ellaville

Little Ocmulgee State Park

Alamo

Gordonia-Alatamaha State Park

Tybee

Florence Marina State Park

Americus

Cordele

McRae

Glennville

Savannah

Skidaway Island State Park

Tybee

Eufaula N.W.R.

Providence Canyon State Park

Lake Blackshear

Georgia Veterans Memorial State Park

Hazlehurst

Baxley

Hinesville

Fort McAllister State Historical Park

Wassaw Is.

Wassaw Isl. N.W.R.

George T. Bagby State Park

Dawson

Ashburn

Fitzgerald

Ossabaw Is.

Cuthbert

Walter F. George Reservoir

Albany

Sylvester

Ocilla

General Coffee State Park

Jesup

St. Catherines Is.

Harris Neck N.W.R.

Kolomoki Mounds State Historic Park

Tifton

Douglas

Sapelo Is.

Blackbeard Island N.W.R.

Blakely

Flint River

Nashville

Waycross

Nahunta

Sapelo Island Nat'l Estuarine Research Reserve

Colquitt

Camilla

Reed Bingham State Park

Adel

Satilla River

Wolf Island N.W.R.

Brunswick

St. Simons Is.

Laura S. Walker State Park

Moultrie

Banks Lake

Banks Lake N.W.R.

Homerville

OKEFENOKEE N.W.R. AND WILDERNESS AREA

Darien

Jekyll Is.

Bainbridge

Lapham-Patterson House State Historic Site

Valdosta

Crooked River State Park

Cumberland Is.

Seminole State Park

Cairo

Thomasville

Quitman

Stephen C. Foster State Park

Okefenokee Swamp

St. Marys River

St. Marys

Cumberland Is. Nat. Seashore

Lake Seminole

FLORIDA

Chattahoochee River

ALABAMA

SOUTH CAROLINA

Savannah River

Broad River

Ogeechee River

Ocmulgee River

Altamaha River

Oconee River

Legend

— Primary Highway
— Secondary Highway
♠ State Park
🦅 Wildlife Refuge
▭ National Forest

N
W · E
S

0 30 mi.

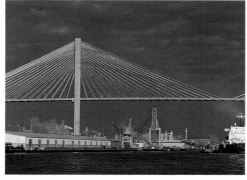

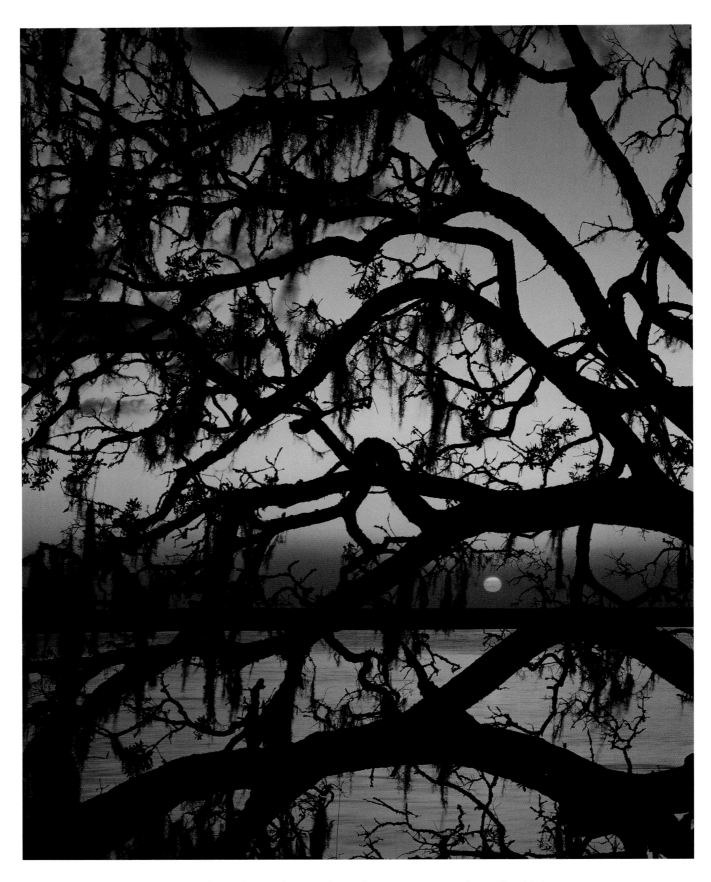

△ A solitary live oak provides a dramatic canopy through which to view the sunset over the Brickhill River at Cumberland Island. The massive, horizontally spreading, and often Spanish moss–draped live oak is Georgia's state tree.

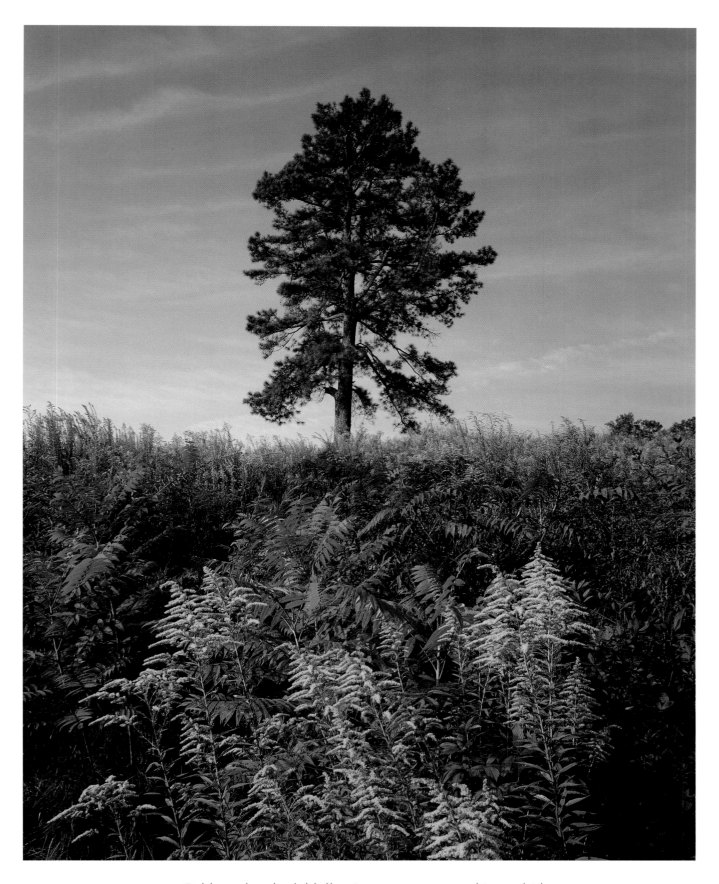

△ Goldenrod and a loblolly pine tree punctuate this roadside scene near the town of Suwanee. Named for one of the principal villages of the Cherokee Indians, present-day Suwanee is a mix of rural scenes like this one and growing residential development.
▷ ▷ Atlanta—called Marthasville by its thirty residents in 1842—has grown from a terminal on the Western & Atlantic Railroad to its present-day status as the capital and largest city of Georgia.

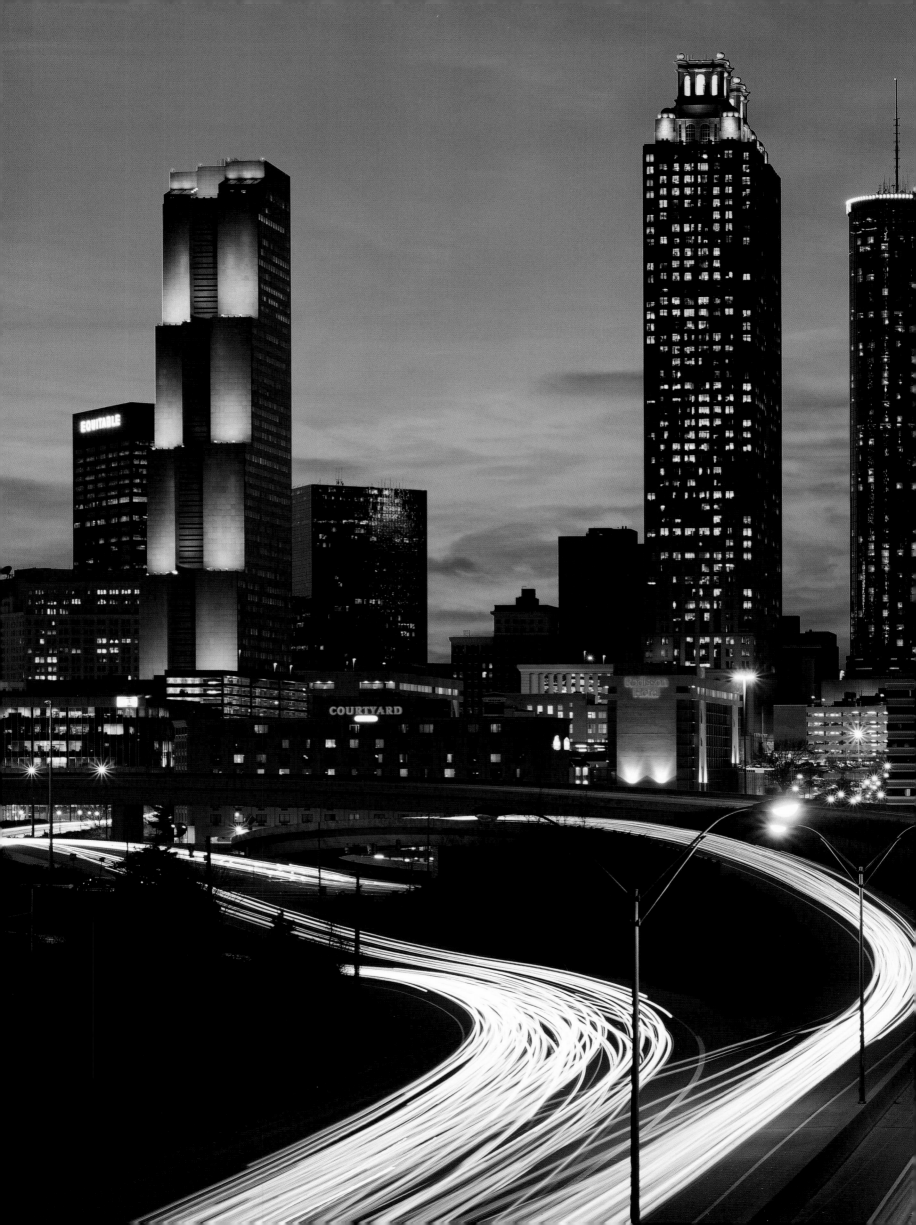

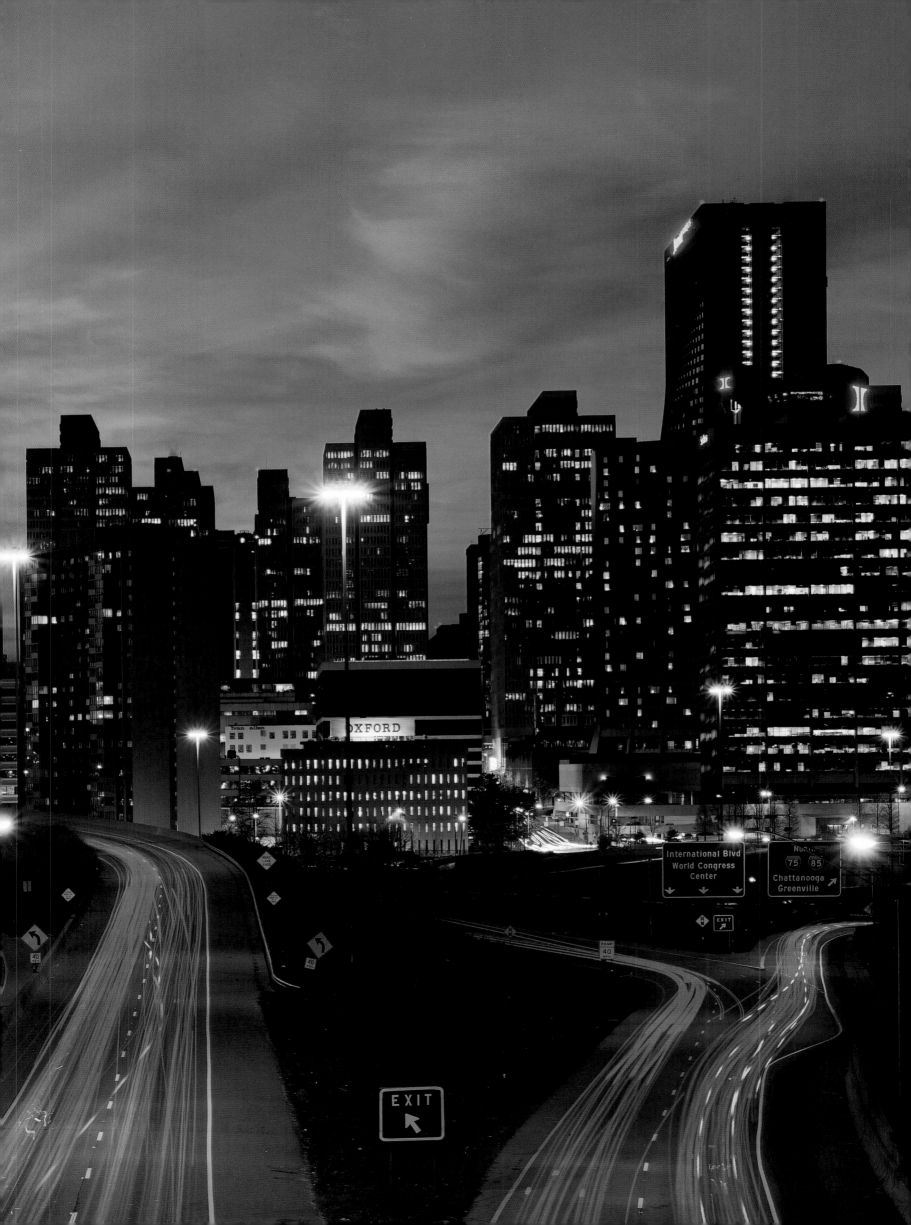

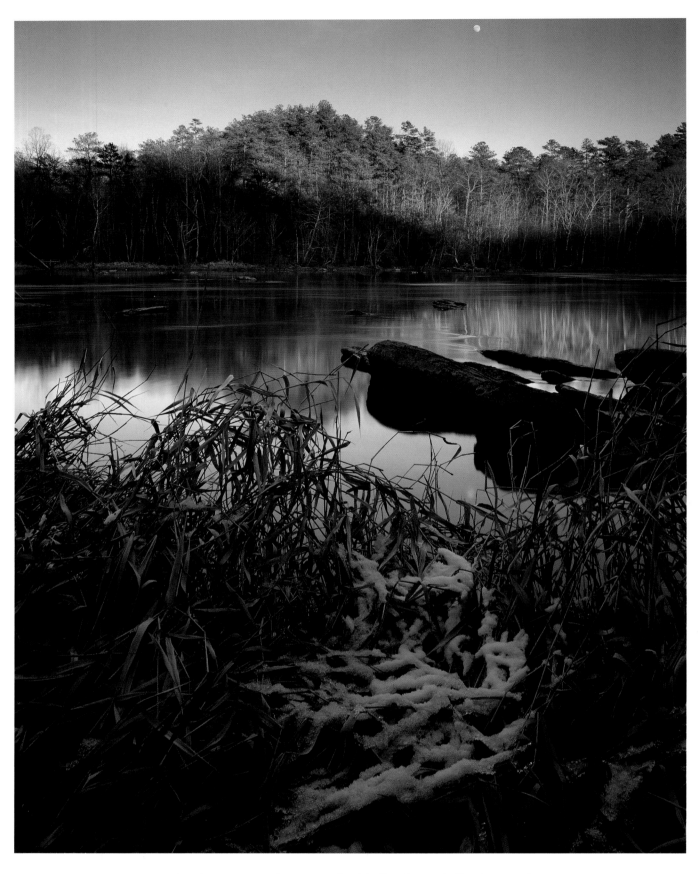

△ A winter moon rises over the bluffs of East Palisades on the Chattahoochee River near Atlanta. Just upstream, a series of rocky shoals known locally as the Devil's Racecourse, serve as a popular training ground for kayakers and canoeists.

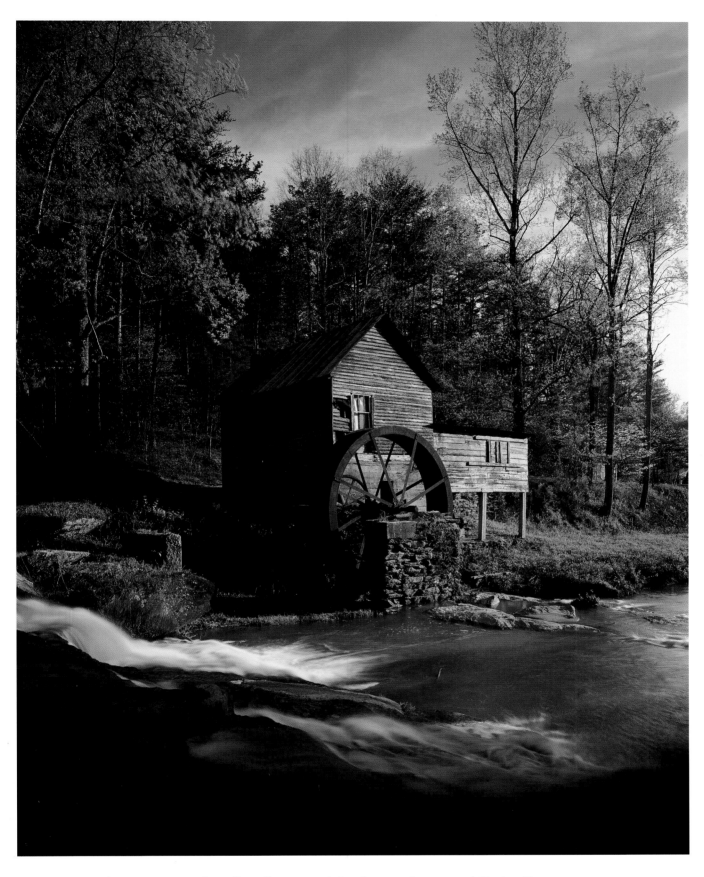

△ Loudermilk Mill on Hazel Creek, near the town of Clarksville, is one of many old mills that can still be found along the water-ways of north Georgia. During its thirty-year heyday in the early 1900s, owner Homer Ansley used Loudermilk Mill to process seventy-five bushels of meal a day.

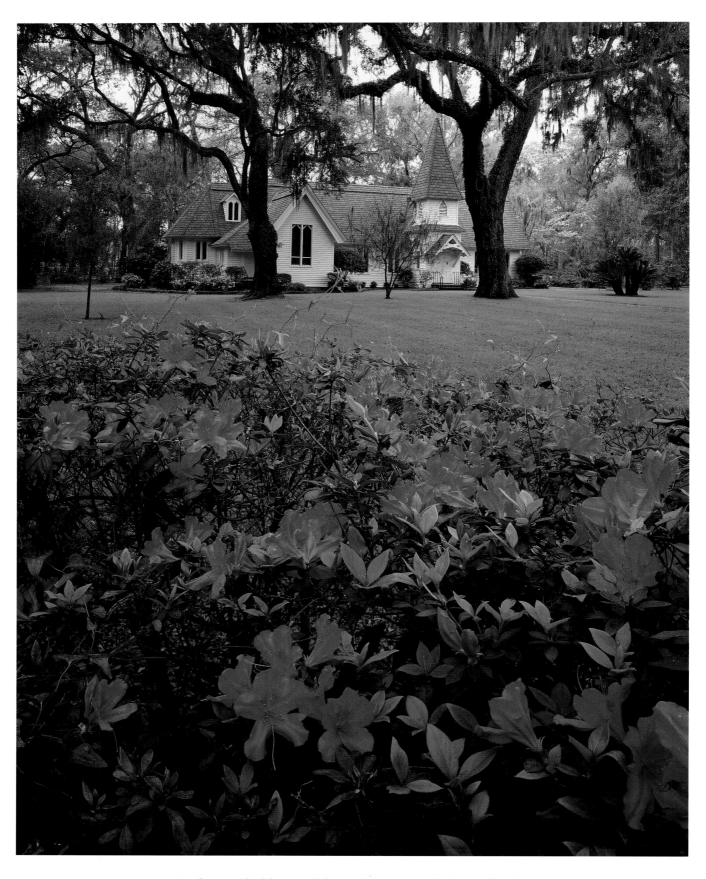

△ Azaleas and old-growth live oaks surround Christ Church on St. Simons Island. This beautiful Episcopal sanctuary is the third-oldest church in Georgia.

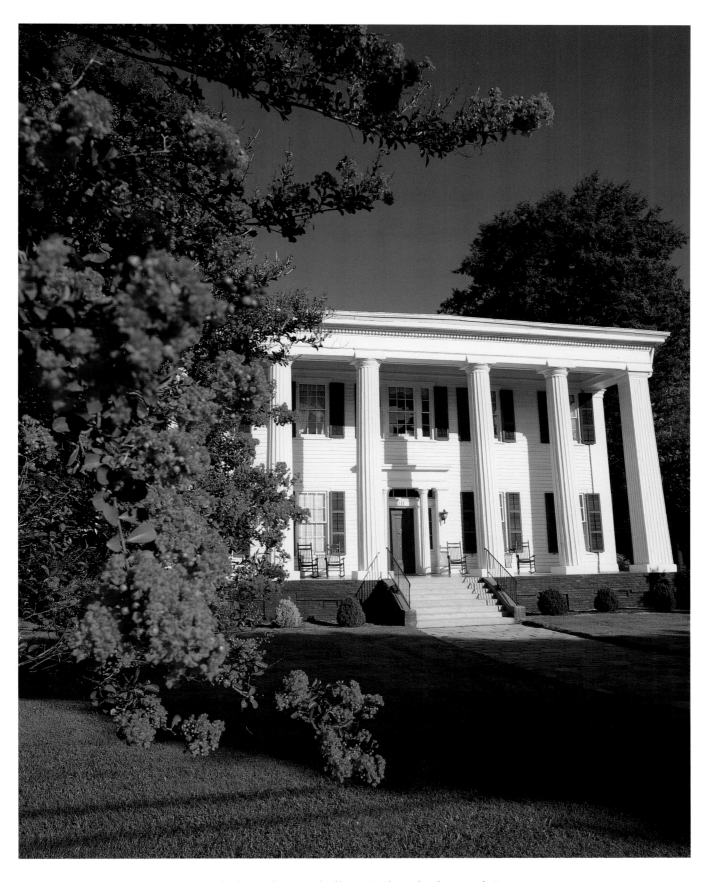

△ Located along the Antebellum Trail in the heart of Georgia's Piedmont country, the town of Madison is home to some of Georgia's most treasured architecture. Crepe myrtles frame this view of Heritage Hall, a Greek revival house built in 1833.

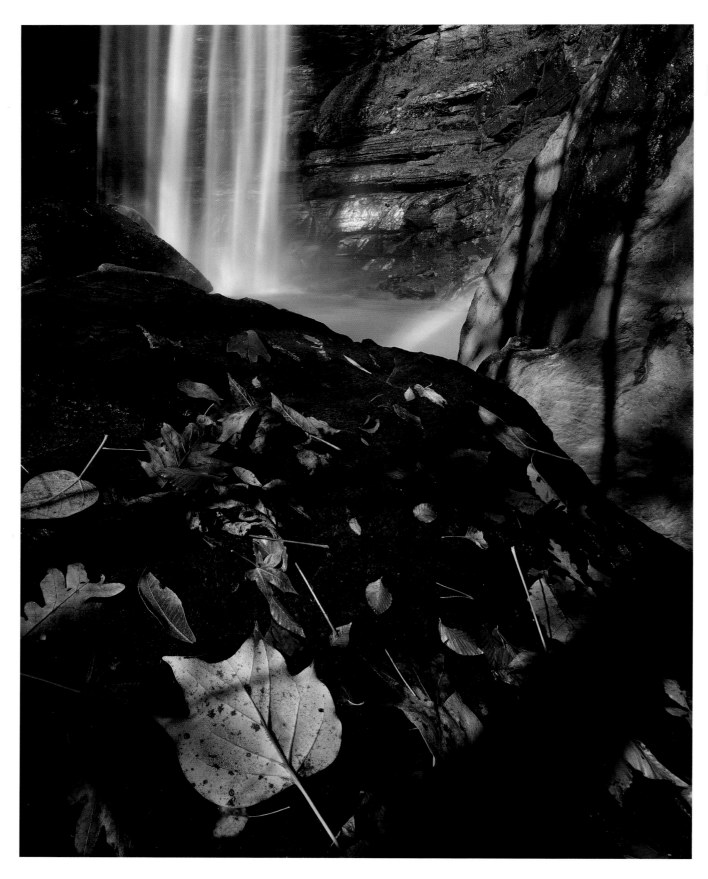

△ Fall leaves and a mist bow color the landscape at the base of Toccoa Falls. Toccoa is the state's highest single-stage waterfall.
▷ Morning light falls on the palmettos and live oaks of the maritime forest at the R. J. Reynolds Wildlife Refuge on Sapelo Island. Sapelo is the fourth-largest barrier island in the state.

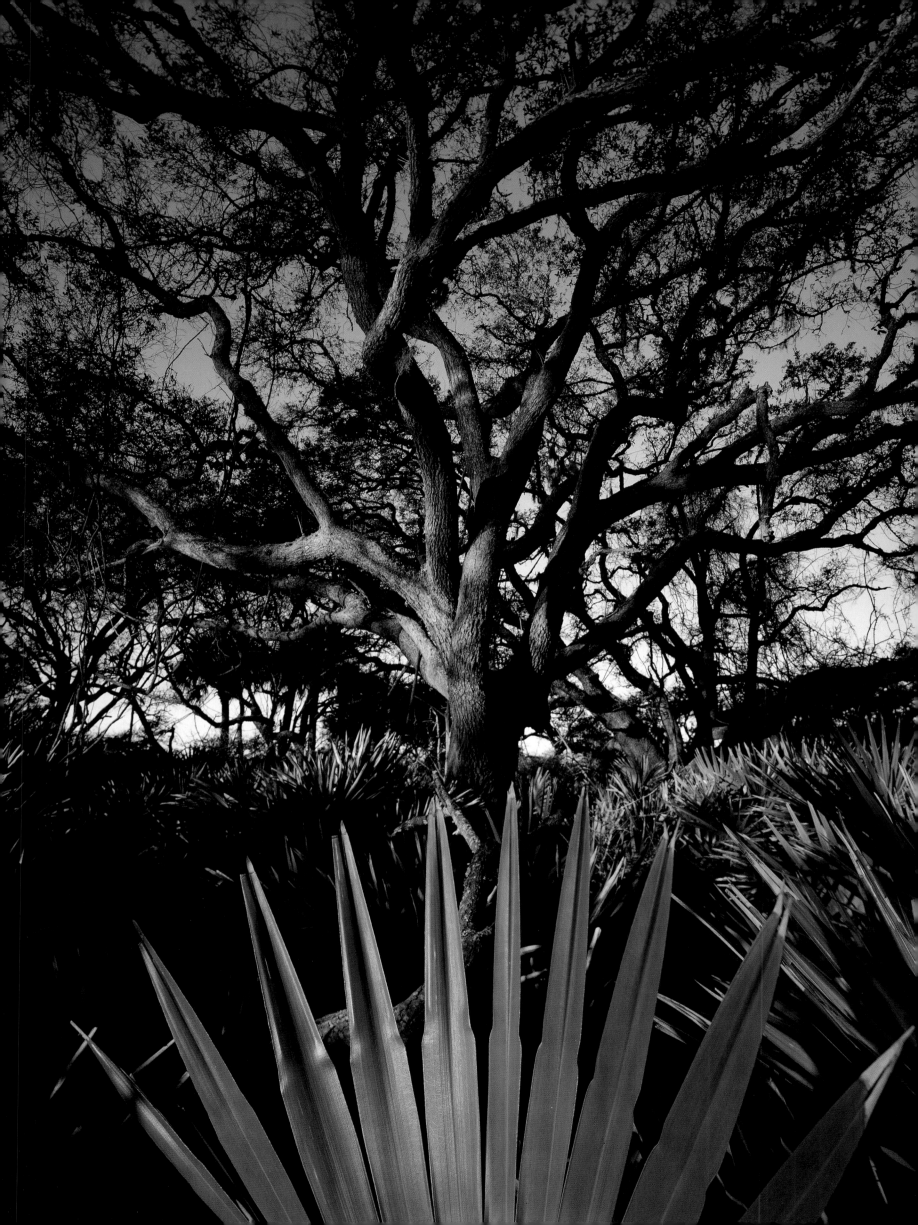

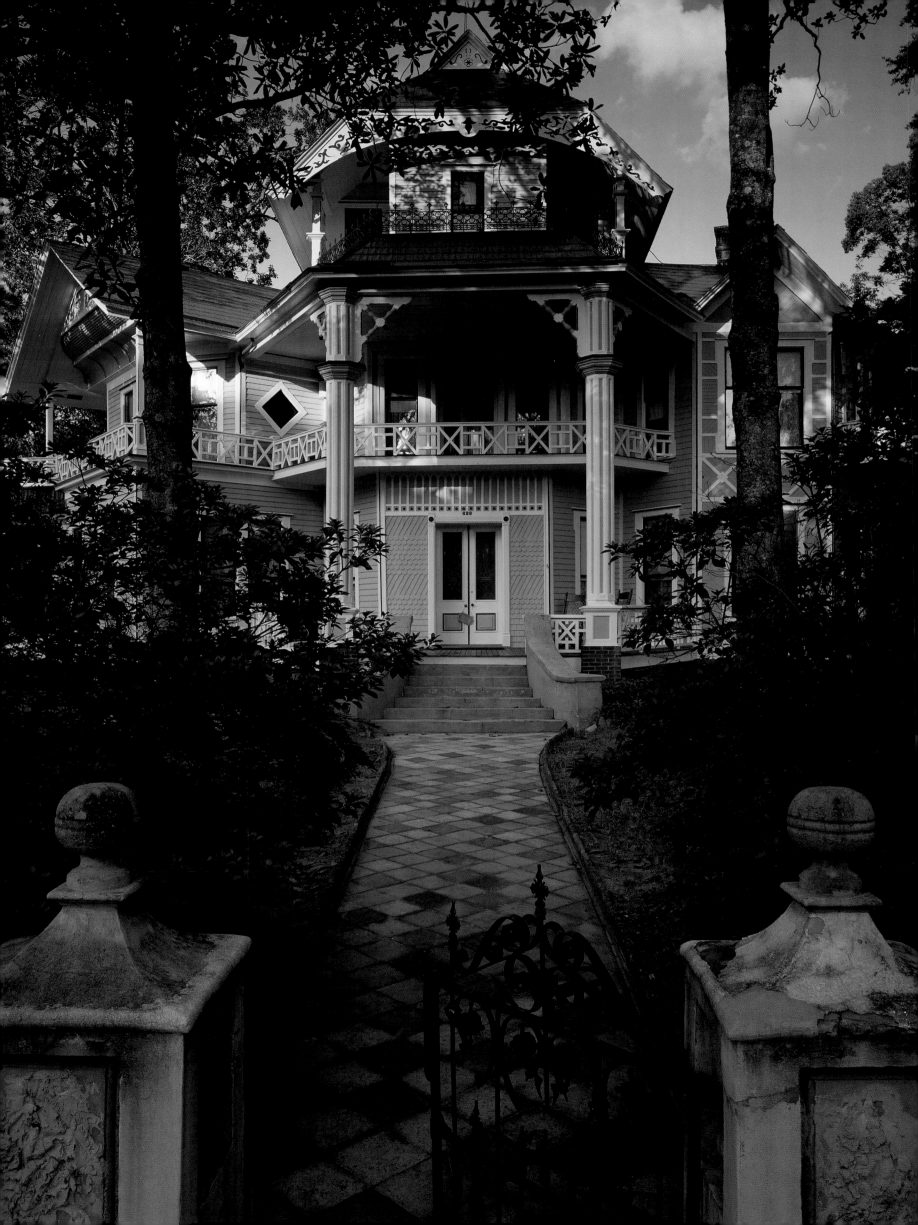

A SONG FOR GEORGIA

I was born in Georgia in 1953, the same year that Eisenhower took office and Hank Williams died. Both my grandfathers were proud Georgia farmers; my father was a butcher in a meat market in Colquitt, Georgia; and my older sister was the reigning Little Miss Colquitt. Our Georgia roots ran deep.

But my father took a job in Alabama when I was just a baby, and it would be four decades before I spent more than a year in my native state again. I think it was that long absence that elevated Georgia in my mind and gave it an almost mythical status. All those years away and the good memories of childhood summers grew inside my head until Georgia became, not a state, but some misty Camelot. I understood perfectly why songwriters so often sing about Georgia—and they do—and why poets frequently use its sweet and evocative name.

When faraway Georgia tickled his muse, for instance, Indiana composer Hoagy Carmichael wrote that immortal line about the moonlight through the pines. He gave us an abiding image, and one not yet totally relegated to song. For in many parts of my birth state, the moon remains unobscured by city lights. And you can still find it through a plenitude of pines.

If I were touring Georgia for the first time, it would be that celebrated moonlight I'd look for. Georgia has mountains—the southernmost Appalachians—and it has seashore and antebellum homes aplenty. It has the capital of the New South in Atlanta. It has a gigantic knob of granite carved with Confederate heroes, Stone Mountain. It has a canyon called Providence, dug by soil erosion caused by poor farming techniques. And it has a spectacular swamp populated with alligators.

But I'd start my visit with a look at the moonlight. From a front porch. Not just any front porch, but the front porch of a small rustic lodge called The Wallow, in a peaceful community named Hog Hammock, on the barrier island Sapelo, just a short ferry ride from Darien on the mainland.

The porch is plain and solid, not antebellum or fancy, and the view is of a makeshift pen where two mules frequently take dust baths. A network of dirt roads intersects nearby at a four-way unmarked by any signs. The sounds from the porch are even better than the view.

You can hear the rattletrap trucks and rusty cars of Hog Hammock's one hundred or so residents coming and going from the ferry dock. At night you can listen to a thousand different critters, chirping and screeching and stomping through the palmetto and pine woods toward some mysterious destination. If the wind is right, you can even hear breaking waves of the Atlantic Ocean.

And it seems to me, on Sapelo, you also can hear the quiet. You can hear the world the way it was meant to sound, before man got it by the tail and swung it into the noisy, productive future. If, however, you want company, conversation, and a condensed history of the island, Cornelia and Julius Bailey will sit on the porch with you and pass a deep, Deep South twilight. The Baileys built the lodge for a steady stream of paying visitors who come to Sapelo Island to mine for meaning. Writers, photographers, beachcombers—all arrive on the state-run ferry from what the islanders invariably call "the other side." Visitors stay a few hours, or a few days. They look for birds, shells, the lighthouse, for a meaningful glimpse of the Geechee community of Hog Hammock. Those who live in Hog Hammock full-time are not looking for anything, except to hold tight to their 434 acres deep in the island's interior. For them, Sapelo Island has been, and will be, home.

Nobody really owns Sapelo, of course. Florida's Marjorie Kinnan Rawlings had the right idea when she said that the most any of us can be is a caretaker of land. To claim to be more is presumptuous. The land really belongs to the wind and the sea and time, she wrote. It was a fact she discovered at her own beloved hammock of Cross Creek, Florida.

But of all the land that humans would like to own, islands must top the list. This one has been jealously guarded at various times by the Native Americans, the French, the Spanish, and the British. It has been inhabited by Northern millionaires and Southern tobacco heirs. Today, with the notable exception of little Hog Hammock, the state of Georgia "owns" Sapelo. The state operates an island wildlife refuge, a marine institute, and the ferry.

It seems to me the most legitimate claim is that of the people in Hog Hammock, most of whose ancestors came here on slave ships, who cleared the land and picked the cotton, who were herded like cattle and driven up the mainland when the Civil War threatened.

◁ *The Lapham-Patterson House, built in 1885 in Thomasville, is Georgia's most unique architectural treasure.*
▷ *Centennial Olympic Park.*

The former slaves came back of their own accord, to Sapelo, the place they knew. Sherman's Field Order No. 15 promised forty-acre allotments to the freed slaves, but politicians—soon enough, once again—served best the interests of rich white men and took the allotments away. So the Sapelo natives raised the money and bought what they'd already been given.

For generations, the African Americans on Sapelo have struggled to keep their island toehold. After all, their folks are buried in the sand here. Despite the development moratorium that today's state ownership means, there's always the nagging thought that their beloved Hog Hammock community could change again, shrink some more. Islanders say they fear a shift in political winds, or the gradual succumbing of some Hog Hammock landowners or their heirs to tempting real estate offers. You get the feeling that "the other side" has a second meaning, beyond that of a geographical designation.

But at night, on the splendid Bailey porch, when the soft, salty wind blows, it is hard to worry about anything much. The threat from the mainland, where trouble so often brews, seems far, far away.

There are other beautiful barrier islands just a short boat ride from the Georgia mainland. The coastline looks like an elongated hopscotch game. Tybee, Wassaw, Ossabaw, St. Catherines, Blackbeard, Cumberland, St. Simons, Jekyll, the sound of the names is musical, hypnotic. And to see them, well, is a privilege. With the exception of heavily inhabited St. Simons, Jekyll, and Tybee, the Georgia islands remain a vital part of a fast-vanishing thing in this modern world—wilderness. It's a happy accident of capitalism that millionaire industrialists at the turn of the century held onto their pristine island playgrounds long enough to foil widespread development. Today environmental groups have more clout and a significant say in what happens to unspoiled places like Ossabaw and Cumberland. Otherwise—and I know this from personal experience—the same urge that gripped the millionaires would overcome the islands. People want to do more than just visit an island. Once they get there, they want to stay.

I was twenty-one and had been married less than a day when first I saw St. Simons. My groom had discovered it the week before on a ragged state map and pointed excitedly: "We could make it here in one day."

We married early in the morning, clear across the state, at another of Georgia's famous Edens, the lush, manicured Callaway Gardens. After we swapped vows at the Callaway chapel, we quickly struck out toward our honeymoon destination. By nightfall we were on St. Simons Island, with absolutely no clue that it was a routine stop for newlyweds. We were still young enough to believe we were the first to do everything.

Both of us had been journalism students, and we couldn't help but notice that the bustling island had no real newspaper, only a couple of advertising shoppers. We dismissed those, and on the way home began preparing a pitch for seed money. It seemed a great excuse to return, not only to the exotic island, but also to my home state.

The rest is painful history. A few months after the honeymoon, with a grubstake from a generous editor, the two of us tried to start a weekly newspaper on St. Simons; it lasted twenty-six weeks. The *St. Simons Sun* set on Christmas day, but only after we rolled and tossed five thousand newspapers to most of the homes on the island for the last time. Then we pointed our Pinto back toward Alabama, where we figured poor kids like us belonged.

That was in 1975. I wouldn't live in Georgia again for nearly twenty years, but my stay on St. Simons Island was plenty long enough to learn a couple of important lessons. One, I was never meant to be my own boss. Two, living on and then leaving the Golden Isles of Georgia is like a failed marriage; it may not last long at all, but to get over it takes forever.

During my short but romantic stay in southeast Georgia, I also learned to love Savannah. (In truth, to learn to love Savannah takes any sane soul about five minutes.) We drove the hour to Savannah from St. Simons whenever we needed something only a city could supply. But any excuse would do. For you could make the case that Savannah is the most beautiful town in America, like an architectural museum with live oaks as docents. Certainly it's one of the most distinctively Southern.

John Berendt's popular book *Midnight in the Garden of Good and Evil,* among other things, made Savannah's Bonaventure Cemetery famous. But Bonaventure is not my favorite of that pretty town's historic graveyards. Colonial Park is.

Nobody taught me to love graveyards. As a child, I was constantly being shoehorned between healthy countrywomen and hauled to funerals where grieving began at the granite. It was a movable grief, progressing from the cemetery to farmhouse tables heavy with deviled eggs and chicken fried in lard—a cholesterol balm. Nobody asked me to like these macabre picnics. Nobody cared whether I did. Children only recently got the vote.

But there was and is something comforting about a land where the citizens are quiet. No land-line disputes, no city council meetings, no talk radio. People leave you alone in cemeteries. You cannot stay for long in the South without noticing our preoccupation with the death part of life. We have made funerals an art form. And our cemeteries are the canvas for that art.

Just as a cigar aficionado has his preferred smokes, a cemetery fanatic has her favorite rest spots. And I'd say Savannah's Colonial Park Cemetery ranks in my Top Five. It was the final stop for five Georgia governors and Button Gwinnett, a signer of the Declaration of Independence. Also buried there are James Johnston, Georgia's first newspaper publisher, and Edward Greene Malbone, famous for painting miniatures.

But dead dignitaries are not so much my passion as the physical plant in which they rest. Colonial Park is an almost-buried treasure.

The British damaged it first. And then Sherman's army camped in Colonial on its way to the sea. To relieve boredom, the Yankees carved fake information on tombstones, changing dates and ages. Susannah Gray, for instance, killed by lightning at 21, became 121, making hers a more timely death. Legend has it that the Union soldiers pried open the vaults and slept in them to stay warm.

But the most intriguing thing about the cemetery, used from 1733 to 1850, is a wall of misplaced tombstones, rescued during one renovation or another. Nobody knows exactly where they belong, so they hang on the wall, like so many extra parts discovered in the box after you've finished putting together a kitchen appliance.

Death, like life, scuttles the best-laid plans.

There are, of course, plenty of live people and lively attractions in old Savannah. The town is teeming these days with fans of the Berendt book and the movie it inspired. You can take *Midnight* tours in carriages, or buy souvenirs at a shop with an exclusive *Midnight* theme. Real estate prices have skyrocketed—and, correspondingly, so have taxes—in the historic districts. Longtime residents have what must be described as a love-hate relationship with their recent notoriety. They appreciate the interest from the outside and the tourist dollar; they'd just as soon visitors did not become permanent residents.

On a recent visit, I couldn't help checking out the Lady Chablis, the unflappable transvestite Berendt featured in his vast cast of Savannah eccentrics. Chablis had been touring with a jazz show inspired by the *Midnight* book, but was home for a one-night performance at Savannah's Club One.

Chablis's red and silver dress caught the light like nobody's business. It was glittery, but tasteful, something Miss Georgia might wear for the talent division. Chablis was amazingly small, with dainty legs and a waist Scarlett O'Hara would have envied. She had a short, smart hairdo, the better to dangle long earrings. Her high heels would have killed a lesser soul.

"Thanks for coming to see Chablis on such short notice," the famous female impersonator drawled. She seemed to mean it.

I didn't know exactly how to feel about watching a drag show in a town famous for its floral native beauty and cultivated good manners. In the name of newspaper work I've sat through a Louisiana cockfight and an Alabama tractor pull. But I'd never watched a former Frank in a skin-tight dress talk nasty and lip-synch songs while customers stuck bills in her blouse.

Yet that's what makes Savannah—and the rest of Georgia, and the rest of the South—so fascinating. You can rattle along brick streets from the historic to the fantastic without a passport. All you need is an open horse-drawn carriage and an open mind.

❖ ❖ ❖

It wouldn't be wise to leave southeast Georgia without seeing the Okefenokee Swamp, eight hundred square miles of sinister beauty and liquid wilderness. The Okefenokee is an environmentalist's dream—despite occasional assaults from some industry or another—with absolutely no roads crossing from one side of the swamp to the other. In a boat, getting clear

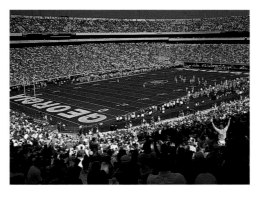

across it might take three days—or longer if the water is down.

I had seen the swamp before, but never as up close and personal as I did one July day in 1994. A young guide had been regaling us outlanders with amusing tales of alligators and cottonmouths and insect-catching pitcher plants and labyrinthine swamp trails that lead nowhere fast. So when my canoe tipped over at the starting point and I stood shoulder-deep in the blood-red, tannic-tinted swamp water, my greatest fear had a name: Old Oscar.

Somewhere not far away was a twelve-foot alligator the guides once clocked at thirty-five miles per hour. Old Oscar was the dominant bull in the park, the guide had said, the head alligator honcho, the one who ran off the other males so he could have the girls to himself.

Had Old Oscar heard the splash as I rolled into the Okefenokee? If only I had been free to succumb to the terror and—as any reasonable person would—squeal like a girl. But, no. When I make mistakes or look the fool, it's never in the privacy of my home or in some foreign country that I'll never visit again. When my canoe tips, it wouldn't be deep in the swamp with only a bullfrog and an opossum or two as witnesses. I had a rapt, happy audience. A group of tourists waited for the next, motorized swamp-boat ride—the one I should have taken—on a platform a few feet away. They were watching, laughing, offering lame advice.

So I pretended to be calm, as if a reptile known to move faster than some cars didn't faze me in the least. I was trying to move my feet through the muck, when I remembered my camera. Trying to look graceful while flailing about in alligator-infested waters, I began the search. It didn't take long.

I had assumed that the thing wound tight as a tourniquet around my leg was a snake. But it was the camera strap that was wrapped around my right foot. I hoisted myself, and my camera, from the swamp to the dock, to the delight of the crowd.

Even that swamp story won't keep me from returning some day, maybe in the wintertime when there are fewer mosquitoes and no unsympathetic tourists. The swamp is a primal draw of vast proportions.

If you travel a straight line from the Big Swamp across the state to the west, you eventually hit my little hometown of Colquitt, population 1,991. I mention Colquitt because it may well represent the opposite pole of Georgia, as far as you can get from Savannah and the exotic, romantic Coastal region of barrier islands and golden marshes. Nobody honeymoons in Colquitt.

Southwest Georgia is serious farming country, serious country period, beautiful but in a strictly workaday and sensible way. It is a land of peanut farmers and migrant tomato pickers, Baptist churches and their ceremonial foot-washings, irrigation sprinkler rainbows, and dust devils—a land whose undeniable physical beauty is of secondary concern to most of the inhabitants. Rain— or a lack of it—is the first topic of any conversation, as much of a factor in the farming life as wind to a sailor.

As I mentioned, both of my grandfathers were farmers—peanuts, corn, row crops. But my own father had seen enough of the farm life. After World War II, he came home, became a butcher and soon enough took the advice of the masthead of the local newspaper, the *Miller County Liberal:* "Pull for Colquitt, or Pull Out." My family pulled out when I was a mere toddler. But my mother insisted throughout my childhood, which was spent in the Central Time Zone of Alabama, that the family operate on "Georgia Time." If it was 8 P.M., she said with great authority: "It's bedtime. It's 9 o'clock in Georgia." No, none of us was entirely successful at shaking that prolific south Georgia topsoil from our roots.

As it was, I spent many childhood summers in the pastures, bosky backroads, and tree-shaded creeks of Georgia's Miller and Seminole Counties. I went for extended visits with grandparents, aunts, uncles, and cousins. I learned to water ski among the cypress stumps of Lake Seminole and helped my grandmother make jelly from the rare, native mayhaw berries that grew on bushes in the bogs. I played on the railroad tracks in Arlington and slid down the Indian mounds at Kolomoki. I took for granted the dual life I led—fall, winter, and spring in suburbia, summers in a rural paradise.

I loved the way people stayed close to the earth in south Georgia, as if they remembered whence they came. You didn't go to the store for an egg or a chicken, you went out to the chicken house. There were smokehouses and outhouses and barns with

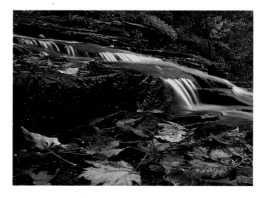

sparrows roosting in the rafters. And it was a major adventure to go into town, into Colquitt, where the sidewalks were raised and you could shop every store on the square in an hour. Nobody followed you around with suspicious eyes the way adults sometimes did in suburban shopping centers. In Colquitt, they knew your mother, your grandmother; they knew you.

There was a reliable rhythm to life that is missing in the city. You could depend on things remaining the same from one visit to the other. Almost. One memorable year, when I was nearly grown, a wooden Indian took shape from a tree next to the drug store; little Colquitt finally had rated real art.

Last time I noticed, that proud Indian was rotting fast, assaulted by the steamy days and Buick-sized bugs that are all part of Colquitt's considerable charm. Free-spirited artist Peter Toth had carved the sculpture from a big oak tree, officially presenting it to the town and the state of Georgia in 1973. Toth made an Indian in each of the fifty states, choosing sites that had some connection to Native American history and, maybe more important, an appropriate tree. It pleased me no end when Toth came to Colquitt and found his Georgia tree in Seminole country.

Toth worked for donations and drove a hippie van, his pet duck waddling behind him as he worked. My maternal grandfather was fascinated by the artistic evolution—stump to imposing figure—and he added the Indian-in-progress to his habitual route through town. We'd take Peter a plate of food from my grandmother's miracle kitchen, and the artist always seemed grateful. Peter was skinny, but he could eat a lot. (I always worried a little about that duck.)

If you don't count the dissolving Indian, Colquitt changes less than any other town for which I have affection. Yet even here things have changed. There's one fast-food restaurant now, but most chains have studiously stayed away. The town limit signs tout the Mayhaw Festival; they used to proclaim Colquitt a Bird Sanctuary. The old courthouse burned down years ago, and the modern one looks squatty and wrong. Hobos used to sit on the steps of the old edifice and eat ice cream right out of the carton; you can't see that happening now. Wyatt's Grocery is gone, and so is the E-Z Shop, the dime store where I spent enough money on paper dolls to finance a small country.

The theater is long gone, too. The last movie I saw there was *Please Don't Eat the Daisies* with Doris Day. For a while the theater became a feed store, and the owner posted the price of cow pellets on the marquee. I kept thinking it might become a movie house again. As long as some name was up in lights there was hope, even if the name was "Ralston Purina." It never did.

Colquitt has changed, but the atmosphere is exactly the same, the molasses-slow voices and life. And the things that are precious about Colquitt are suddenly becoming precious all over. An old hotel where teachers used to room and board has been refurbished and has reopened as a stately inn. Local thespians have made a name for themselves with a folk-life play called *Swamp Gravy.*

They moved my grandmother's house from its century-old roost on U.S. 27 to a new spot out on the Bainbridge highway. Moved that precious landmark, minus its porches, right down the road.

All things, all people, are a little like the eroding Indian, I guess. Time and the elements do a mean job on them all. But some visionary comes along and carves a new face. And that's how it has to be.

❖ ❖ ❖

You can take U.S. 27 from Colquitt, straight up the western edge of Georgia, all the way to Rock City. Barns along that three-hundred-mile route used to advertise a popular tourist destination: "See Rock City. See Seven States from Atop Lookout Mountain." (See Rock City almost sounded like biblical admonition. Thou Shalt Not Steal. Thou Shalt Not Kill. See Rock City.)

After a lifetime of exhortations, I finally saw Rock City in 1999. I followed the old barns and my heart skyward through suburbia and pines. What a quiet, nostalgic place it was. What a surprise. (The first surprise being that Rock City is in Georgia, half a mile from Tennessee.)

Before you get to Rock City, however, you have another, more rudimentary treat in store. Riding up 27. There's no other road quite like it anywhere. It doesn't rank as the most scenic road I've ever taken—too many improvisational dumps and kudzu craters and serious men spitting off porches as if that's what they are paid to do. But for my money, Georgia's Martha Berry Highway (as U.S. 27 is called in this state) is the most interesting road in the country. It

has character. If roads were actors, this one would be Ben Johnson.

Named to honor a Georgia educator, the road itself is an education, a crash course in Southern culture. From Amsterdam in the South, through pretty Pine Mountain and military Columbus, past Warm Springs where FDR built his Little White House and gave courage to polio victims, to the bloody Civil War site of Chickamauga at its northern end, U.S. 27 is an unabridged book on what makes the region special.

If you are tired of 27, to paraphrase Samuel Johnson, you are tired of Southern life. In the forty miles between LaGrange and Carrollton, for instance, you can watch "Pro Mud Racing," buy a cow from Deer Oaks Black Angus farm, or deposit your sweet potatoes at the W. E. Johnson Sweet Potato Curing and Storage House. (Actually, the little red sweet potato house is a well-preserved relic.)

In Carrollton, if you detour just a few miles off the highway to the State University of West Georgia, you can see for free a beautiful reproduction of the famous Bayeux Tapestry, faithful in size, detail and color, to the one in France. The massive work loops around itself in the school's Humanities Building. Its story is explained at eye level in captions that read like a medieval soap opera: "Here Duke Harold dragged them out of the sand.... And Conan took to flight...."

Half a million people a year see the real Bayeux Tapestry, a band of linen 231 feet long with fifty-eight embroidered scenes of William of Normandy's Conquest of England. The original was created around 1092; Georgia's version—the only Bayeux Tapestry reproduction in the Western Hemisphere—is only a dozen or so years old and was commissioned by a local judge. Few even know about it.

Watch out for traffic if you stand by the side of the gentle-sounding Martha Berry Highway to take a picture. This is not some backroads blue highway. A Peterbilt truck might flatten you.

Berry College near Rome was founded by Martha Berry, the highway's namesake, whose family lived on an antebellum plantation—now part of the 26,000-acre campus, the world's largest. The size is something, all right, but I'm more impressed by the devotion that graduates feel toward this institution decades after they get a diploma. It might have something to do with the

fact that Berry was started for kids who otherwise could not have afforded college. Everyone worked his or her way through.

One day I met the members of a male quartet that had been popular on the conservative campus in the 1950s. When rich Northern benefactors made their annual pilgrimages to Berry College, nervous administrators wanted to showcase campus talent. So they asked the boys to sing. Martin McElyea, Derward Powell, Marion Lacey, and Jim Hawkins were rebels, or as close as students came to being rebels in the days of gray flannel. They sang a song that begged "Daddy get your baby out of jail. Come and get someone to go my bail...." The ditty made reference to morphine and "coke"—not the stuff to impress influential visitors who had heard so much about the hard work, clean living and strict rules atop Mount Berry.

"At the time I didn't even know what morphine was," McElyea told me. "And I thought 'coke' was Coca-Cola."

I caught up with the quartet at a reunion held after forty-odd years. One member journeyed all the way from California. It was touching to hear them talk of walking arm in arm through the night, warbling innocence. And now, every time I drive on the Martha Berry Highway by Berry College, I can almost hear them singing.

❖ ❖ ❖

Near Rome and Berry College, in a park as quiet as a church, is the print shop of the Cherokee genius, Sequoyah. New Echota is the old Cherokee National capital. An old hand press is housed in the one-room print shop that Sequoyah built, a press much like the one used in 1828 to ink the first issue of the *Cherokee Phoenix,* the first Native American newspaper. It was made possible by Sequoyah's Cherokee alphabet, or syllabary, as it is more precisely called. It took him twelve years to develop it.

"His wife burned his work once," a park guide told me. "Thought he was neglecting his chores."

Other villagers believed Sequoyah crazy, too, cloistered as he was each and every day, muttering nonsense and making crazy marks on stones and scraps of paper. They burned down his cabin, proving once more that genius is always suspicious in a world ruled by mediocrity. Sequoyah persevered. And in time he gave his

people a written language, then spent the rest of his life teaching them to use it.

In the 1830s came the north Georgia gold rush, and the state decided the Cherokees—who had tried so hard to fit into the white man's alien world—were in the way. The press at New Echota was seized, even used for a while to print anti-Indian propaganda. In 1838, the forced removal of fifteen thousand Cherokees began the heartbreaking ordeal known as the Trail of Tears.

Sequoyah's own westward odyssey took him to Arkansas, then Oklahoma. He died alone in the Mexican Sierra, no ceremony, no monuments. But Sequoyah is honored in the best imaginable way, his name forever attached to some of the most beautiful and enduring of living things: the California coastal redwoods.

The *Cherokee Phoenix* had circulated as far as Berlin, and Sequoyah was known internationally. In the nineteenth century, Austrian botanist Stephen Endlicher proposed the genus name "Sequoia" for the conifers. An English botanist wanted to call the giants *Wellingtonia gigantea* in honor of the Duke of Wellington. American botanists countered with *Washingtonia califonica,* honoring George Washington. It might have been an accident of fate and nomenclature, but the Austrian's *Sequoia sempervierens* prevailed.

Poetic justice. The Cherokees won one after all.

❖ ❖ ❖

Not far from New Echota is Calhoun, a friendly little town that boasts, among other things, an aspiring novelist and former presidential aide who lives in a tree house. I first met Sam Edwards in 1995, after climbing straight up into the branches of an old oak tree.

Sam had warned me over the telephone that his roost was "more adolescent fantasy than *Architectural Digest.*" And that's true, since it isn't in some pristine wood or overlooking a babbling brook. Instead, it is on the back end of a restaurant parking lot, next door to a motorcycle repair shop.

Sam once worked as an advance man for the Jimmy Carter election campaign, and later for presidential hopeful John Glenn. He's also been to law school, worked for a blue jeans factory in Texas, as an overnight disc jockey in Wyoming, and as a bit actor in Los Angeles. Now he prefers the solitude of the tree house for writing, and also enjoys the fact that it's become a minor tourist attraction.

For Edwards's tree house is the talk of Calhoun. Every time he finishes an addition—an old airplane fuselage recently became his bedroom—somebody alerts the newspaper. City officials aren't crazy about the crazy house, and the tax appraiser used to teach a seminar based on thorny questions the unconventional high-rise raised.

After twenty-five years in the newspaper business, the whole time in the South, I find Edwards's story not so much bizarre, just typically odd. Southerners are given lots of credit for showcasing their eccentricities, and sometimes they may work a bit overtime to live up to the reputation.

Sometimes, of course, tolerating eccentricity pays off, as it did just to the east of Calhoun in tiny Cleveland, Georgia. That town today is best known as the birthplace of a notion—the Cabbage Patch doll. A local man, Xavier Roberts, one day in the mid-1970s had the idea of making an over-stuffed doll, a baby that would be born in a cabbage patch and "adopted," not bought. The dolls became a national obsession, and Roberts eventually teamed with Coleco to sell them. Over the years more than eighty million Cabbage Patch babies have been born, named, and adopted.

You still can buy a stuffed Cabbage Patch doll in Cleveland. Babyland General Hospital—once a real infirmary, later the factory site, now a combination museum and store—may well be the South's most effective sex education class. You can watch your doll being born in a silk cabbage patch, then "adopt" it forthwith. A pretend nurse in the pretend pediatric hospital explains that all tours are self-guided and that she's "certain there will be a birth soon."

North Georgia's mountain towns don't really need such gimmicks to draw visitors. In the land James Dickey made infamous with his novel *Deliverance,* the mountains themselves are sufficient draw. Worn down by one hundred million years of weather and hard use, the peaks don't compare to North Carolina's Smokies, and that fact so far has kept tourist crowds to a reasonable size. It's as if nature struck a compromise deal.

One of the prettiest of the mountain villages is Dahlonega, the place the Georgia Gold Rush began, the rush that caused the Trail of Tears. They say that in 1828 a man stubbed his toe on a rock, and that rock had gold in it; you might say he stumbled into fortune.

They mined enough gold at one point to justify locating a branch of the U.S. Mint in Dahlonega, but it's long gone now. The mines are only memories and tourist attractions. Most of the gold in Dahlonega dangles from dainty chains in the jewelry stores. But that rich period of Georgia history isn't completely forgotten. It is Dahlonega gold that covers the capitol dome in Atlanta.

❖ ❖ ❖

Thanks to *Deliverance* and the Foxfire books, the best known of the north Georgia mountain counties is Rabun, in the easternmost corner of the region. The daring routinely raft the Chattooga River (used as Dickey's Cahulawasee in the movie), and swarms of city residents stream northward from Atlanta on weekends to breathe the clean mountain air.

In 1995, I headed up to Mountain City to interview the new head of the famous Foxfire organization, perhaps the nation's best-known alternative educational movement. Bobby Ann Starnes is a self-proclaimed "hillbilly" with a Harvard degree. For me, she typifies the best of today's Georgia—an educated citizen with a healthy degree of respect for the past. In a way—in a dozen different ways—Bobby Ann had been preparing for the demanding Foxfire job all her life. She was born in Caney Creek, Kentucky, one of seven children in the family of a poor coal miner. Her father left the hills searching for a better life. He got a job in Ohio, operating a factory elevator, and his family landed at the bottom of society as despised urban Appalachians.

"Anyone who has ever been, in any way, part of a minority—and most of us have—would understand," Starnes said. She moved to the 110-acre wooded compound in Rabun on a May day, when wildflowers covered the Georgia hills. "I felt as if I'd come home."

Rabun County residents had embraced Foxfire when it first began and had helped catapult it into national prominence by sharing local folklore, crafts, and home remedies. Students interviewed old-timers, whose involvement was essential. After the unexpected success of the first Foxfire magazine, there were more magazines, the popular books, a movie, and a Broadway play. The hillbillies of north Georgia found reason to be proud, and about things that in the past had invited derision from outsiders.

To a gratifying degree, the world at large finally has come to appreciate the old-fashioned ways and rituals that some in rural Georgia never really abandoned. All over the state, not just in the mountains, time-honed crafts and skills are passed from generation to generation the same routine way a clock is wound. And for the same reason: to keep it going. In the nooks and crannies of the state, you find, as William Faulkner once observed about the entire South, that the past is not really past at all.

One fall day in a Carroll County community called Farmers High, I watched (and smelled) the making of pure sorghum syrup. It is not a quiet enterprise. Not when you use an old International tractor engine to power the press that squeezes the juice from the stalks of cane that rumble in from all over the region, one pickup truckload at a time.

It's not a quiet business, but it is a beautiful one, colored exactly like fall—the red and jade cane, the rusty tin top of the cookhouse, the whiskey-colored syrup. And it's done in a countryside so peaceful and uncluttered it's hard to remember that Atlanta and its gridlock are only sixty miles away.

The Bradley brothers who own the syrup mill talk like Larry McMurtry Indians, in poetic phrases, descriptive but uncontrived. They make their syrup, they told me, "every other day, from the end of August until the first killing frost."

And they don't have to advertise or worry about marketing and delivery. They sell it straight from the mill, as fast as they can cook it. Those within smelling distance know when it's time.

The day I visited, Lawrence Prater was chief cook, and the Bradleys deferred to his expertise. He had been making syrup for over sixty-five years, since 1929, when he was twelve years old. Mr. Prater had a regal bearing, as a man in charge should. Roger Bradley explained the time-honored system: The cane farmers get two-thirds of the finished product, the syrup. The miller keeps one-third. Used to be, the farmers contributed firewood and helped with the cooking.

The old copper pans and tanks have been replaced with stainless steel, and Bradley used gas instead of wood to cook the juice. The sputtering engine took the place of a horse going round and round. But otherwise the enterprise is the same as it was when Bradley's father made syrup to help feed his twelve children.

There used to be a schoolhouse in Farmers High, and a hardware store that was first-rate. Now, except for the mill, it is residential, rural homes spaced between the small farms. At night, you see why they called it Farmers High. You can look far into the distance, across the Little Tallapoosa River valley, at the bright kitchens of other farm homes and the lighted chicken houses. From the hilltop called Farmers High, you can see the whole world.

❖ ❖ ❖

There must be magic in the tired dirt of the Georgia Piedmont. The red clay produces more than the grass for dairy cows. It grows writers. Or seems to. And not just writers, but provocative writers who dwell in Hell awhile and endure to report back.

A fiction writer might steer clear of beautiful, improbable Putnam County, with its rabbit statue on the courthouse square, a Greek revival home with a suicidal ghost, not to mention the United Nuwaubian Nation of Moors building pyramids behind locked gates. Far too far-fetched for believable fiction.

Eatonton, county seat, is the town with Brer Rabbit on the courthouse lawn and an Uncle Remus Museum. That's because it is the birthplace of Joel Chandler Harris, who was delivered in a tavern to an unwed, seamstress mother in the 1840s. (There is dispute about his exact birth date.)

Putnam County is also the birthplace of Alice Walker, born in 1944 to the bleak life most blacks faced in the rural South.

And, only a few miles down the road in neighboring Baldwin County, is Andalusia, the dairy farm where Mary Flannery O'Connor lived and wrote with the debilitating disease lupus, from 1950 until her untimely death in 1964.

Alice Walker has, in the past, denounced publicly Harris' Uncle Remus tales. (Harris, however, has his scholarly defenders, black and white, who insist his work helped preserve a cultural trove of black folk tales.)

Putnam County appears today to embrace both writers. Docents at the Uncle Remus Museum seem happy to share a map to various Alice Walker sites, which, in turn, are marked by county signs. Even a cursory look at the early lives of Harris and Walker show that, like all black and white Southerners, they had more than geography in common.

Harris bore the stigma of illegitimacy; he reacted with a stammer and extreme shyness. He was poor, but bright, and learned the printer's trade at nearby Turnwold Plantation, which published a plantation newspaper. From a fence post at Turnwold, young Harris watched Sherman pass on his way to the sea, and in the plantation slave cabins Harris first heard African folktales.

Alice Walker catapulted from dire circumstance as well. She, too, was determined and brainy, the valedictorian at her high school. She attended Spelman College before graduating from New York's Sarah Lawrence College. Her most famous story, *The Color Purple,* painted a vivid, lyrical portrait of endurance and won the Pulitzer Prize.

Flannery O'Connor packed her own trunk of problems. She was only twenty-five when stricken with lupus. Cared for by her mother, she wrote when and if she was able, and died at the age of thirty-nine. A collection of her stories published posthumously won the National Book Award.

There is something about the steamy, slothful South that continues to incubate good writers. And there's a remarkable reverence for the ones who were here before. A plethora of authors are celebrated at Georgia museums, including Joel Chandler Harris, Margaret Mitchell, Sidney Lanier, and Erskine Caldwell. Writers' roosts are revealing. It's a great feeling, for instance, to see the cramped kitchen of Margaret Mitchell's apartment—she called the building "The Dump"—and to hear that she hated to cook and rarely used it.

It's not just notable writers that Georgia boasts. You could, in fact, easily base a Georgia tour on all the arts, perhaps starting at Georgia State University's Pullen Library in Atlanta and the Johnny Mercer room. Mercer, of course, is the prolific Savannah native who wrote the words to "Moon River," "The Days of Wine and Roses," "Old Black Magic," "Autumn Leaves," "You Must Have Been A Beautiful Baby," and hundreds of other songs. Mercer wrote songs for ninety films; eighteen were nominated for Academy Awards; four won Academy Awards. Between 1930 and his death in 1976, Johnny Mercer wrote lyrics for 640 songs and the music as well for 55 of them.

Augusta is home to both James Brown and mezzo-soprano Jessye Norman. The rock band R.E.M. started in Athens. Macon claims Otis Redding, Lena Horne,

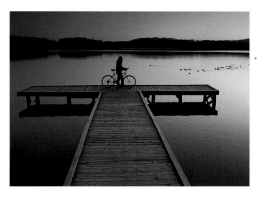

and Little Richard. Ray Charles is an Albany native. Villa Rica was the birthplace of Thomas A. Dorsey, often called the Father of Gospel Music.

Like its literature, Georgia's music is not limited to the past, or to superstars. A cozy Atlanta blues club, Blind Willie's, offers satisfying local acts almost any night of the week. One night, shortly after moving back to Georgia, I watched a singer called Lotsa Poppa float like a Macy's Thanksgiving Day Parade balloon across the floor to the Blind Willie's stage area. He braced himself between two tables, threw back his handsome head and swallowed the microphone.

He sang mostly familiar crowd pleasers: "Blueberry Hill" and "The Dock of the Bay." Every now and then Poppa would lapse into the raunchy, real blues. It wasn't so much his repertoire, which I suspect was born of too many lounge nights and requests scribbled by drunken patrons who wouldn't know the blues from the Moody Blues. It was the voice. The voice was full of pain and knowledge. Too soon, Lotsa Poppa glided to the back of the room and rested, his dark face passive. He was a condemned man with a last smoke and a blindfold. He was the blues.

(Lotsa Poppa, by the way, is Julius High, son of an Atlanta minister. He once spent a lot of time in the Northeast, warming up crowds for the likes of Wilson Pickett. He loves gambling, and his dream is to someday own a dog track.)

We started this tour with a song, so there's a certain symmetry in ending with one. Georgia, by the way, deserves all of its many musical tributes, from "The Columbus Stockade Blues" to "Midnight Train to Georgia." (The latter, for the record, was written by a Mississippian, and originally was to have been titled "Midnight Plane to Houston." Anyone would have to agree, "Georgia" has more poetry than "Houston.")

Since my return, a lot of people have asked me many times how Georgia compares to the rest of the South. In my vagabond life I've lived in Florida, Alabama, Mississippi, and Tennessee. I lack only Louisiana and the Carolinas to hold a royal Southern flush.

Those who ask, of course, only want to hear one answer—that Georgia is richer, prettier, more interesting and culturally diverse than anywhere else I know about on earth. And they want to hear that I could never live anywhere else now that I've rediscovered Georgia. (I'm not the only native who built Georgia into a myth as shimmering and impermanent as a Sapelo sandcastle. Those who love Georgia do so with an intensity and fervor that might be called strident by the uninitiated. I prefer to call it passionate.)

Whether I can give exactly the answer they want to hear or not, I can always satisfy even the most extreme partisan with the most honest of answers, "Georgia is home."

For a birth state is far more than its topography, more, too, than the interesting characters who populate it and make it sing, more than blue byways and the tallest mountain, the deepest gorge—even more than its unique place in a much larger history. More important than any of that is the emotional investment you have in a land—the relatives you've buried in its soil, for instance, who won't be moving anywhere else ever. It's the dirt from the ground in your home county that on a sweaty summer's day of childhood cultivated into round little sweat beads around your neck. It is the love you feel for the very smell of that dirt, the fertilized fields after a summer rain, the Nehi grape of the kudzu blossom, the stench of a south Georgia hog parlor. It is the visceral recognition of bushes and weeds for which you know no botanic name, only the musical-sounding ones your grandmother used to use. It is voices you can hear in your head and heart, the accents peculiar to your region only, the native way of saying "sturm" for "storm," and "directly" instead of "in a little while."

I would write my own song, if that were my talent, the way Otis Redding did while homesick on that immortal dock of San Francisco Bay. I imagine he felt a little of what I'm trying to describe, the late-night preference for a place you know well, even if it lacks the glamour, the adventure, of the place you happen to be.

I have looked for what I best remembered, and on some days that can be a thankless task. The suburban South is quickly taking over the countryside; pastures are annexed daily into the Land of Curbs and Gutters.

Mercifully, in Georgia, there remains enough of what once was to satisfy the most recalcitrant citizen, to satisfy even me. Watching the evolution of a beloved place, or of a person, can be difficult. But holding on is something Southerners are trained to do from birth. And, in some instances, it's not a bad skill to have.

◁ *Martin Luther King Sculpture.*
▷ *Piedmont Park, purchased in 1904 for $50,000 by the city of Atlanta, encompasses 185 acres of lakes and green space.*

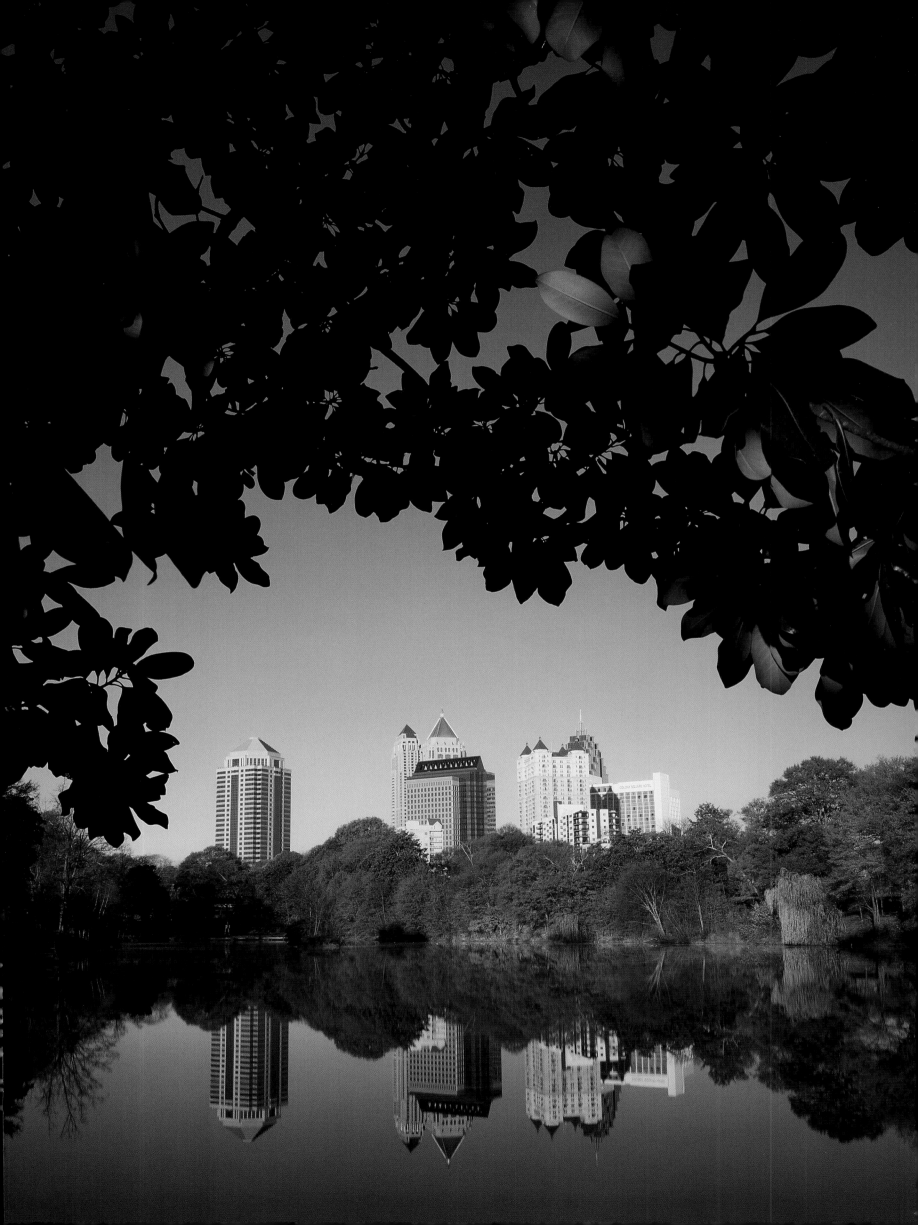

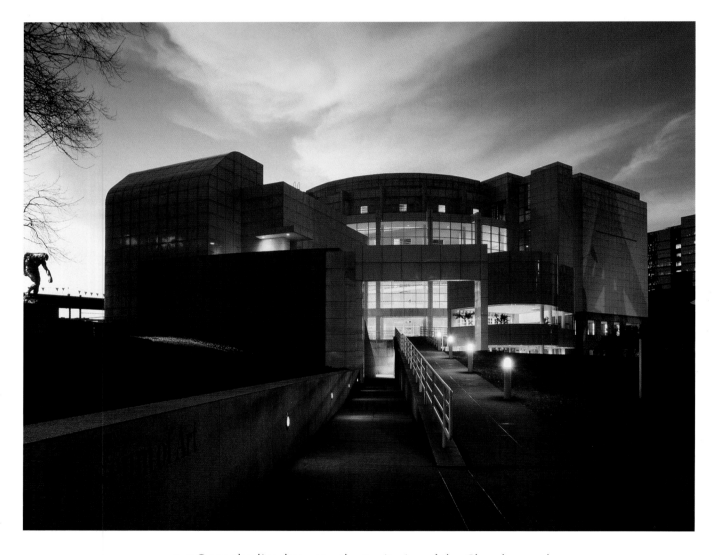

◁ ◁ Once the line between the territories of the Cherokee and Creek Indians, the Chattahoochee River is now the lifeblood of Atlanta, providing over 70 percent of the city's drinking water. △ This dramatic version of the High Museum of Art, designed by Richard Meier, opened in 1983. It replaces Mrs. J. M. High's original residence, donated to Atlanta as an art museum in 1926. ▷ In 1992, the Georgia Dome became home to the Atlanta Falcons.

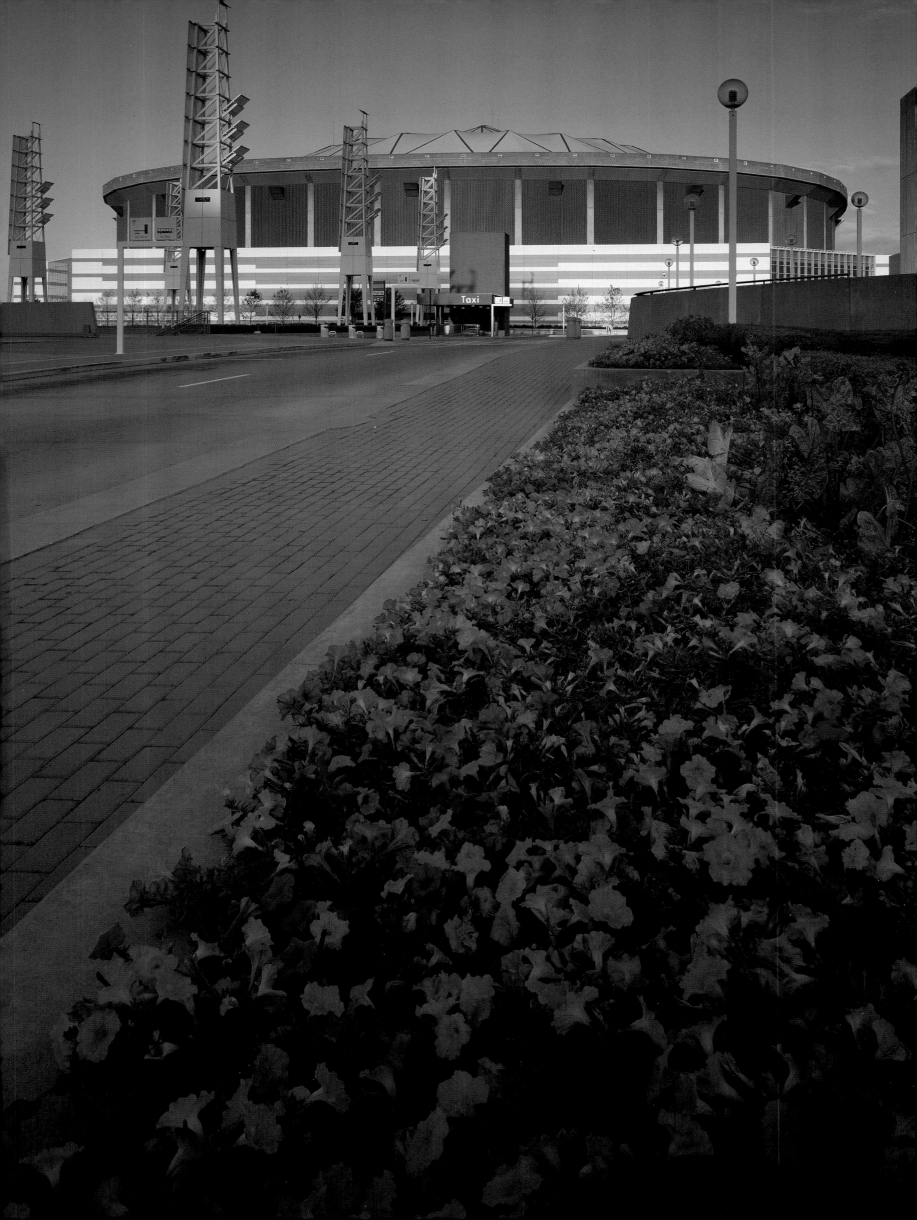

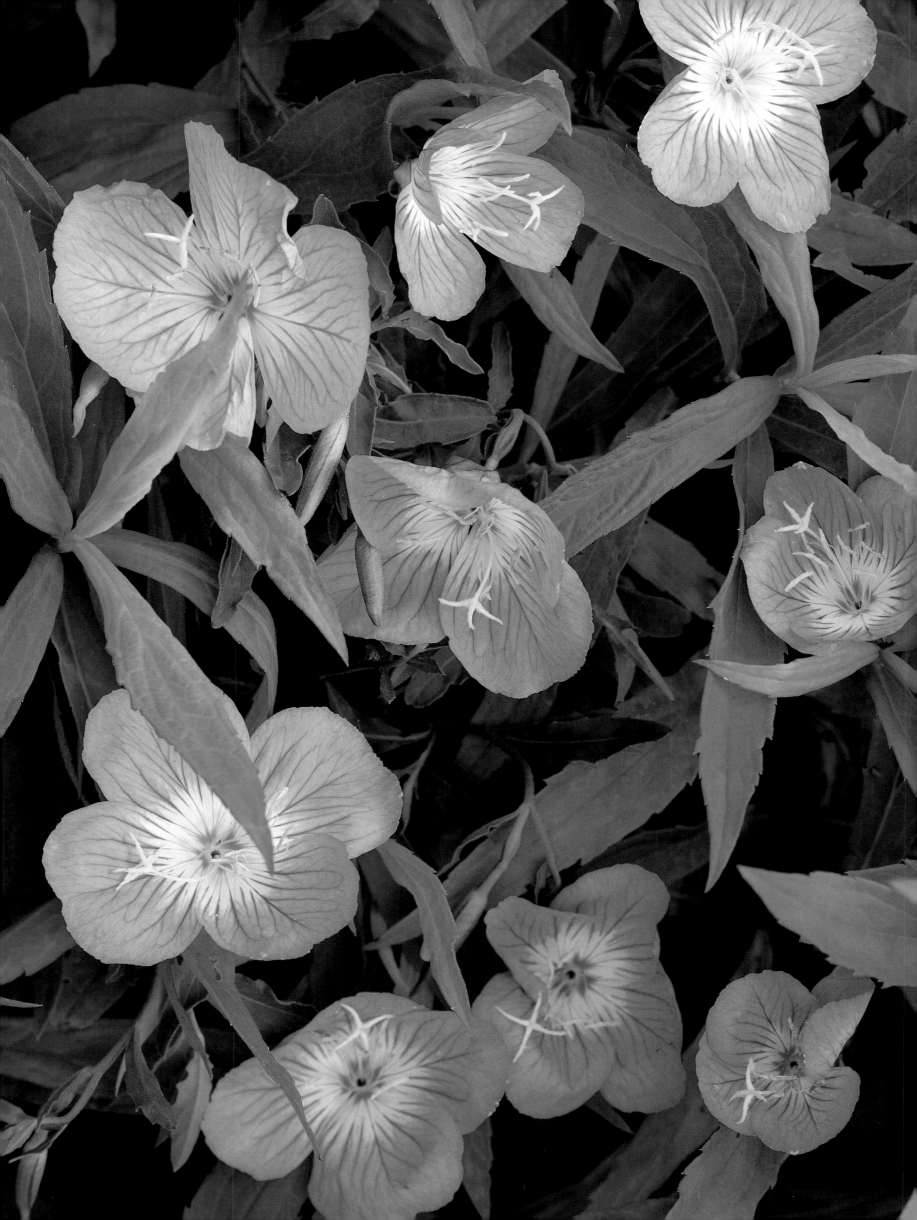

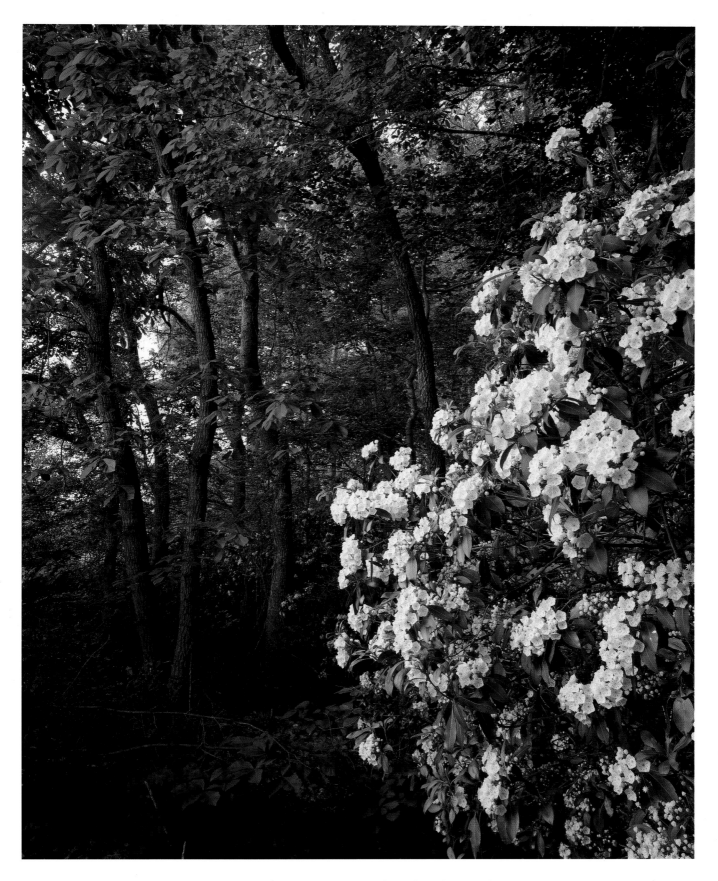

◁ Evening primrose dot the Chattahoochee National Forest at Raven Cliffs Scenic Area. Comprised of 750,000 acres of mountain scenery, the forest spans twenty-six counties across north Georgia.
△ High in the Blood Mountain Wilderness, evening light filters through the canopy of a ridge forest to light up the cup-shaped blossoms of mountain laurel. This wilderness area contains the most heavily traveled section of the Appalachian Trail in Georgia.

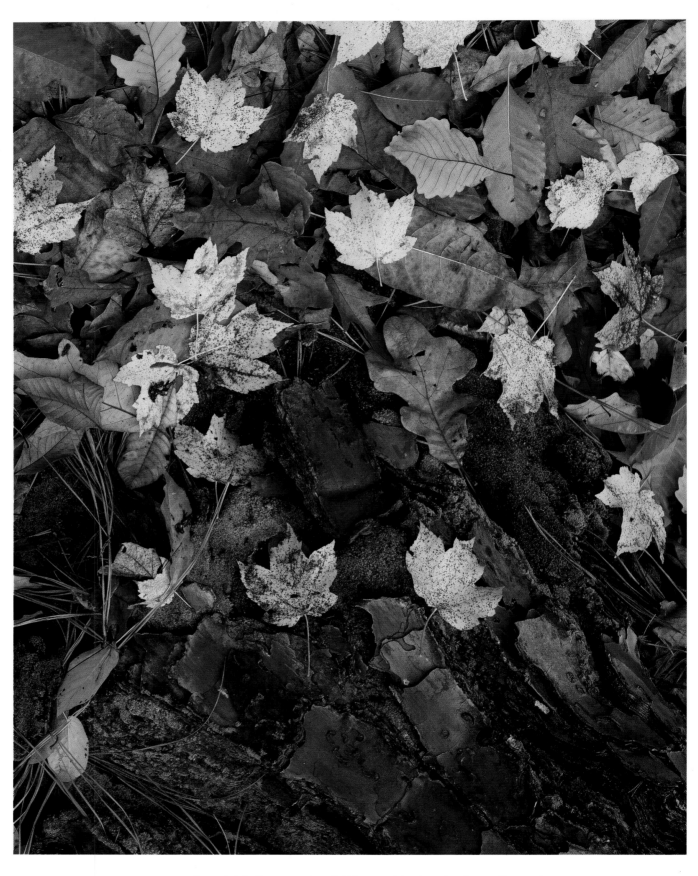

△ Under a loblolly pine tree, fall leaves blanket the forest floor of the Mark Trail Wilderness. Across northern Georgia, more than 115,000 acres are protected in ten separate wilderness areas.

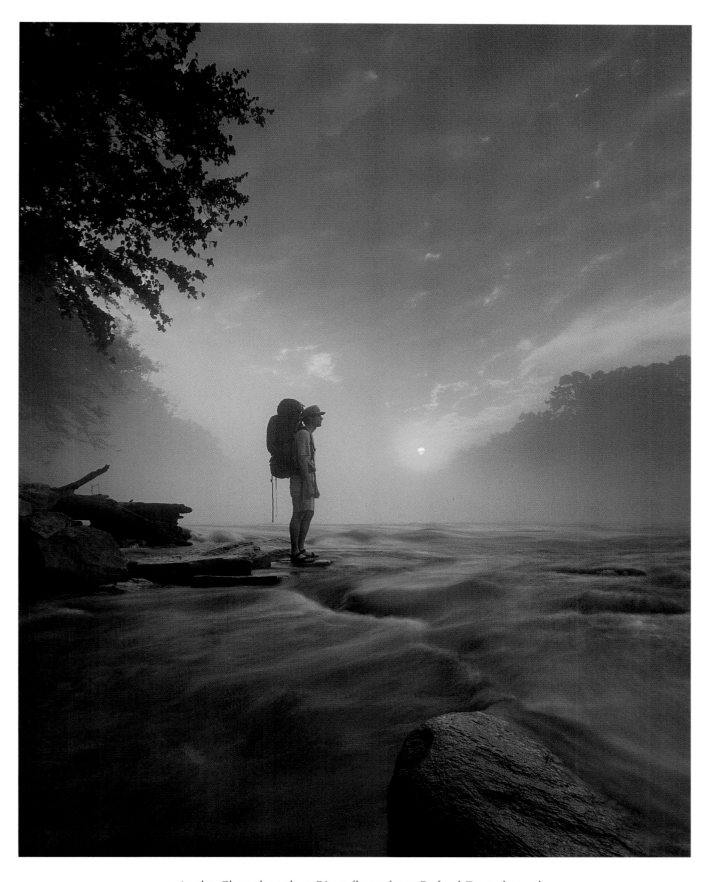

△ As the Chattahoochee River flows from Buford Dam through Atlanta, it is protected in a series of fourteen parklands that comprise the Chattahoochee River National Recreation Area. A hiker enjoys a sunrise at the Jones Bridge Unit of the recreation area.

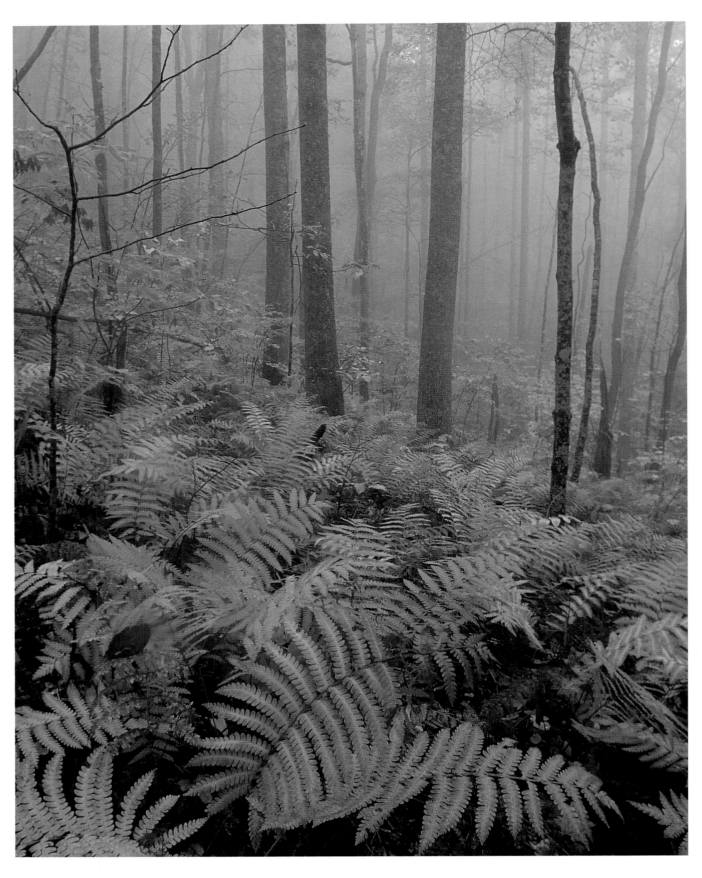

△ Low clouds blanket a poplar cove forest and fall-colored ferns along the Tennessee Rock Trail at Blackrock Mountain State Park. Blackrock is Georgia's highest state park with six different peaks over three thousand feet.

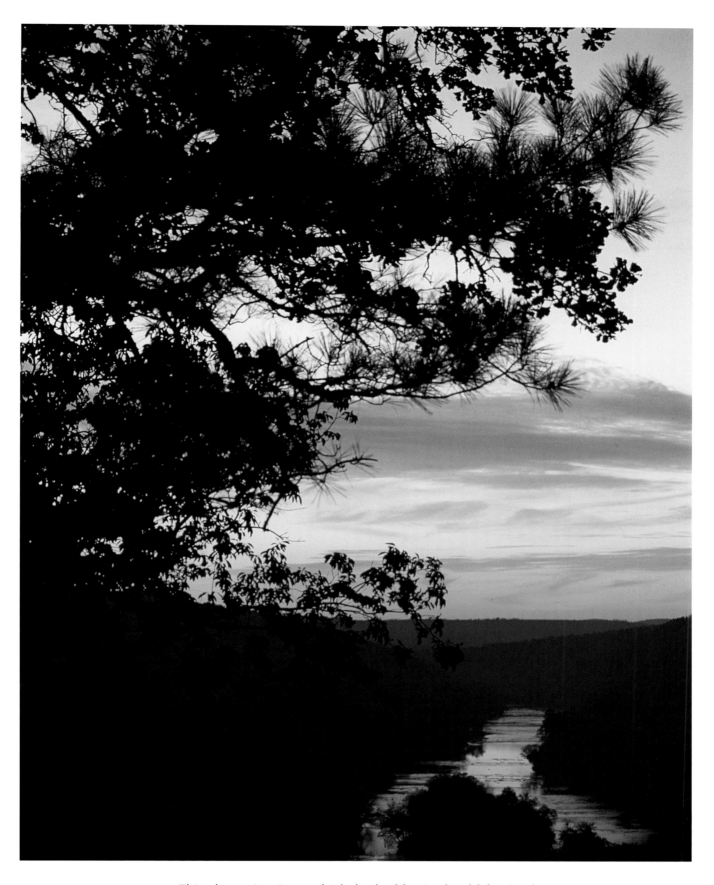

△ This dramatic view, which looks like it should be in the mountains of north Georgia, is actually an overlook on the Flint River, one hour south of Atlanta near the town of Thomaston. High bluffs, beautiful shoals, and thick forests make this area a favorite spot among canoeists.

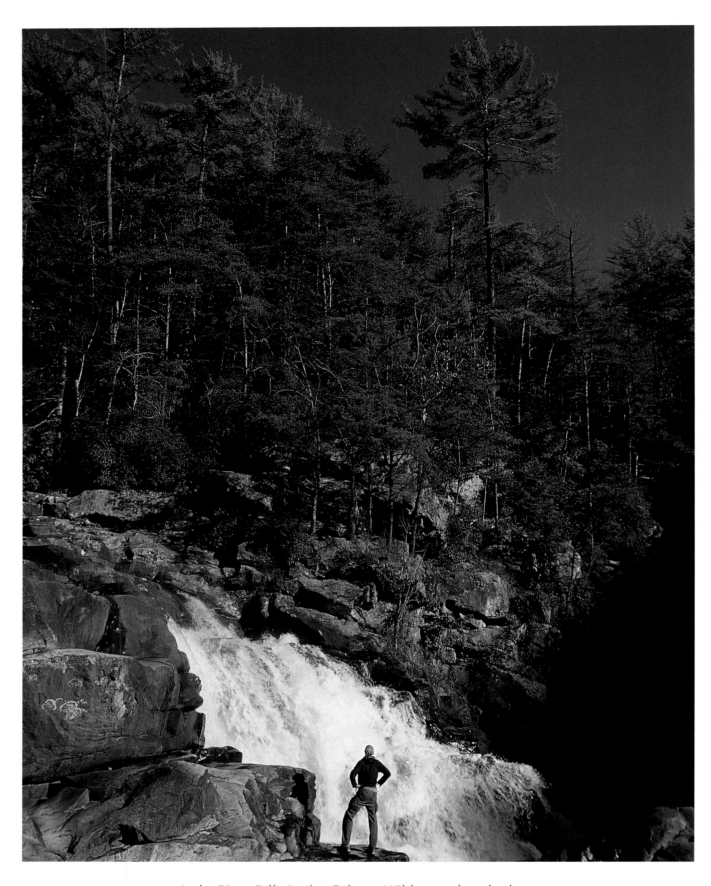

△ Jacks River Falls in the Cohutta Wilderness has the largest flow rate of any waterfall in the high country of north Georgia.
▷ Designated in 1974 as a National Wild and Scenic River, the Chattooga is a world-class destination for rafting and kayaking.
▷ ▷ From the Cowee overlook at Blackrock Mountain State Park, visitors enjoy views of the Great Smoky Mountains, the Nantahala Mountains, and the Southern Appalachians.

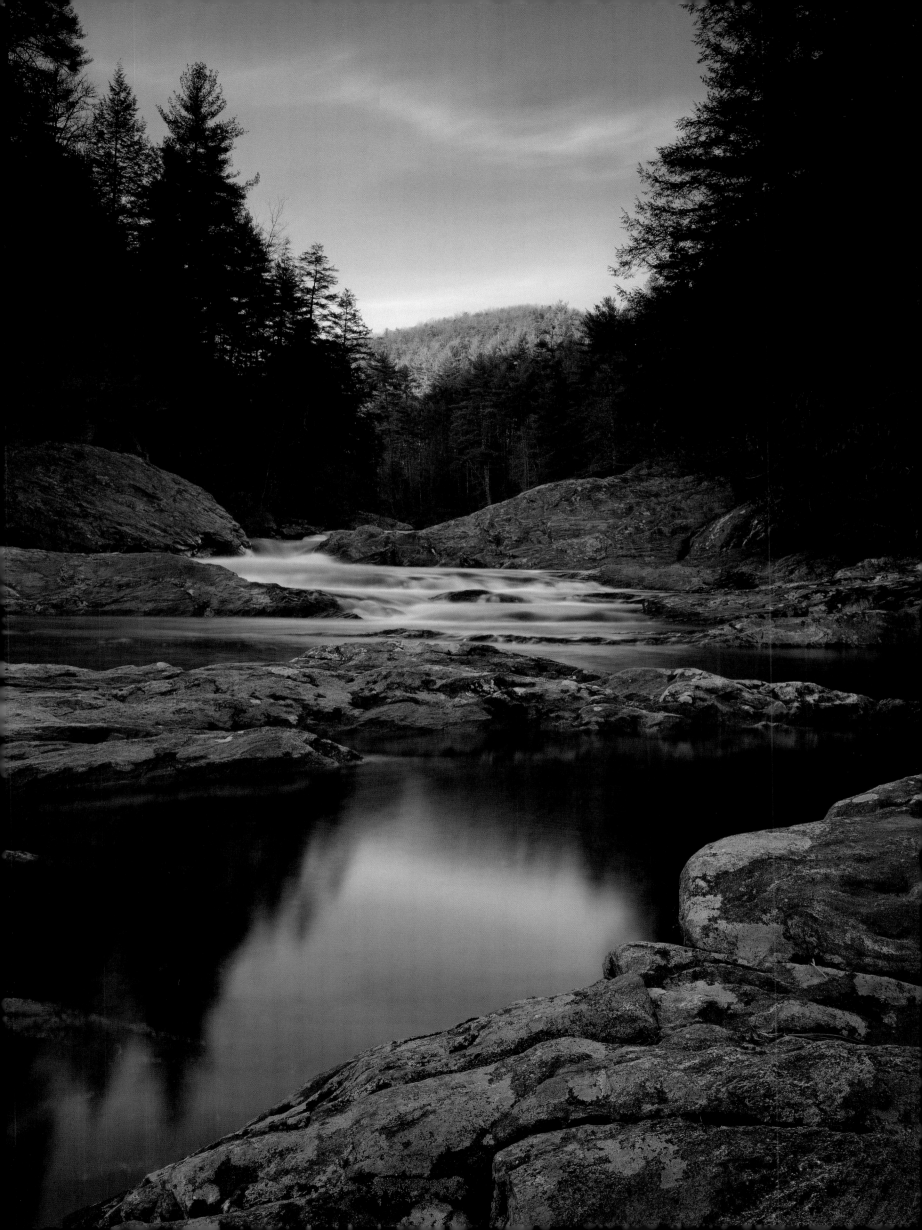

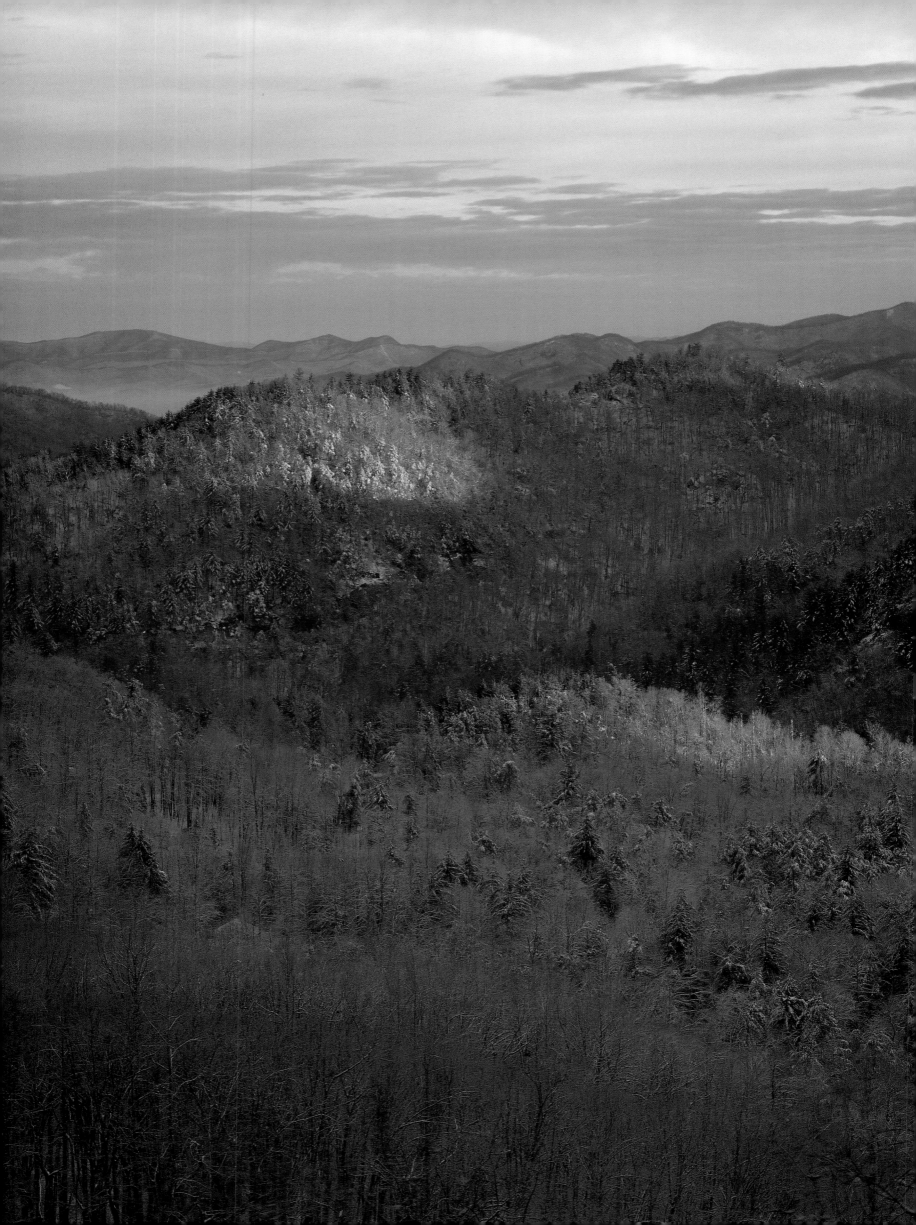

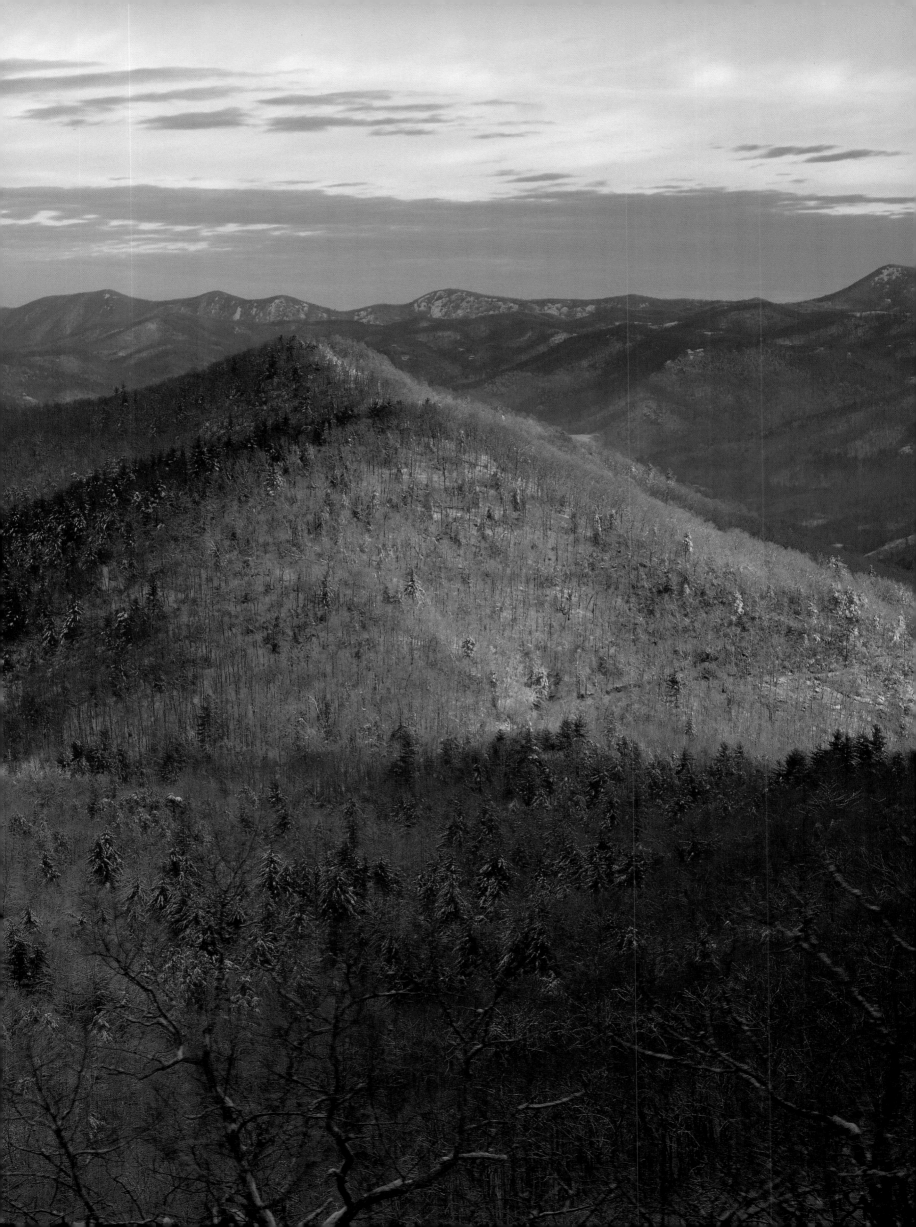

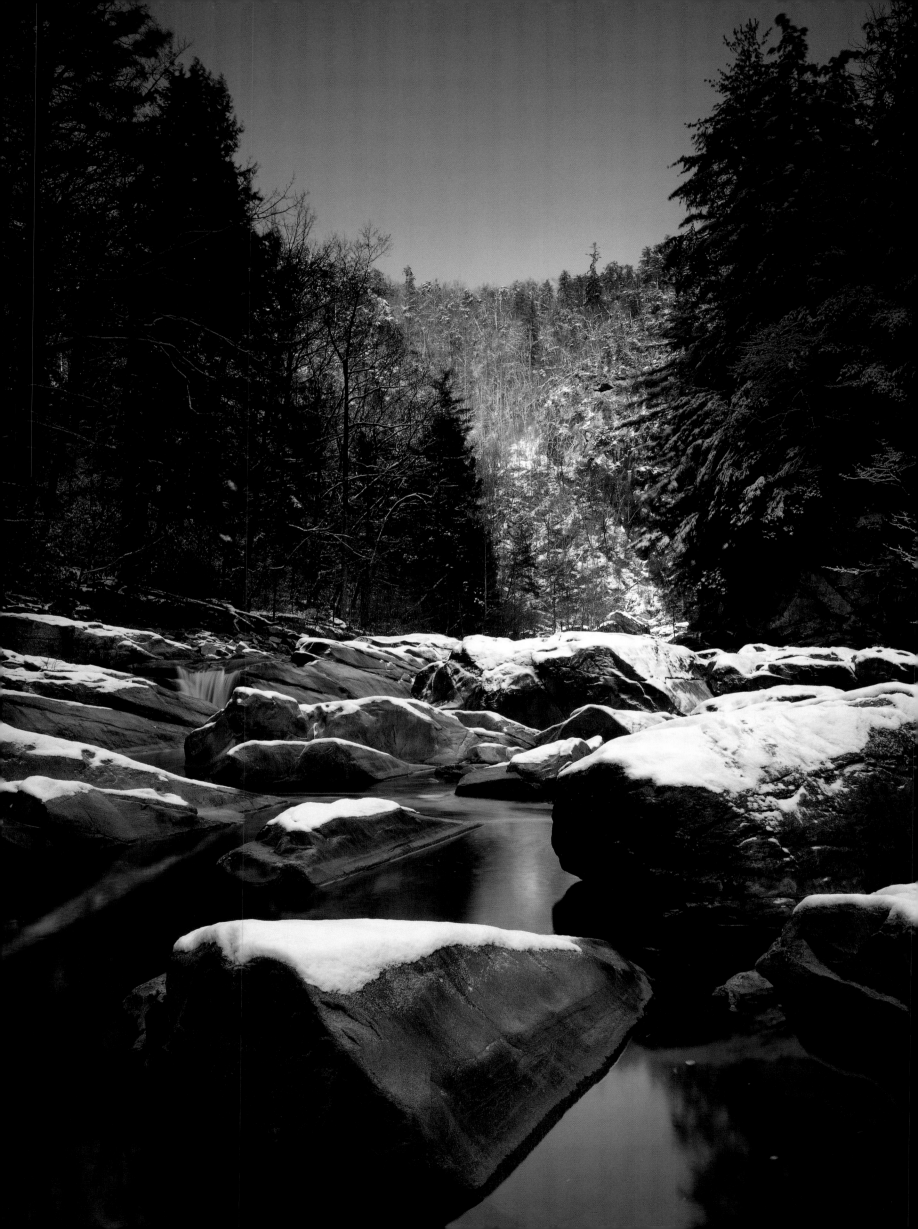

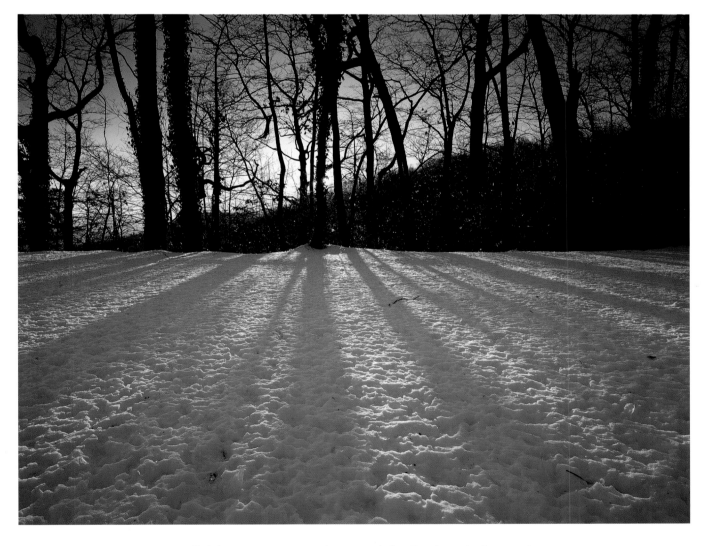

◁ Tallulah Gorge State Park, one of the East's most impressive gorges, is two miles long and more than seven hundred feet deep. △ Situated high on the eastern Continental Divide, Blackrock Mountain State Park records the heaviest snows in Georgia. ▷ ▷ The Appalachian Trail, from its southern terminus at Spring Mountain in north Georgia, winds its way through seventy-six miles of some of Georgia's most beautiful mountain scenery.

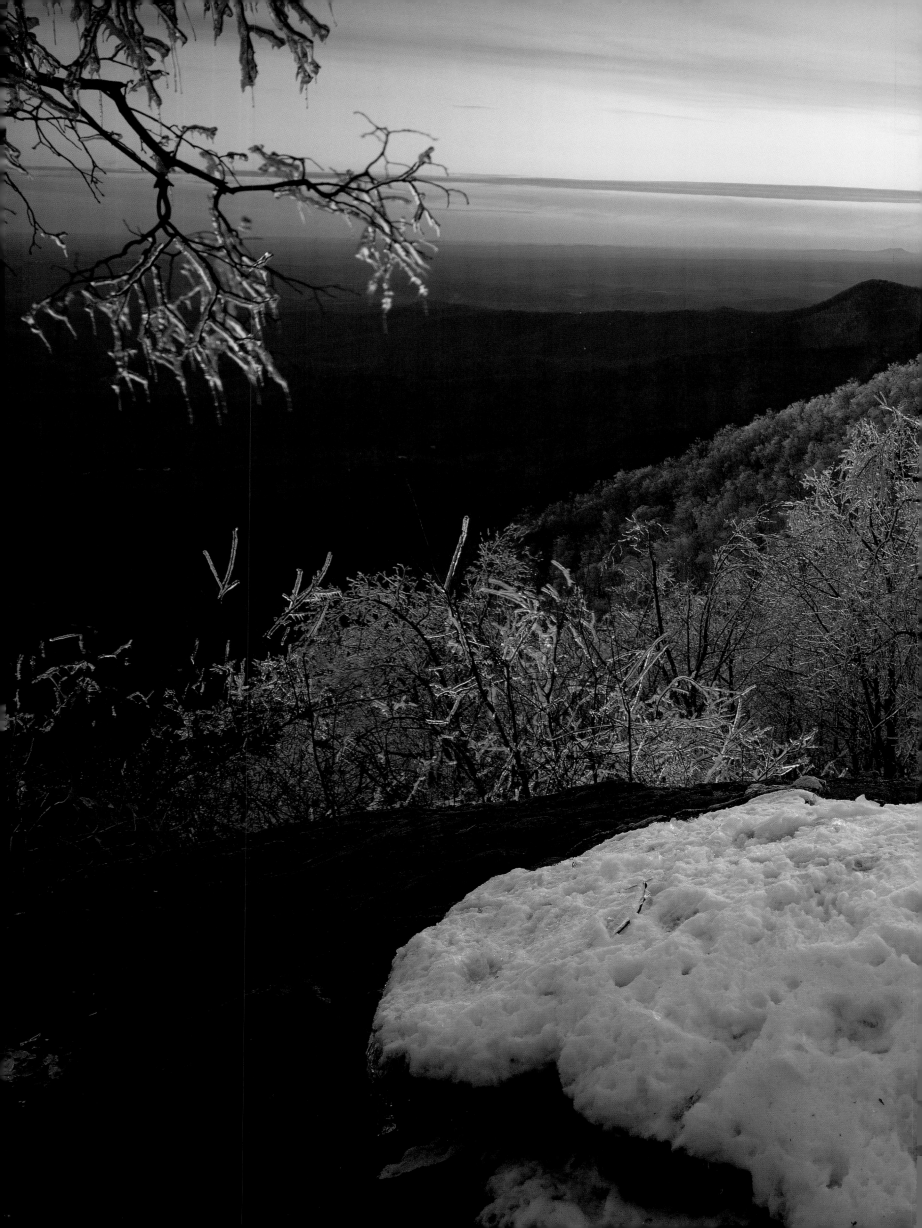

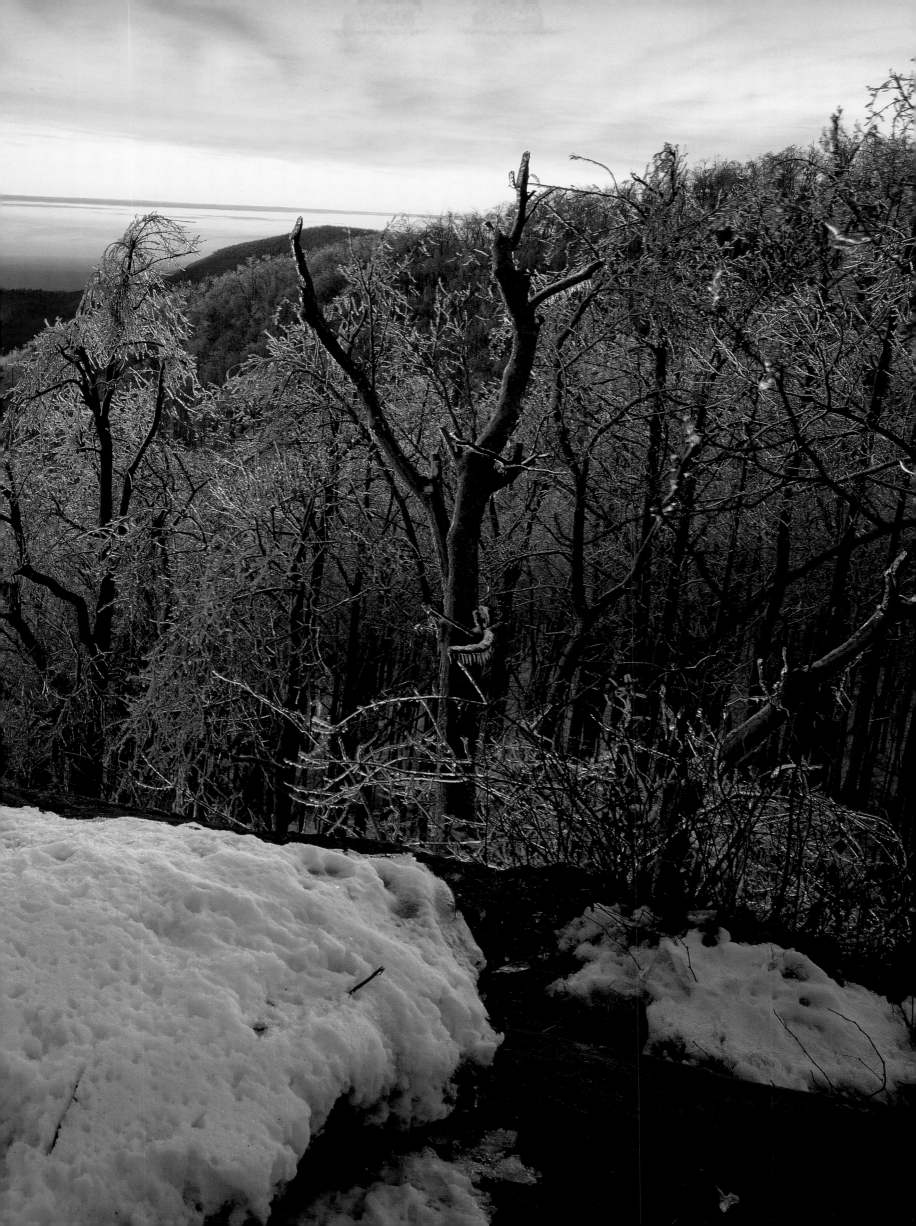

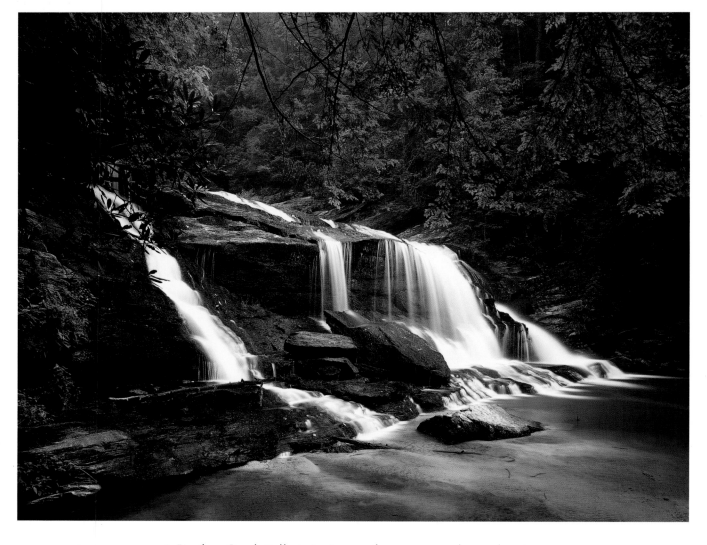

△ Panther Creek Falls is just one of many cascades and waterfalls that await hikers along the six-mile trail at the Panther Creek Recreation Area. Due to the amazing diversity of its plant life, the lower section of the trail is protected as a botanical area. ▷ Towering hemlocks and brilliant fall color surround Upper Helton Creek Falls. This waterfall is one of many scenic attractions to be found in and adjacent to Vogel State Park near Blairsville.

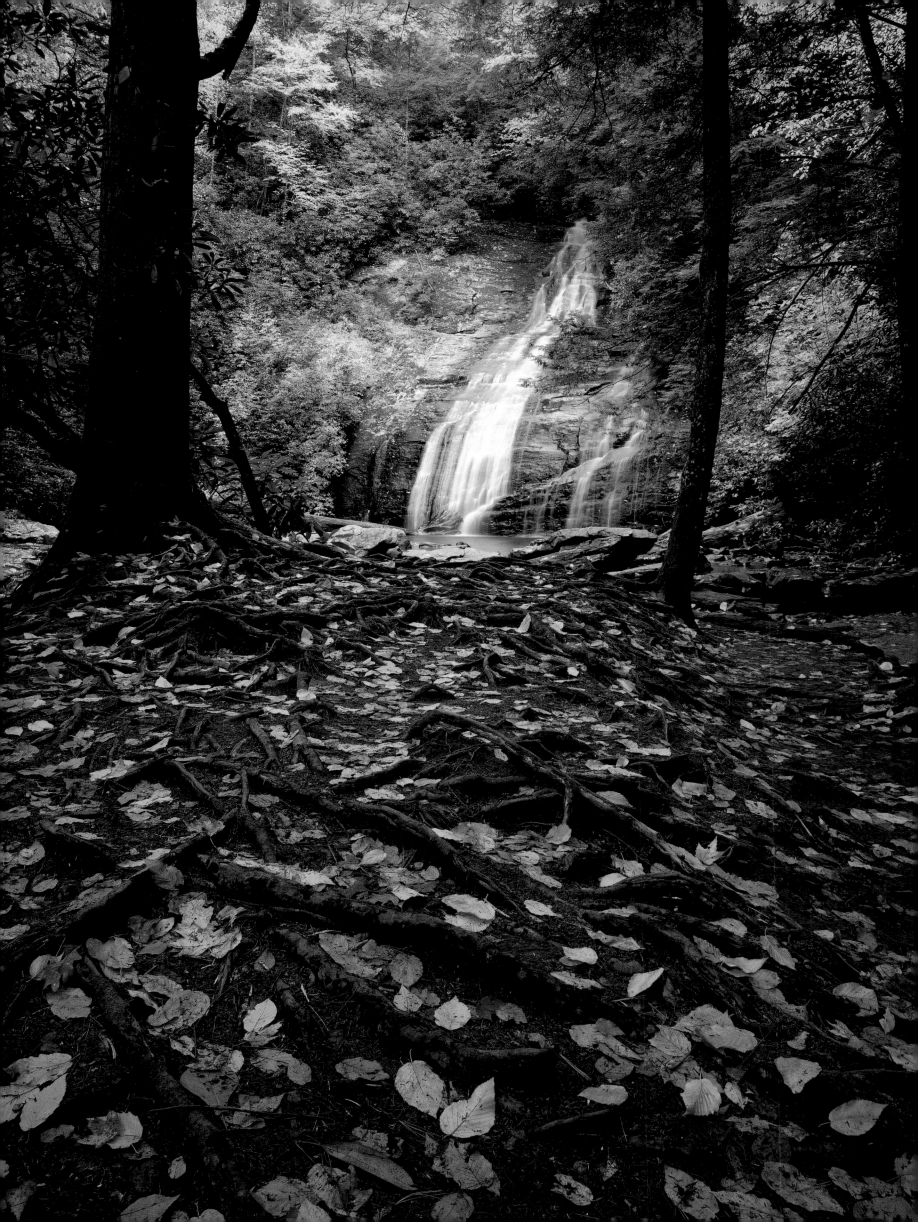

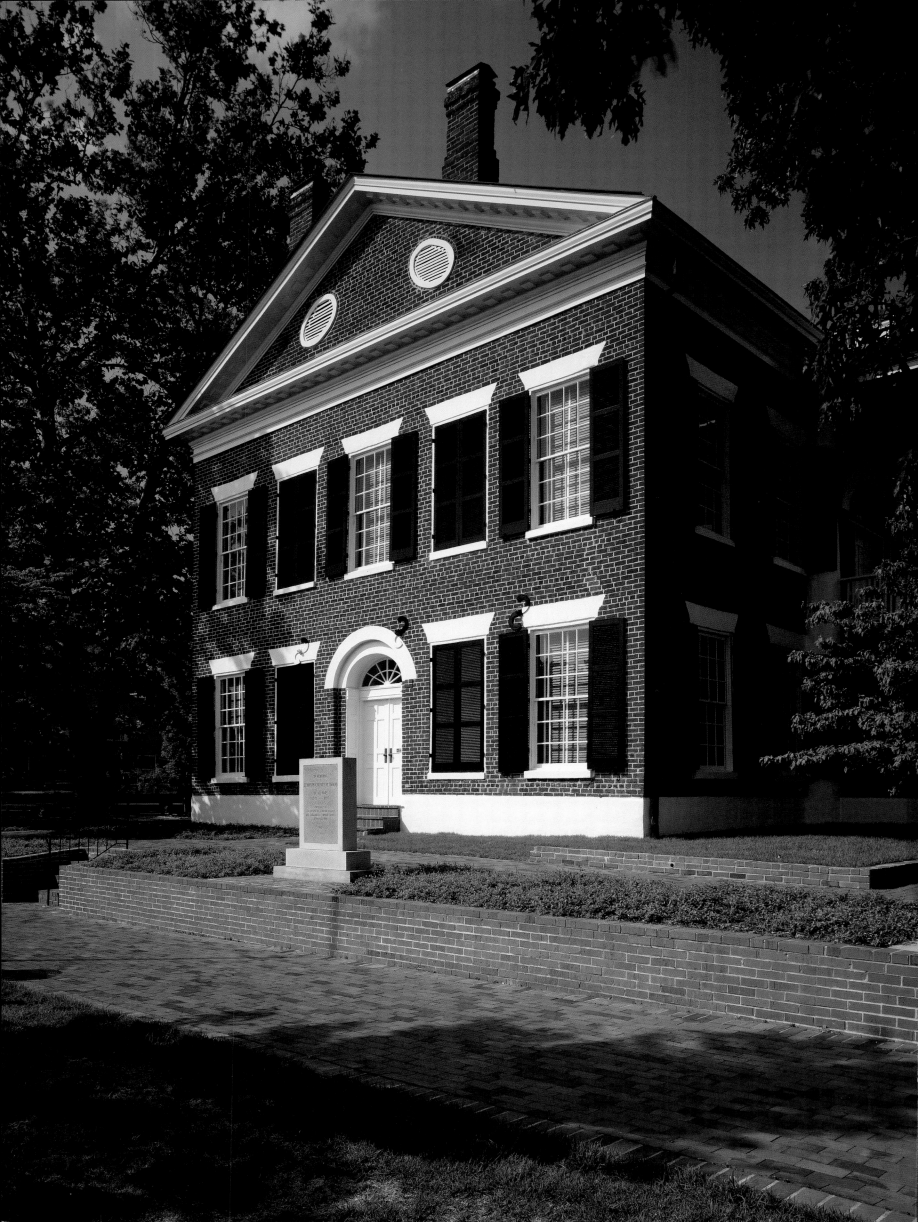

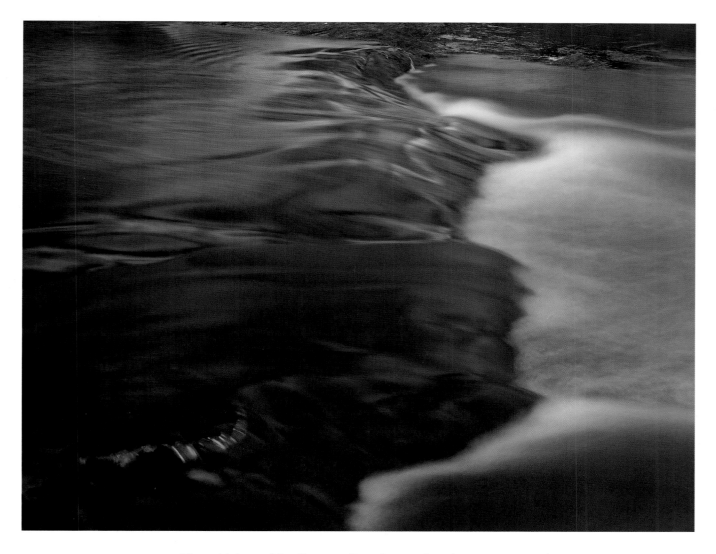

◁ The old Lumpkin County Courthouse has been converted
into the Dahlonega Gold Museum State Historic Site, which
chronicles America's first gold rush and showcases historical gold
mining equipment, massive gold nuggets, and rare gold coins.
△ Reflections of spring foliage color a cascade on the Towaliga
River at High Falls State Park. A dam in the park once generated
power for the manufacture of supplies during the Civil War.

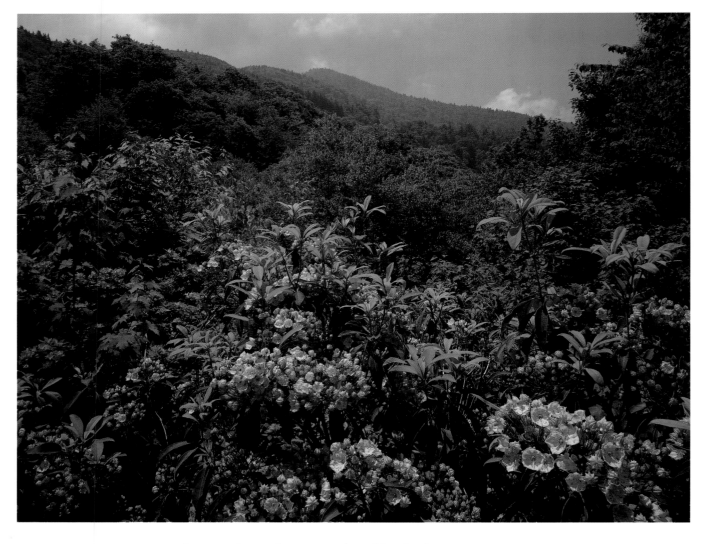

△ Flame azalea and mountain laurel lend color to Tray Mountain Wilderness. This ten-thousand-acre wilderness area contains the second-highest overlook on the Appalachian Trail in Georgia. ▷ The Bavarian-style town of Helen is one of the busiest tourist stops in north Georgia. The town is also the jumping-off point for some of the most spectacular mountain scenery in the state.

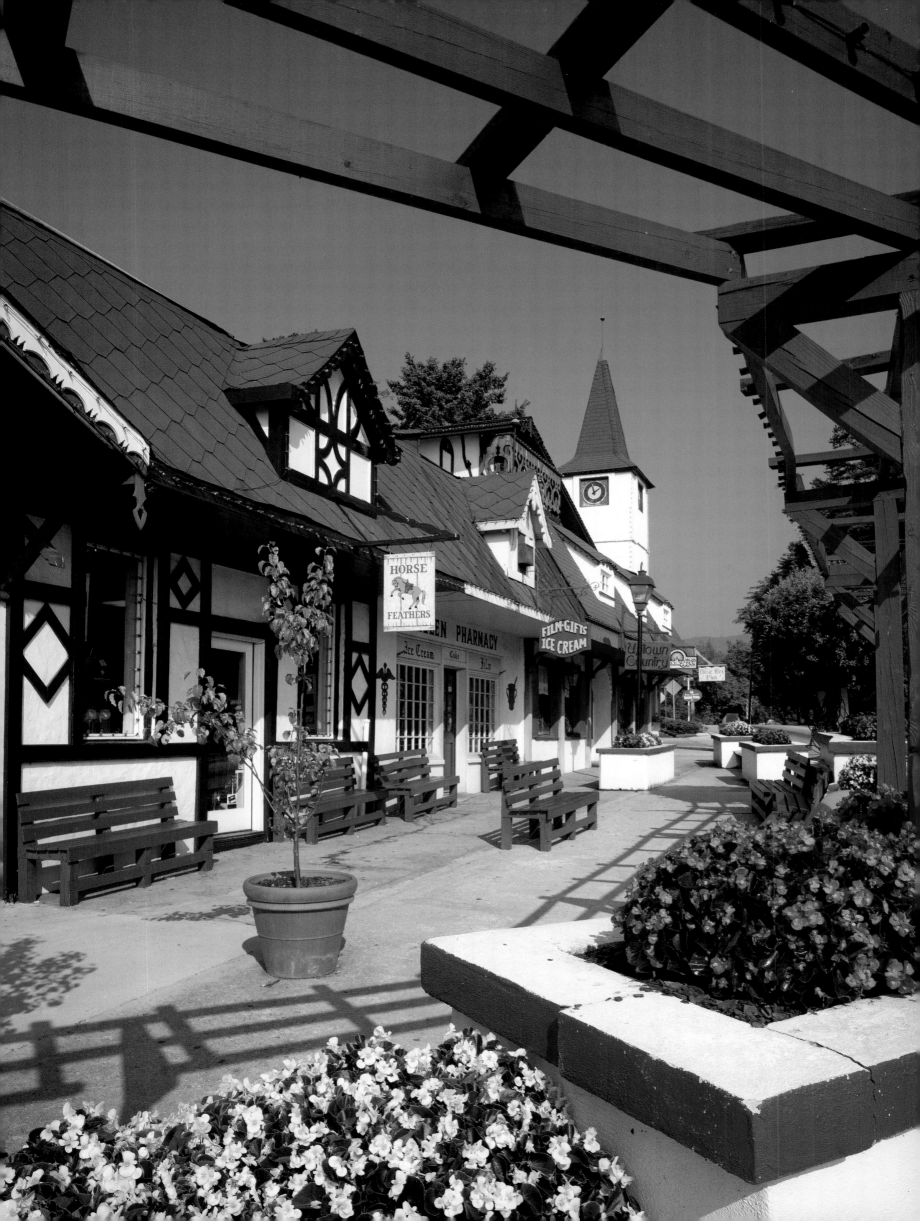

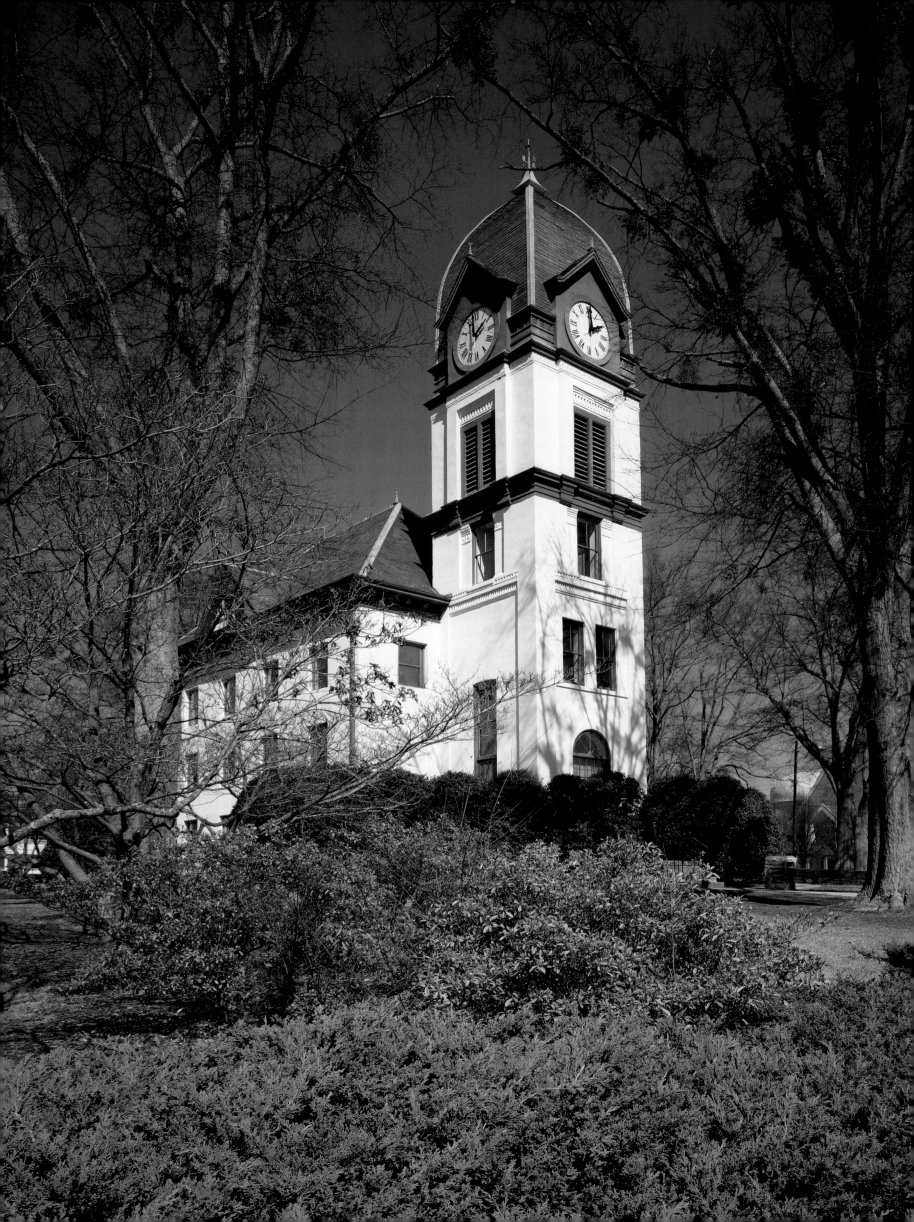

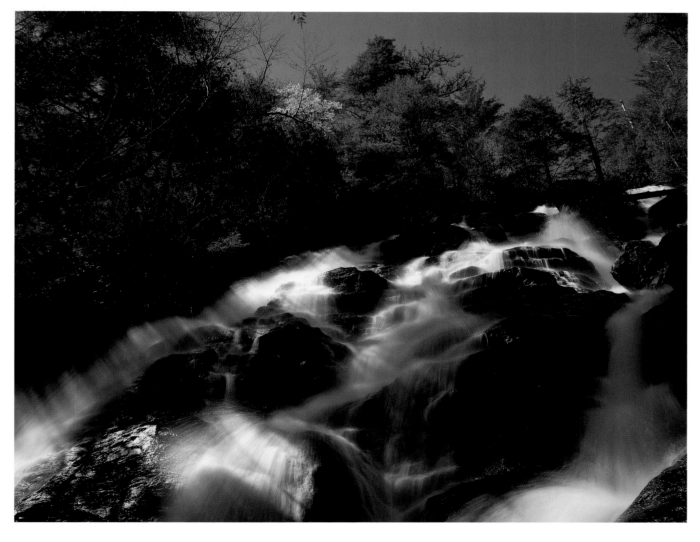

◁ The Fayette County Courthouse, built in 1825, is the oldest courthouse building in the state. The building now houses the Fayetteville Chamber of Commerce and Development Center. △ Rhododendron and eastern hemlock line the upper section of 250-foot Dukes Creek Falls, one of the tallest falls in the state.

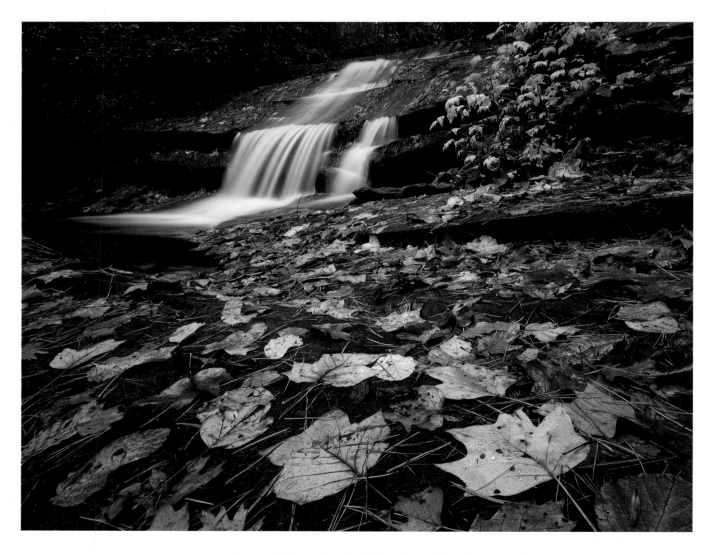

△ Unnamed waterfalls and rock slides abound in the area of the Mark Trail Wilderness, headwaters of the Chattahoochee River.
▷ This granite bald on top of Blood Mountain is the highest point on the Appalachian Trail in Georgia. A nearby stone cabin, built in the 1930s, now serves as an Appalachian Trail shelter.
▷ ▷ It is possible to see four states from the summit of Brasstown Bald. At 4,784 feet, Brasstown Bald is Georgia's highest peak.

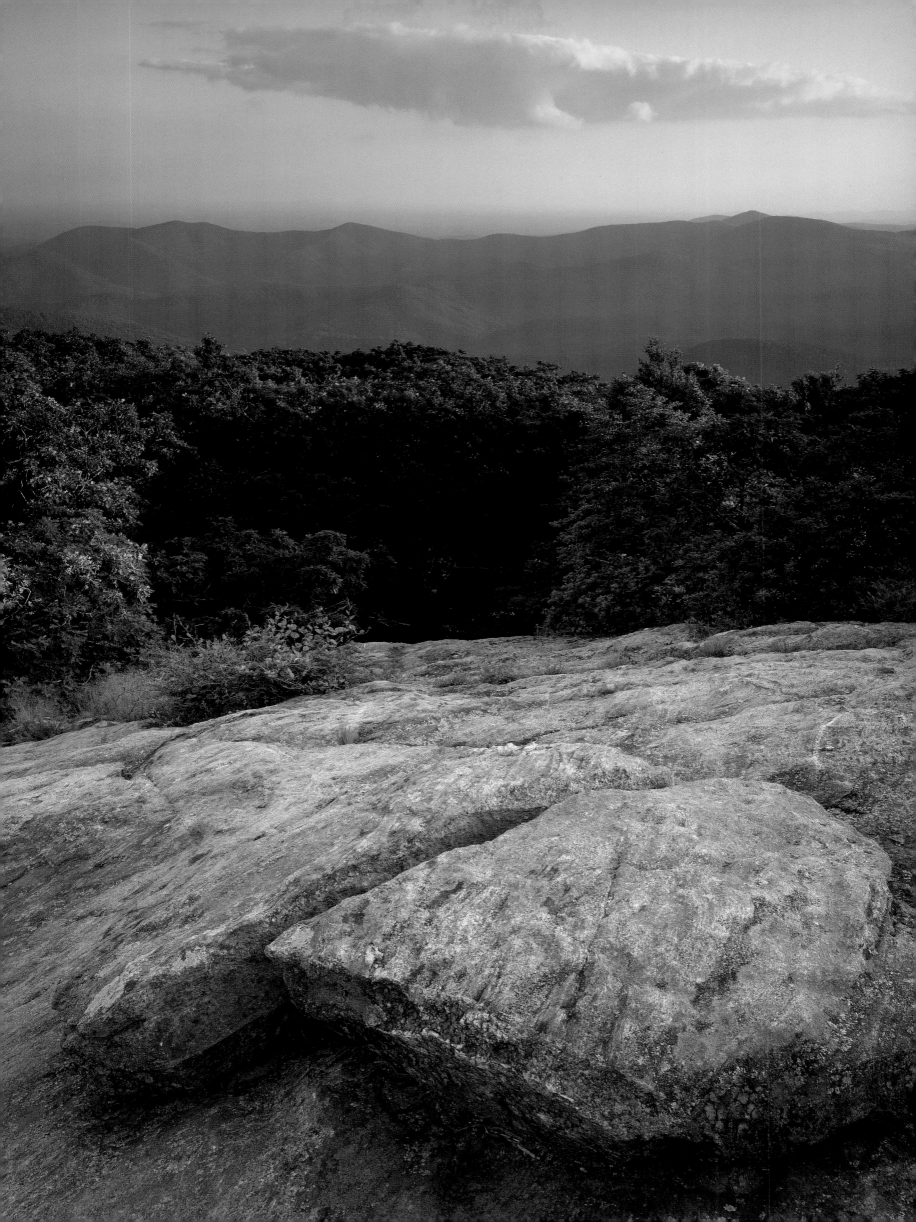

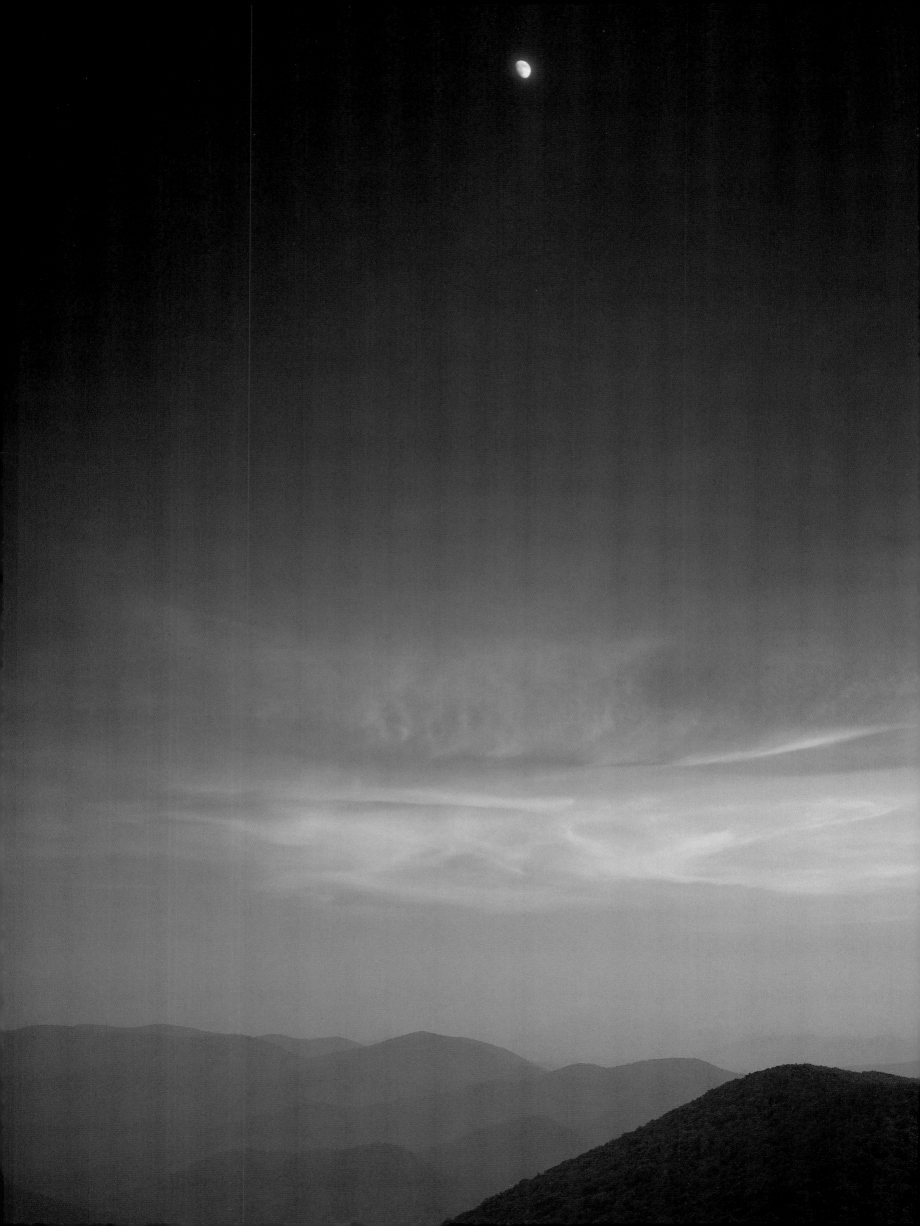

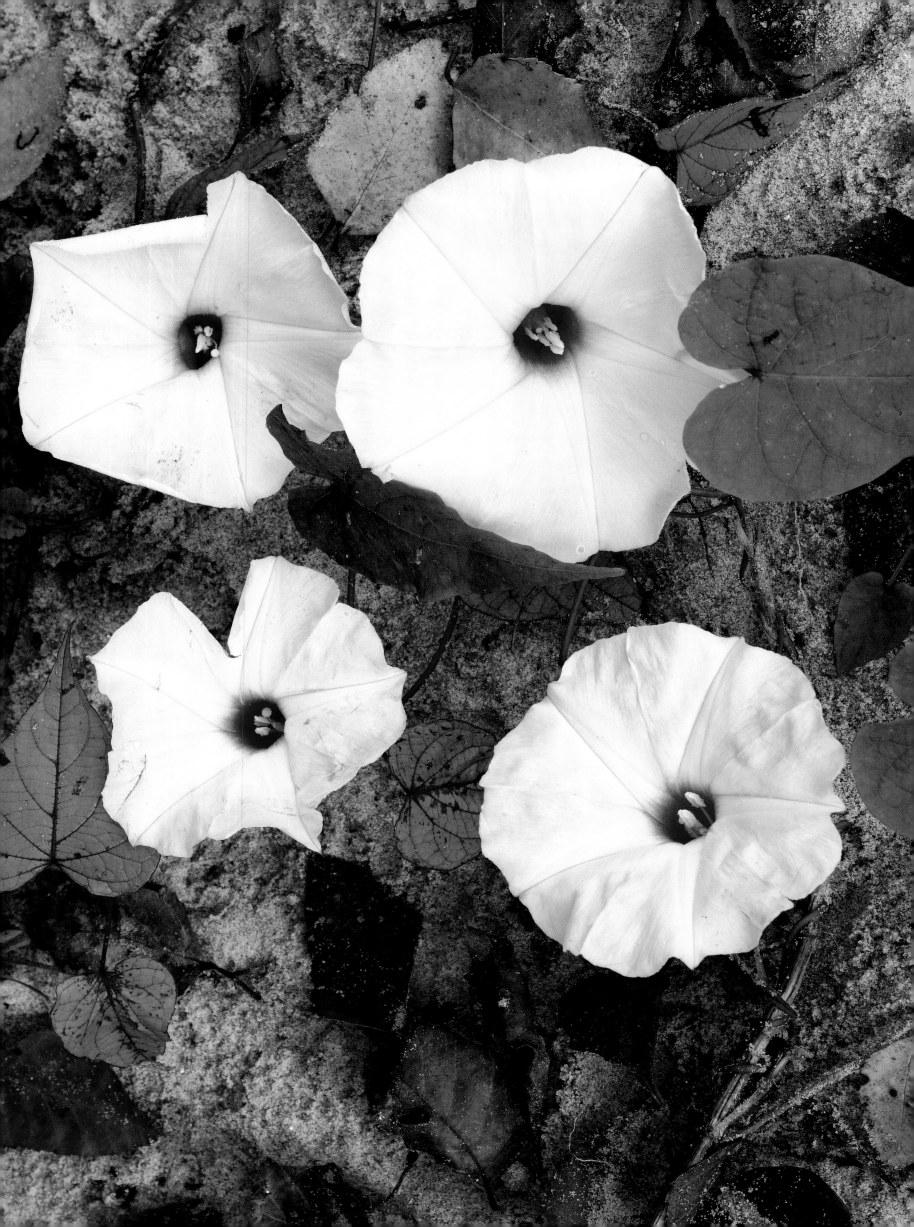

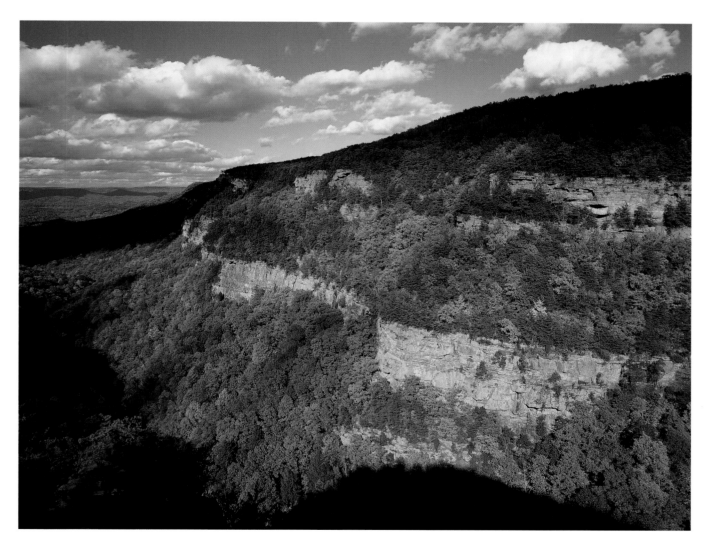

◁ Morning glories blossom on the sandy flood plain of the Chattahoochee River at Powers Ferry Landing. Numerous wildflowers create showy displays along the Chattahoochee River. △ Bear and Daniel Creeks converge to form Sitton Gulch Creek and the main canyon of scenic Cloudland Canyon State Park. ▷ ▷ Known as the "Little Grand Canyon," Providence Canyon is actually a series of sixteen narrow finger canyons.

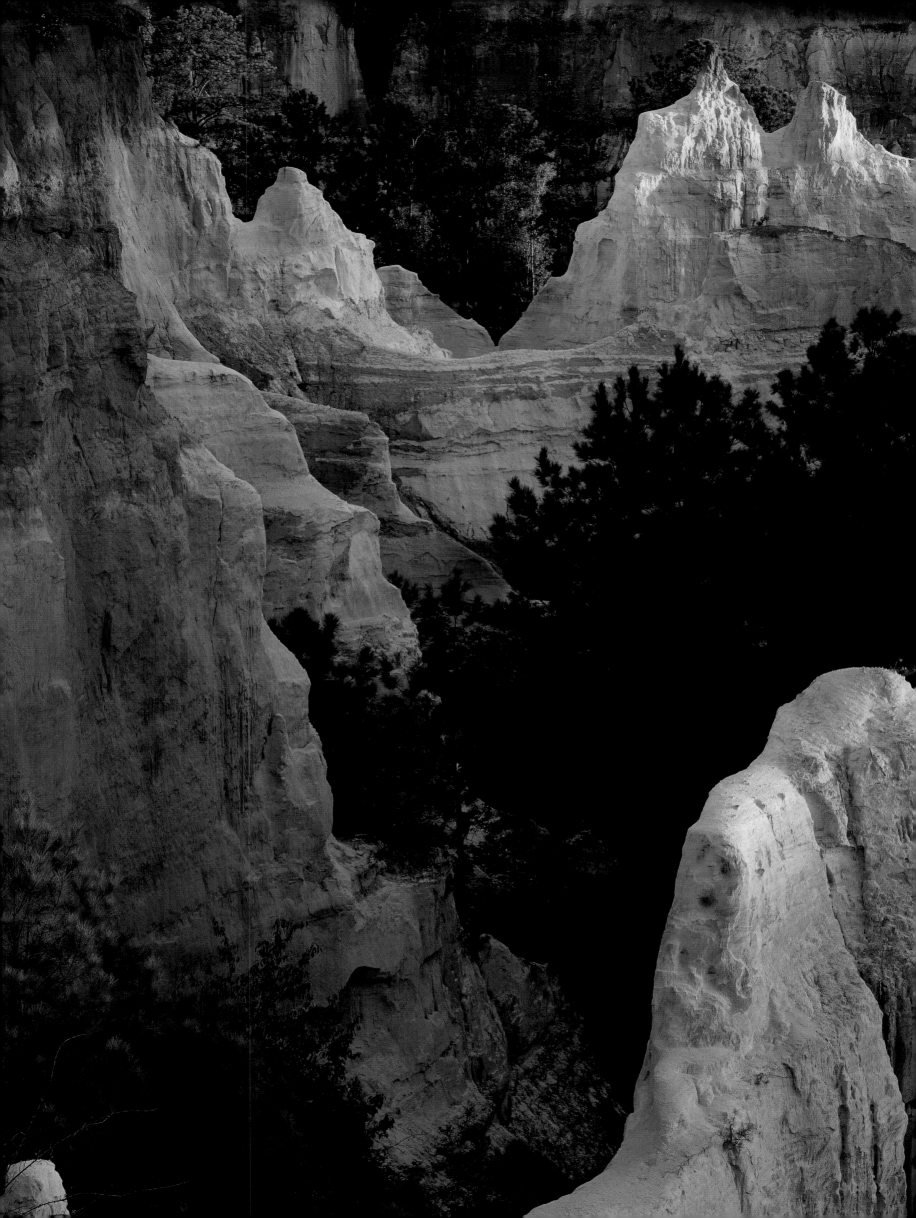

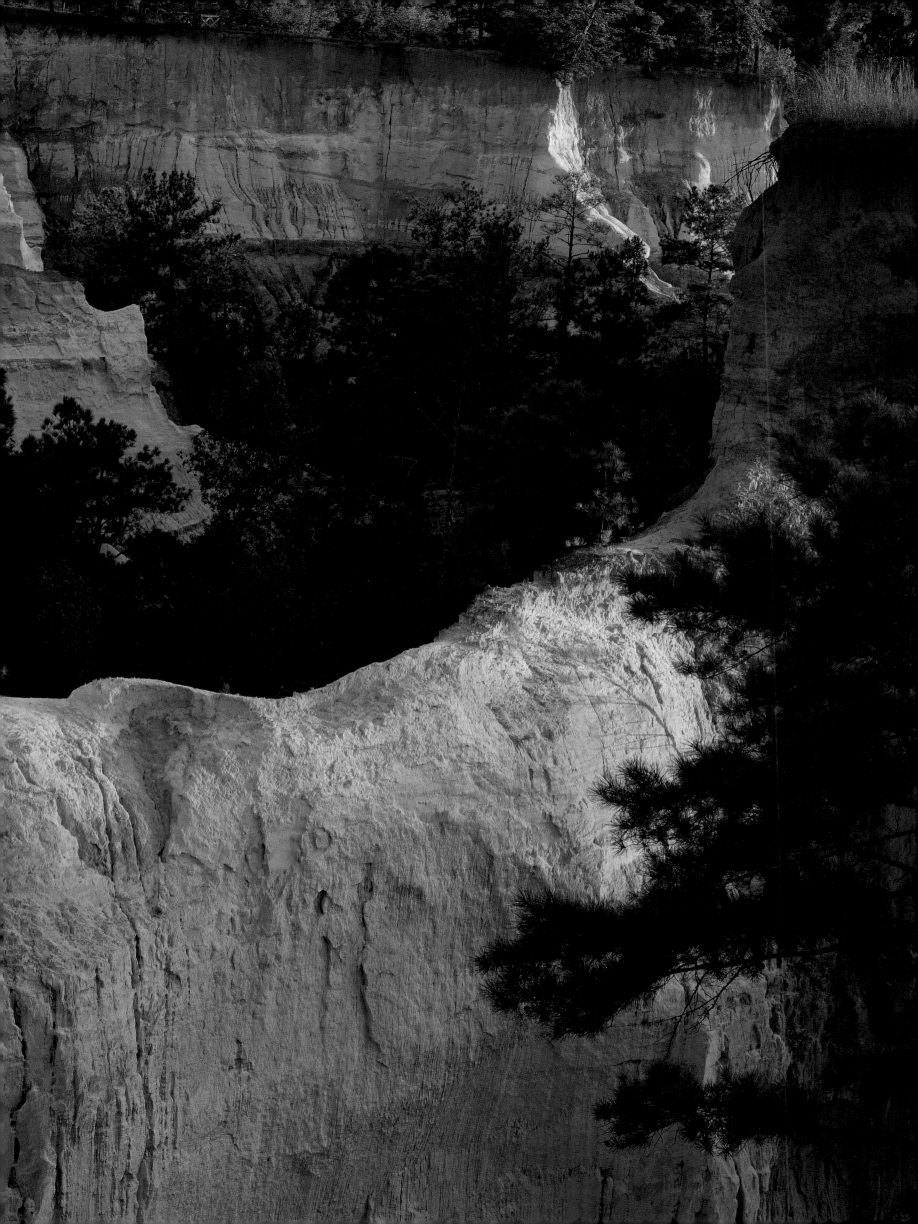

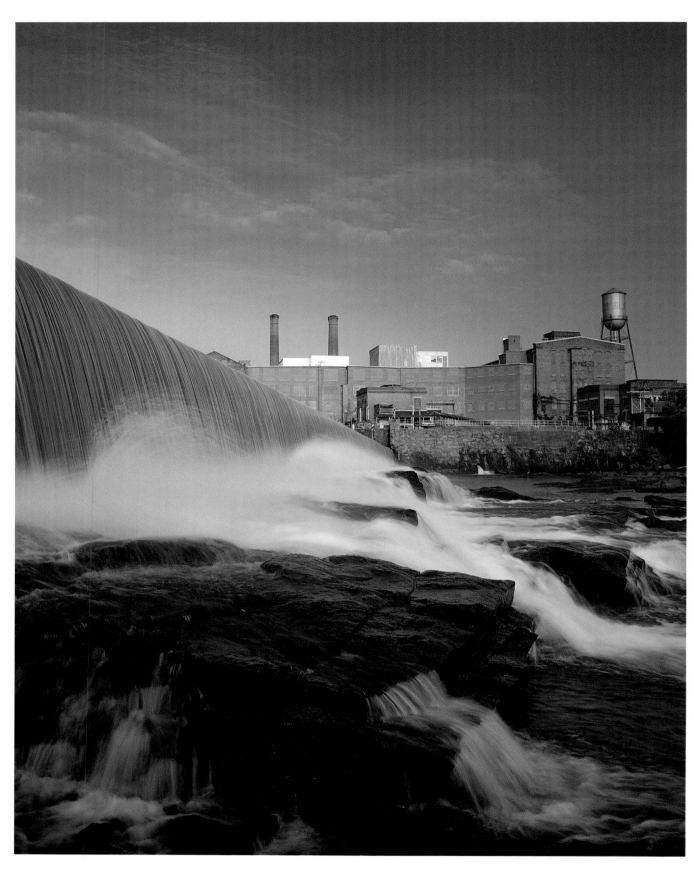

△ The historic Fieldcrest Mills juxtaposed with a hydroelectric power dam is just one of the many points of interest along the Riverwalk on the Chattahoochee River at the city of Columbus. ▷ Near the scenic town of Juliette, the twenty-five-thousand-acre Piedmont National Wildlife Refuge protects a wide variety of wildlife, including wild turkey, fox squirrels, whitetail deer, wood ducks, and the endangered red cockaded woodpecker.

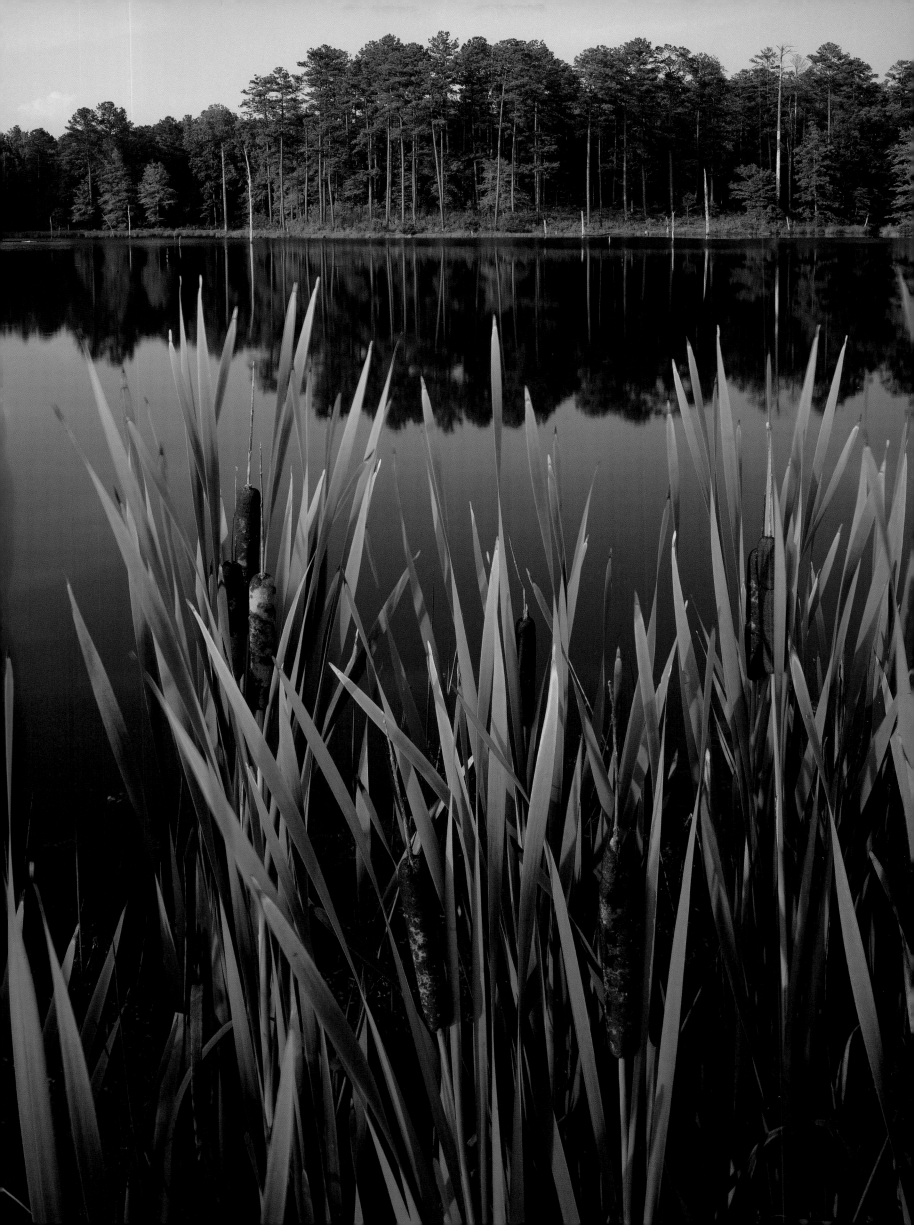

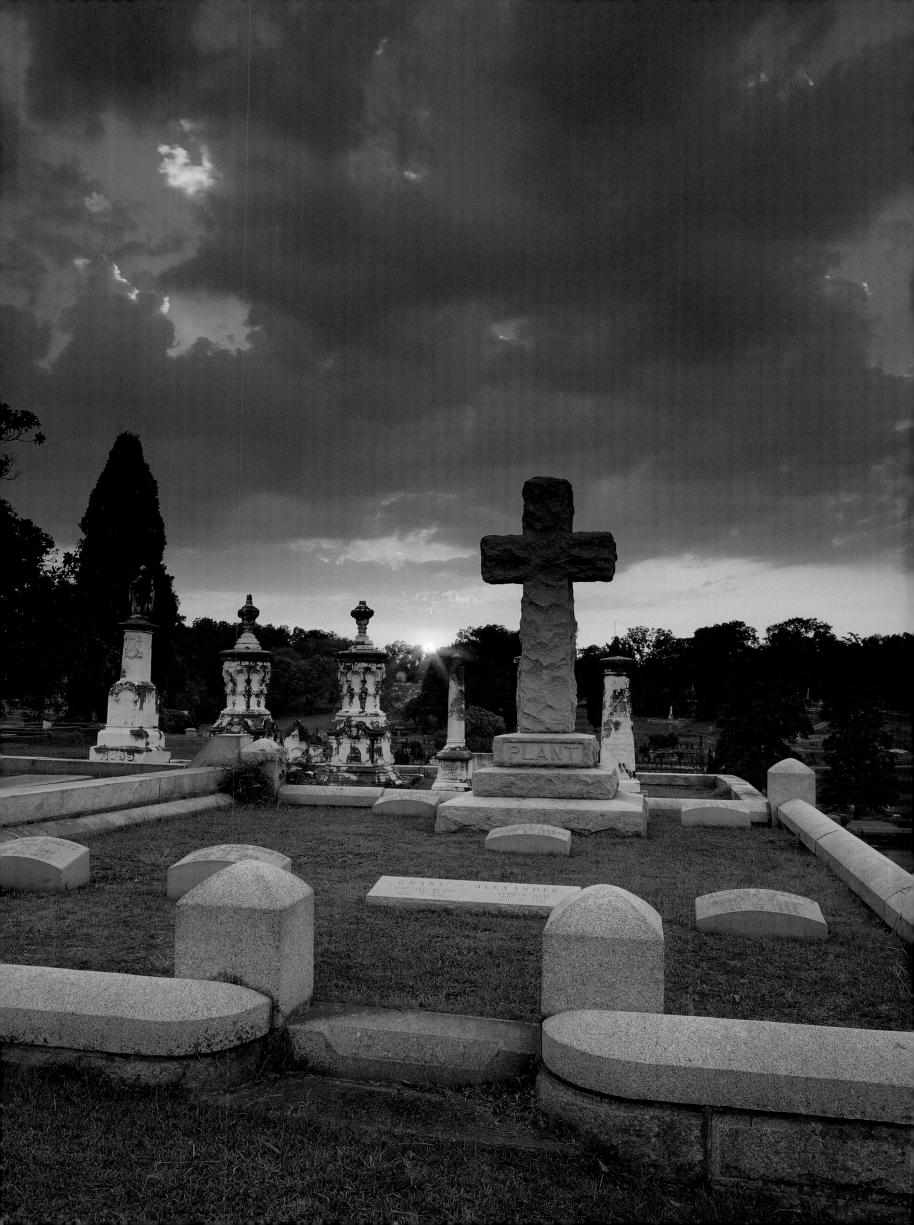

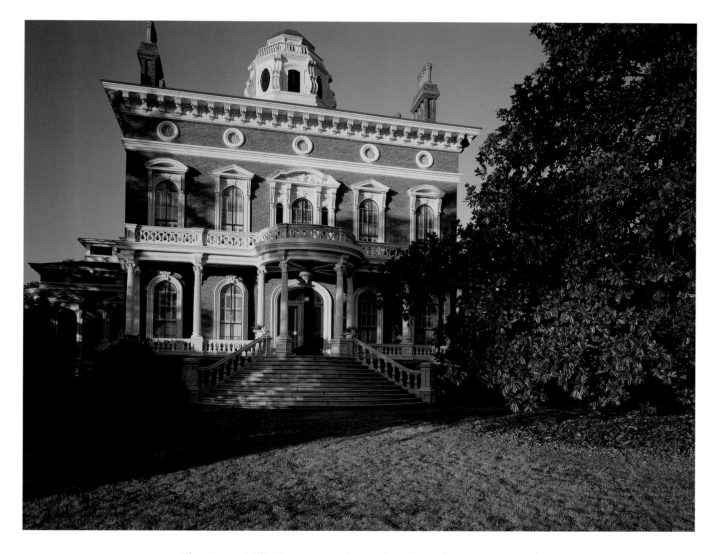

◁ The Rose Hill Cemetery, along the Ocmulgee River, is the final resting place for more than six hundred Civil War soldiers. △ Known as "the palace of the South," the Hay House in Macon is recognized as one of the finest homes to survive from ante-bellum America. This National Historic Landmark House features an elaborate interior with hidden rooms, exquisite decorating details, and amenities and luxuries that were ahead of their time.

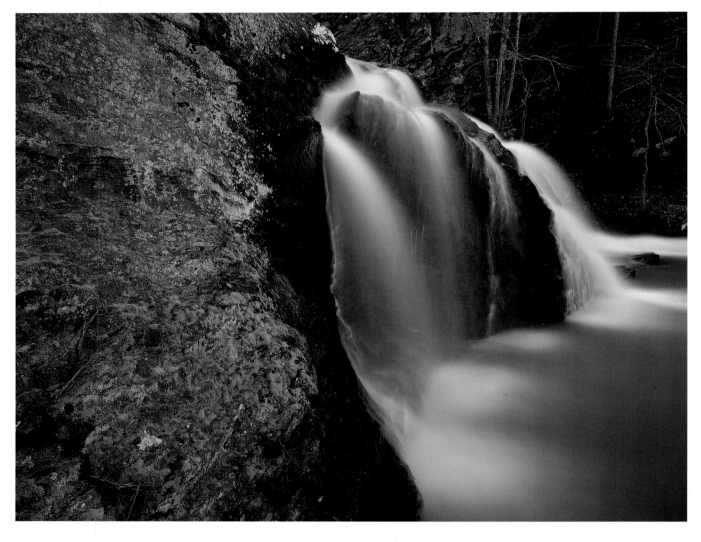

△ Water flows over lichen-covered shoals on Bear Creek near the Cochran Mill Nature Center. The remnants of several mills built in the mid-1800s are found at this scenic area near Fairburn.
▷ High Falls, the main attraction of High Falls State Park, is only a short drive from the historically rich city of Macon. Nearby Indian Springs State Park, the Piedmont National Wildlife Refuge, and Juliette, make this area a popular tourist destination.

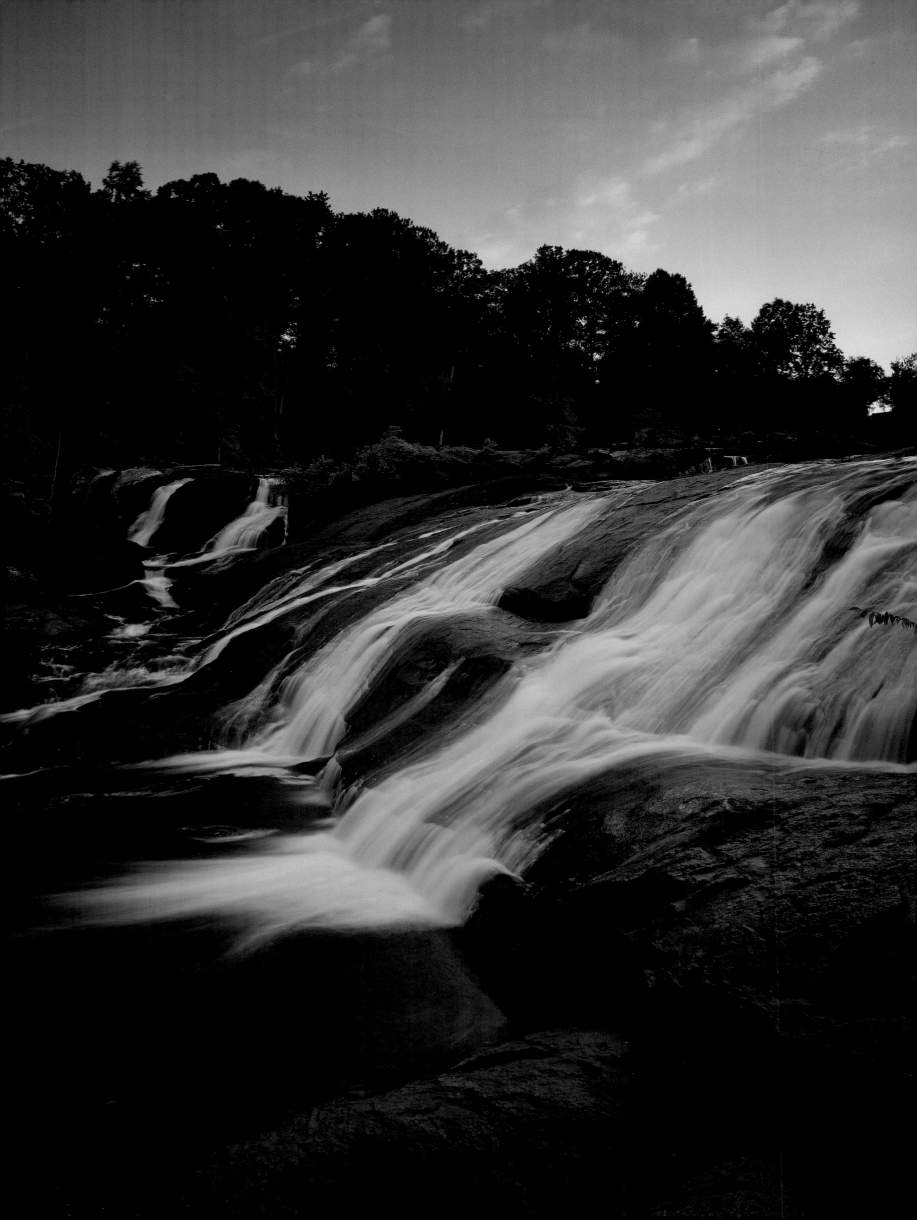

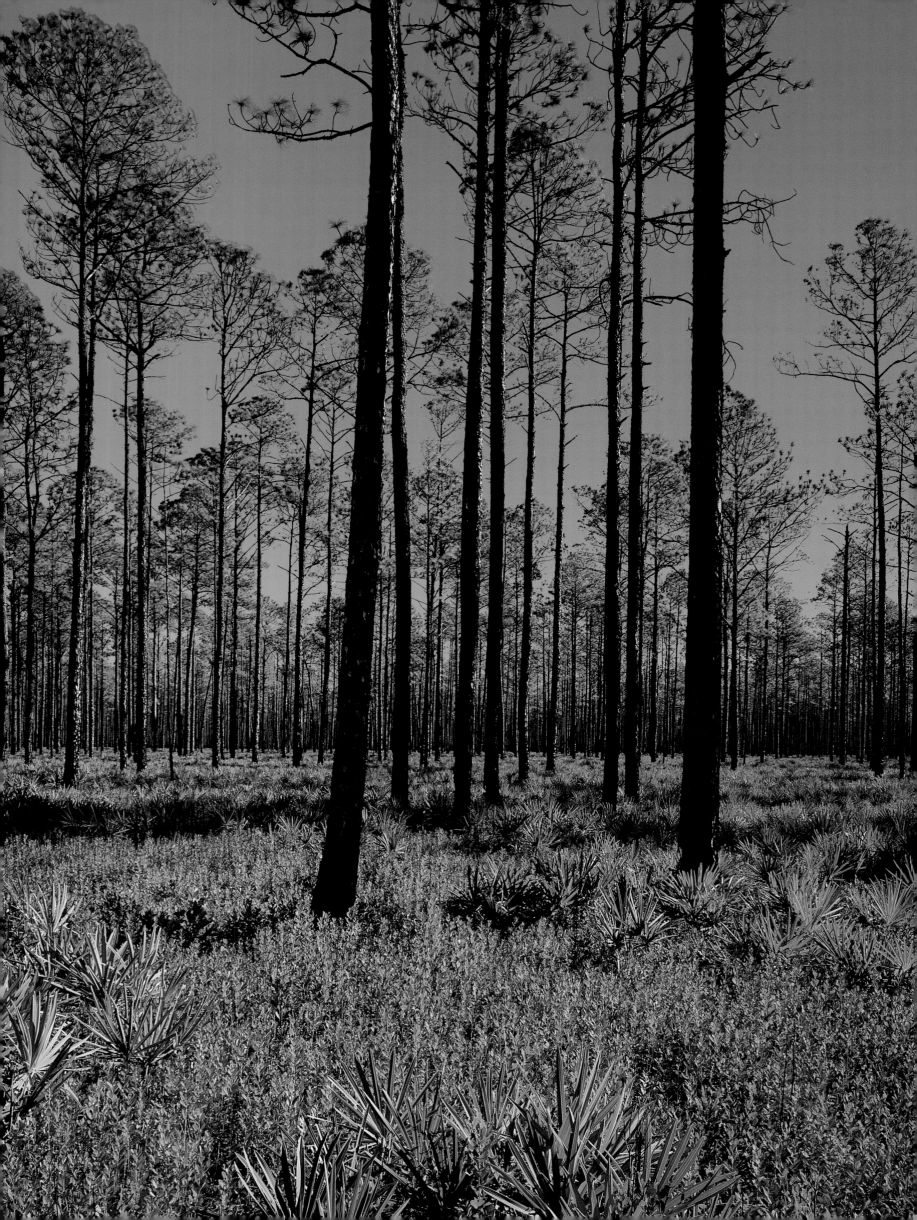

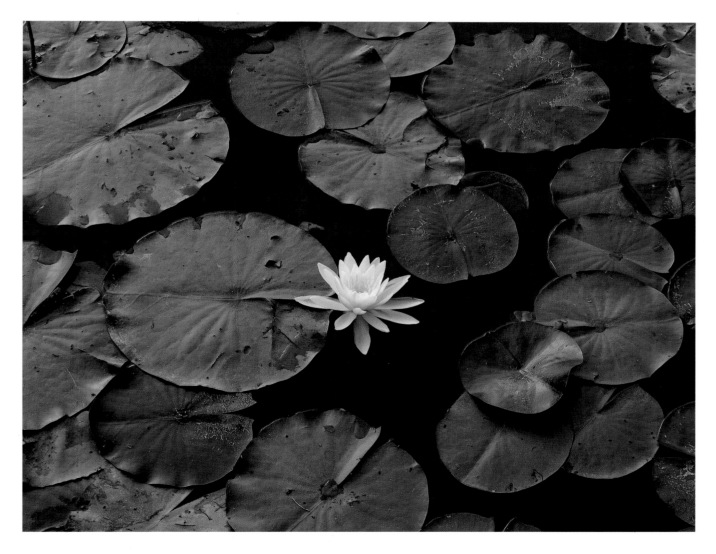

◁ The Okefenokee Swamp encompasses 420,000 acres of southeast Georgia and includes lakes, islands, prairies, and forests. At Billy's Island, palmetto pine, and the crimson leaves of dangleberry stand in stark contrast to the deep blue sky of a winter day. △ A water lily blossoms at the Okefenokee Swamp Park near the town of Waycross. The Okefenokee is considered one of the largest biologically intact swamps in North America.

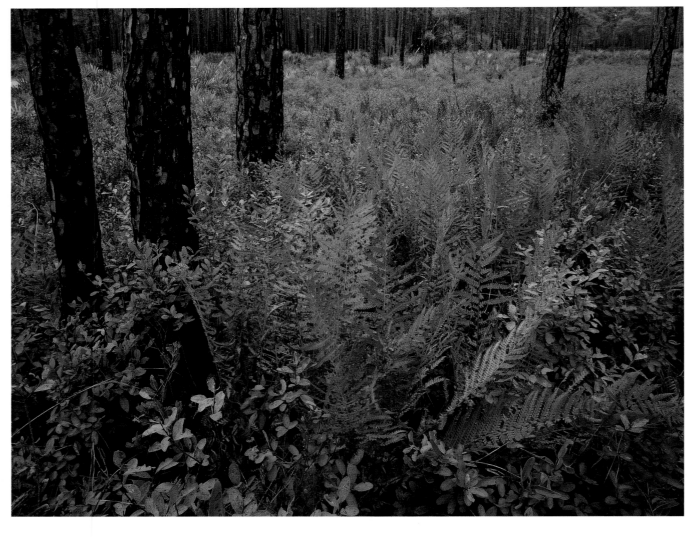

△ Bracken fern brightens a forest floor at the Suwanee Canal Recreation Area. The recreation area is one of two jumping-off points for overnight canoe trips into the Okefenokee Swamp.
▷ Dunes, a tidal runnel, and algae-covered sand create an otherworldly beachscape in Cumberland Island's wilderness area.
▷ ▷ Reindeer lichen and cabbage palmetto line the floor of the maritime forest on Cumberland Island.

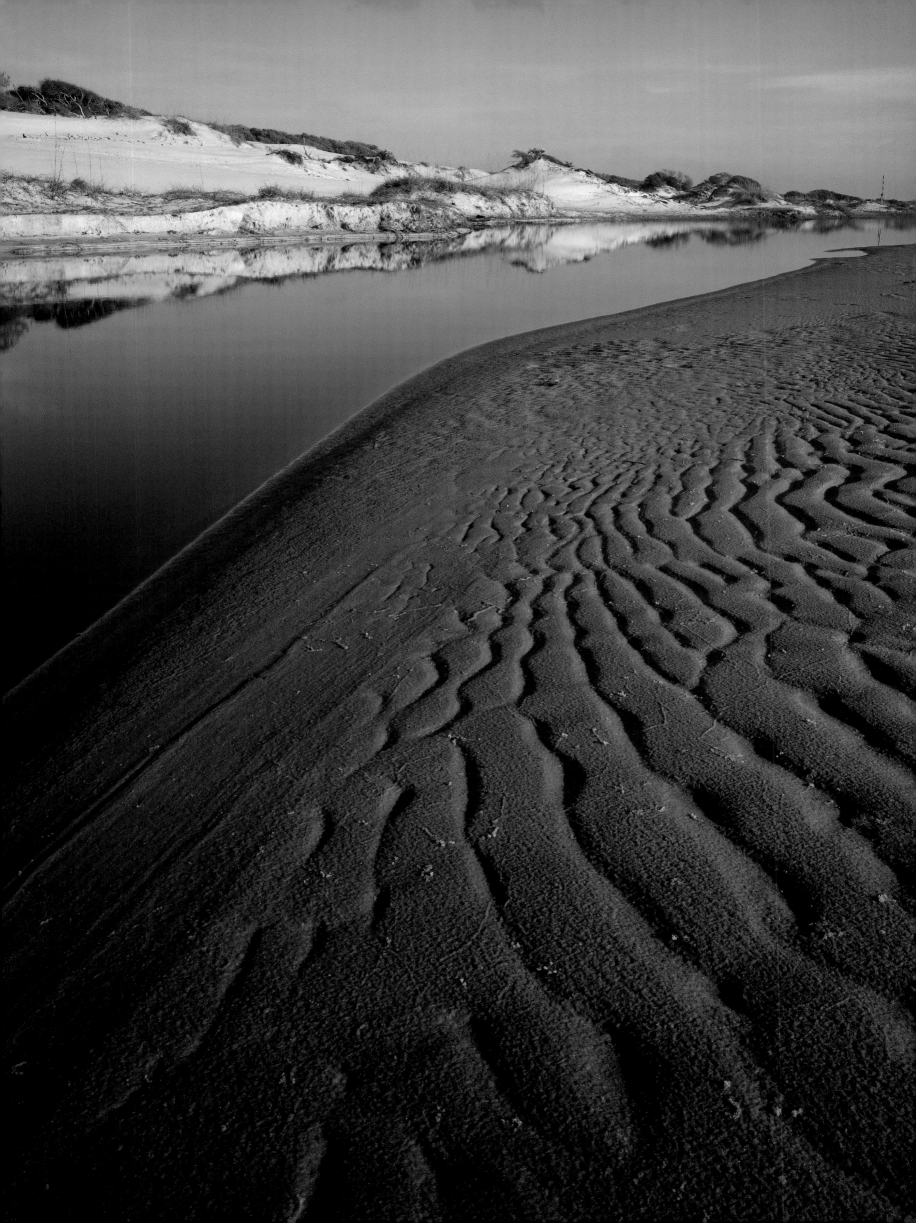

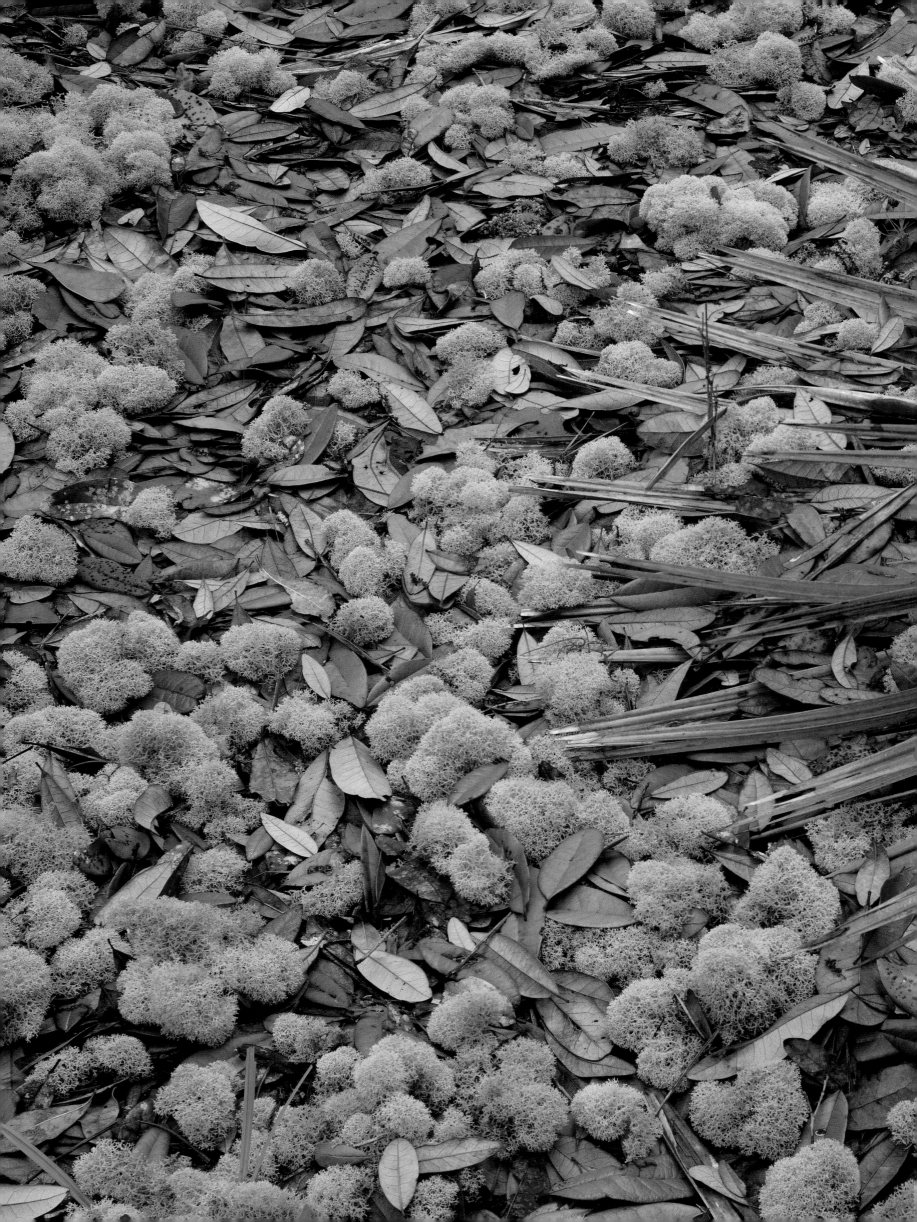

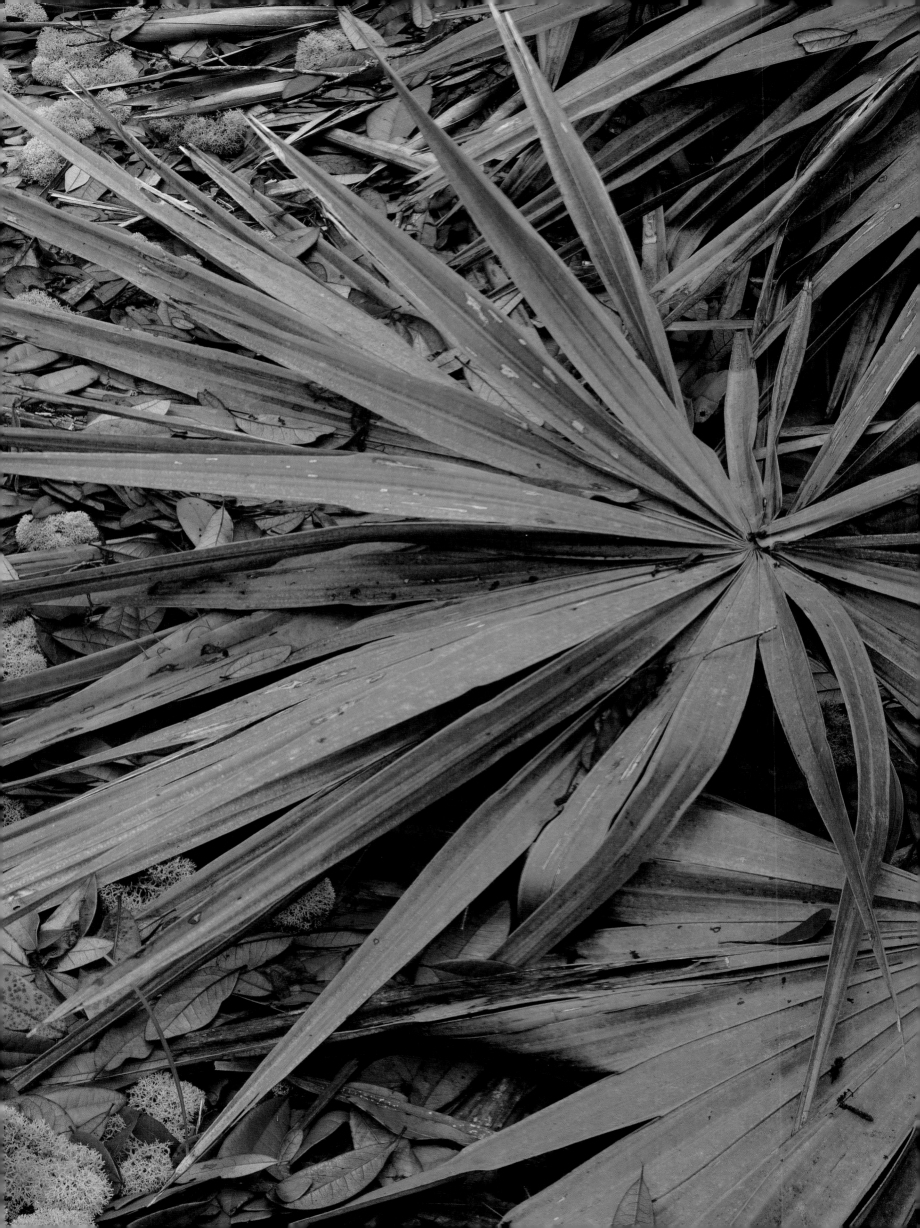

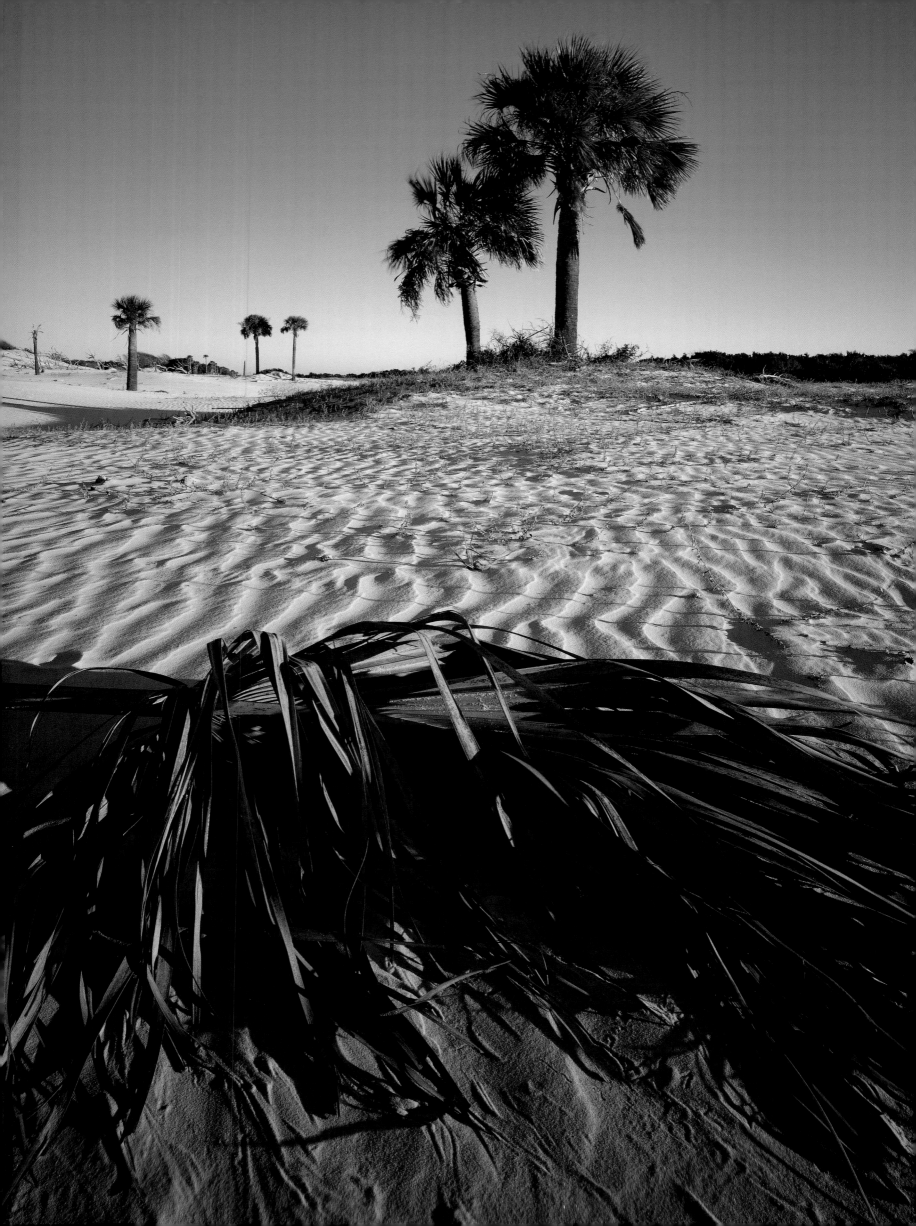

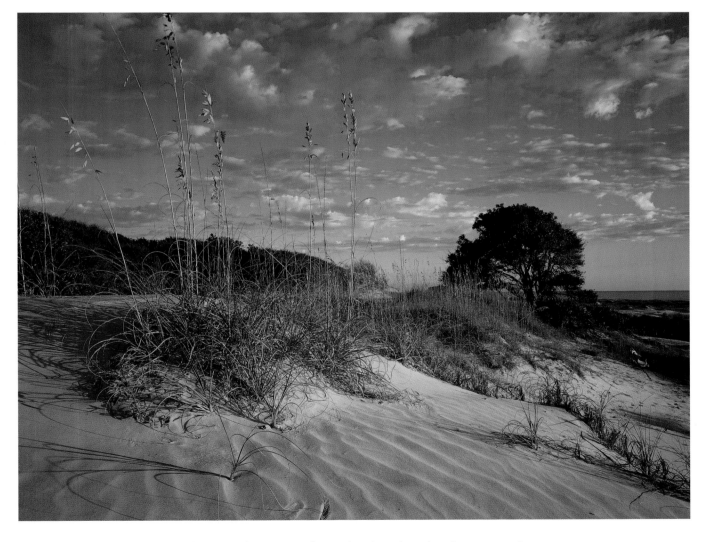

◁ White sands surround a palm frond and palm trees where Cumberland Island's extensive dunefields border a salt marsh. △ Sea oats and a live oak grow high on a dune ridge overlooking the Atlantic Ocean at Cumberland Island National Seashore. ▷ ▷ Managed by the state, Jekyll Island is an example of a mixed-use environment. It is home to a historic district, a permanently protected natural district, in addition to golf courses and hotels.

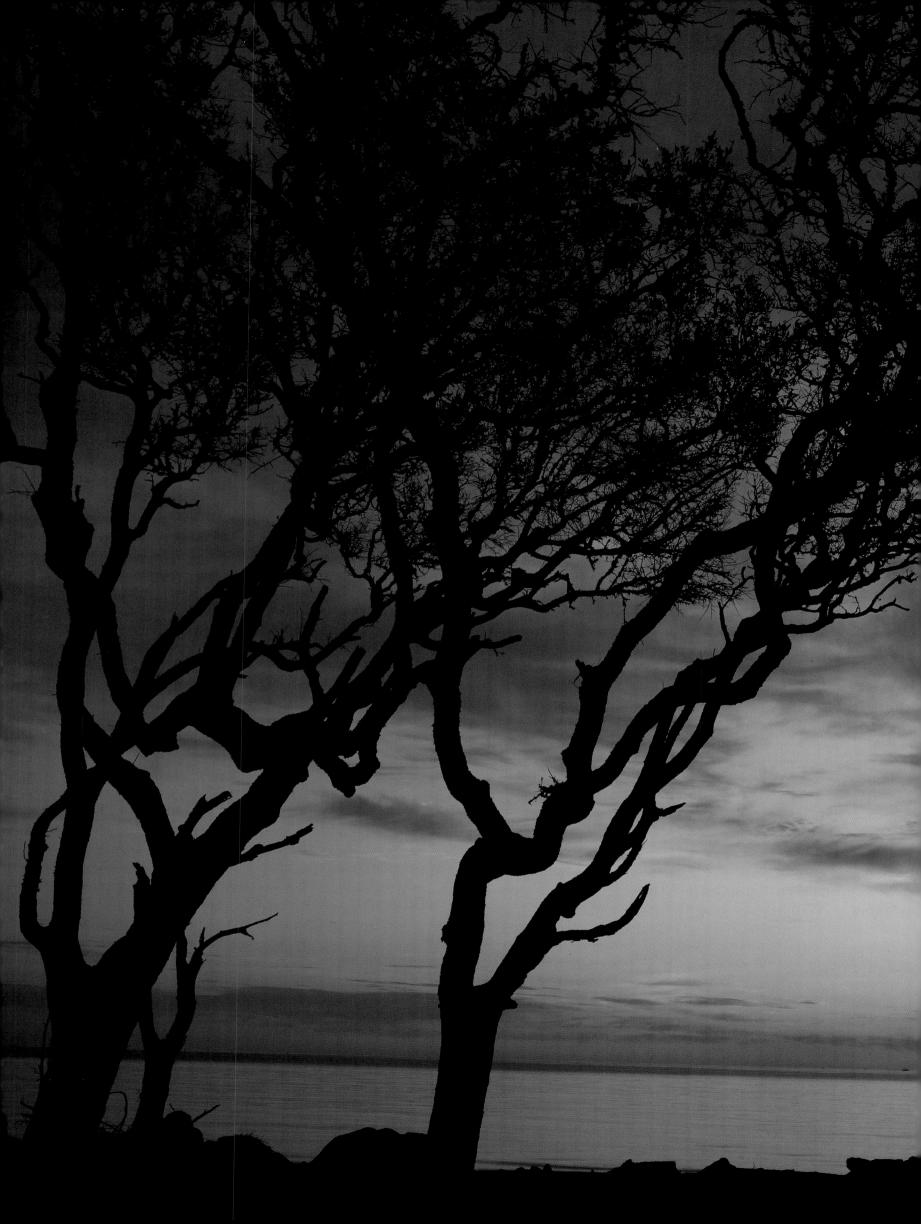

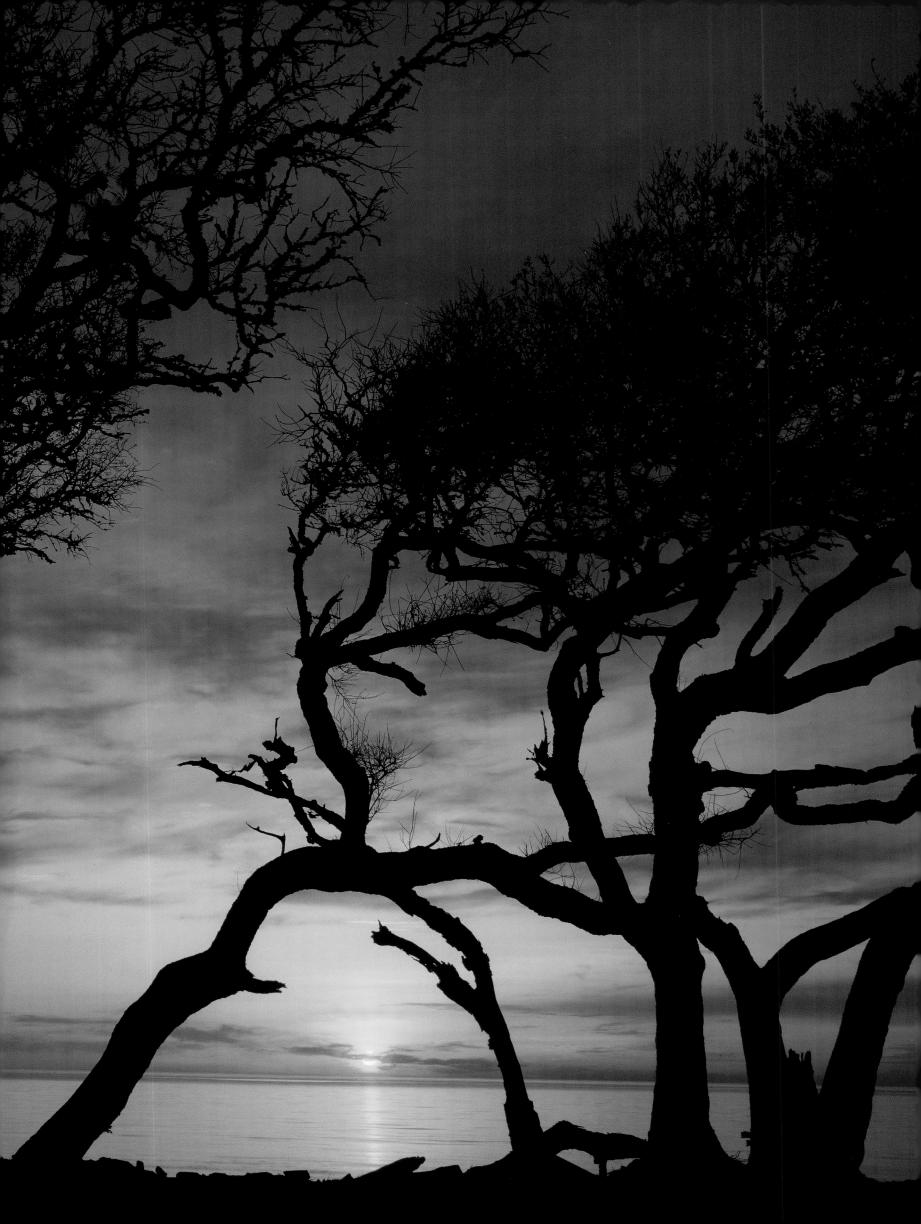

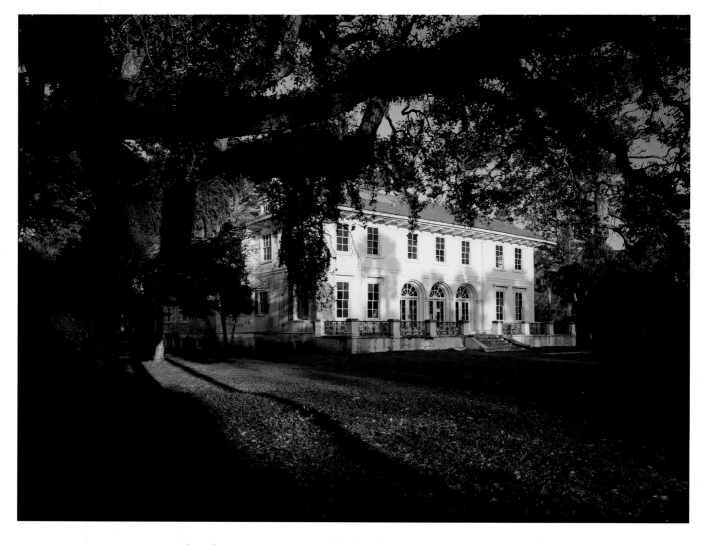

△ Cherokee Cottage on Jekyll Island is named for the Cherokee rose, the state flower. This cottage, built by the Goulds in the early 1900s, is one of the summer homes built by members of the Jekyll Island Club, which included the Rockefellers and Goodyears. ▷ Saw palmetto and dwarfed live oaks border the expansive salt marsh between Jekyll Island and the mainland town of Brunswick.

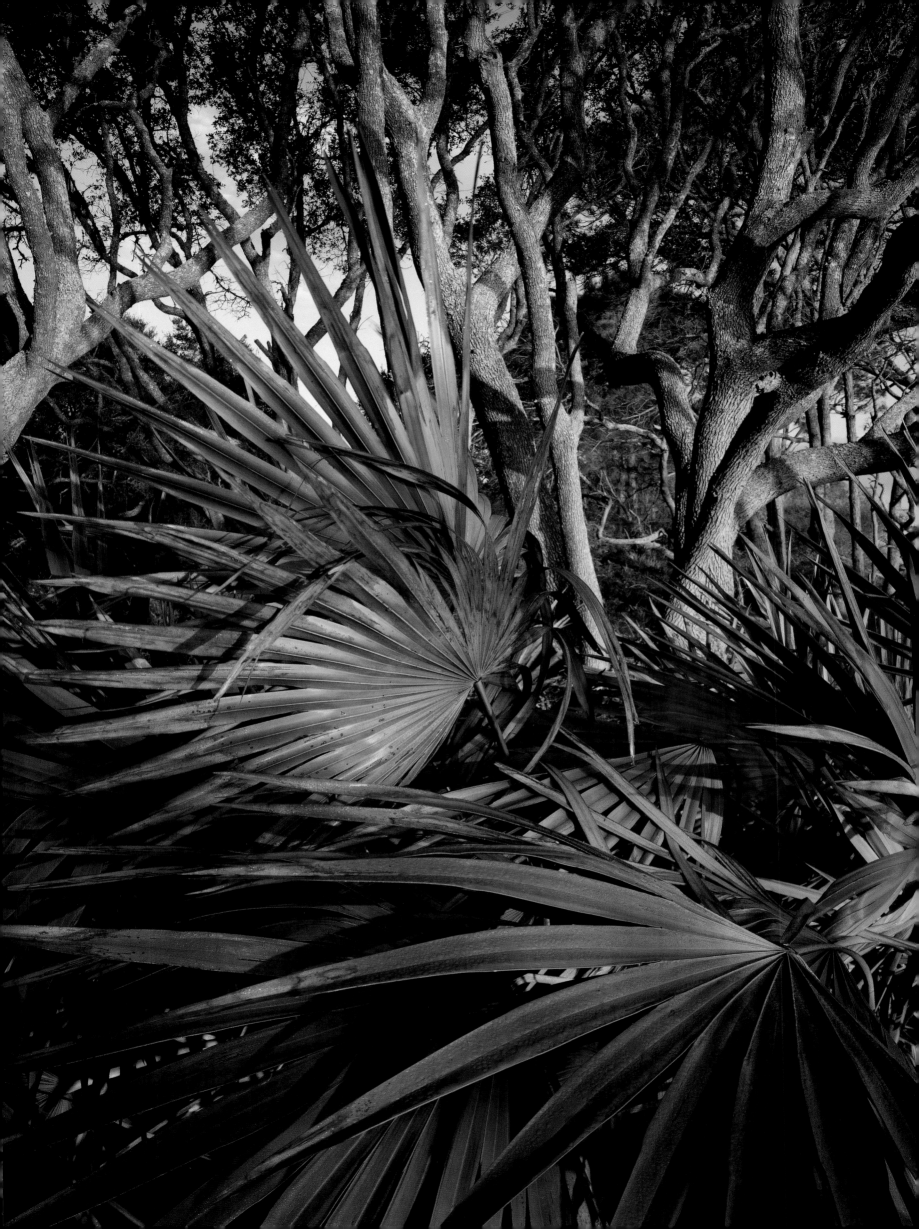

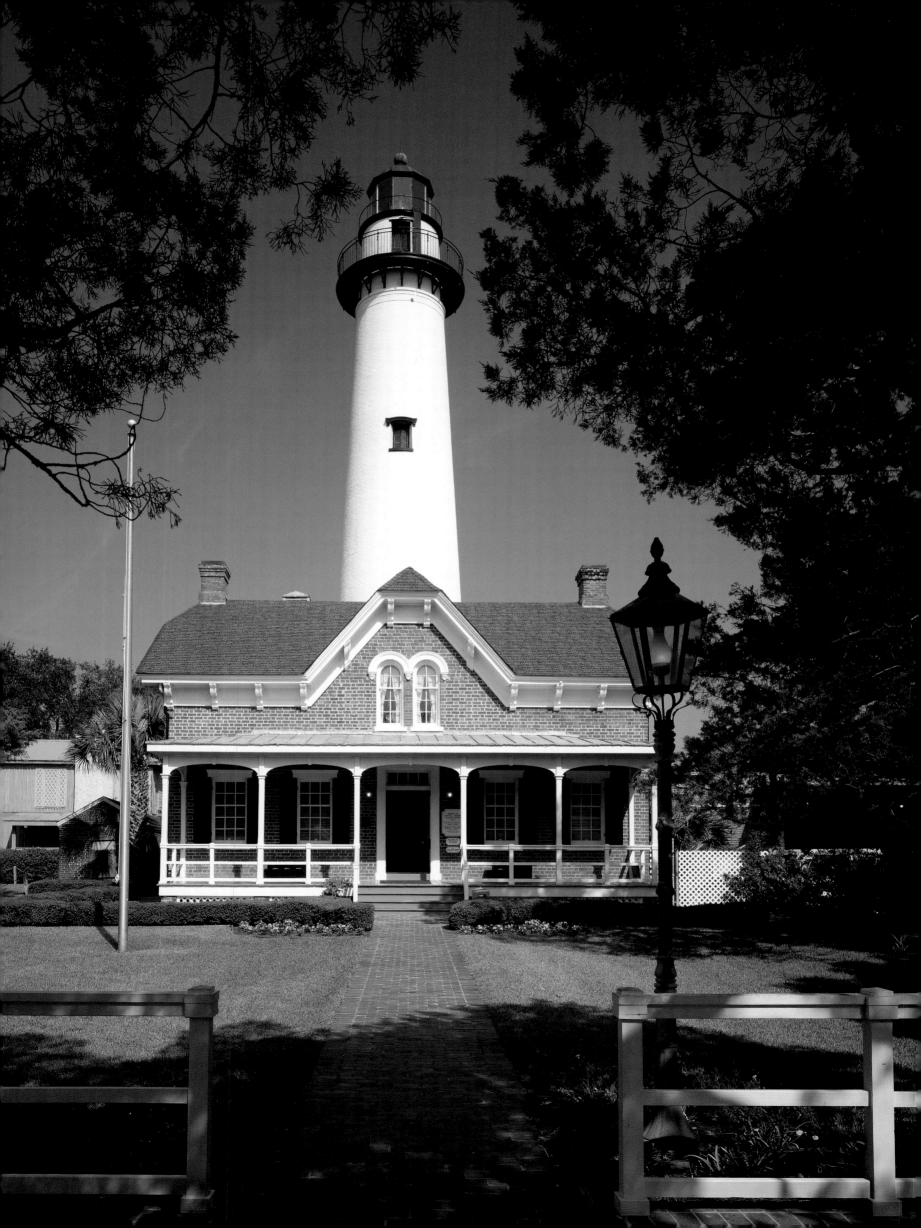

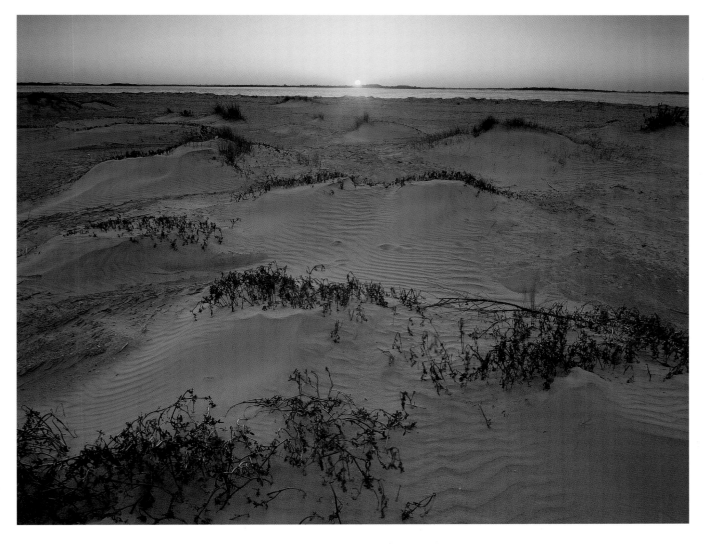

◁ The St. Simons lighthouse, along with a nine-room keeper's cottage, was designed in 1872 by Georgia architect Charles Clusky. Now home to the Museum of Coastal History, it is one of the oldest continuously working lighthouses in the United States. △ Newly formed dunes border the harbor channel at the north end of Tybee Island. Just eighteen miles from Savannah, Tybee is Georgia's most developed barrier island.

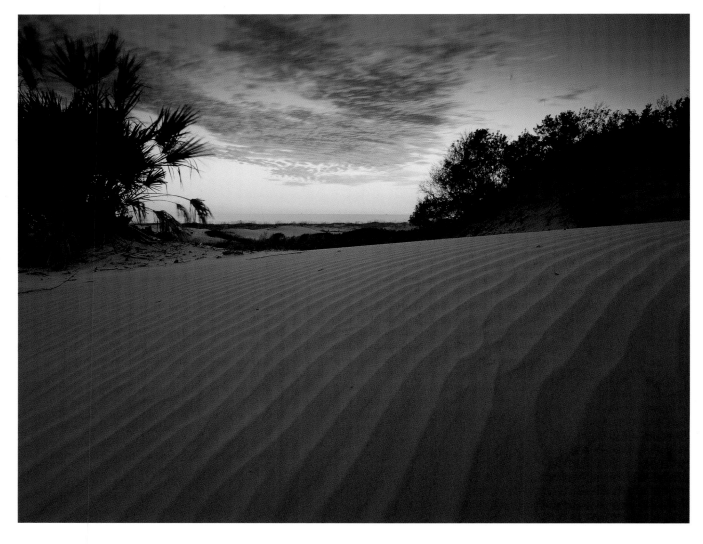

△ Georgia's barrier islands, including Cumberland, help to pro-
tect the mainland from tidal surges as well as Atlantic storms.
▷ Built in 1808, the First Presbyterian Church of St. Marys is
the oldest Presbyterian church in Georgia. The historic town of
St. Marys is home to the Kings Bay Naval Submarine Base and
is the jumping-off point for trips to Cumberland Island.

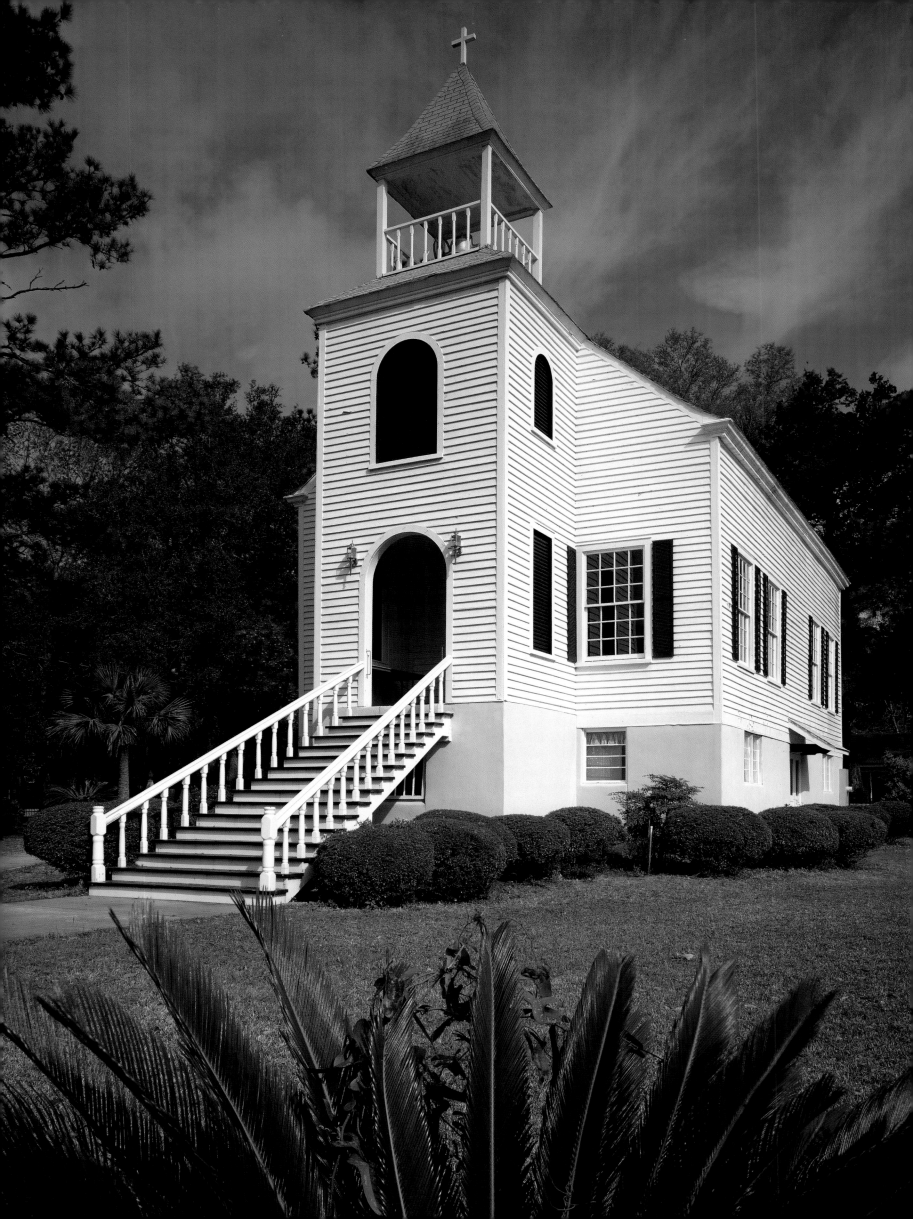

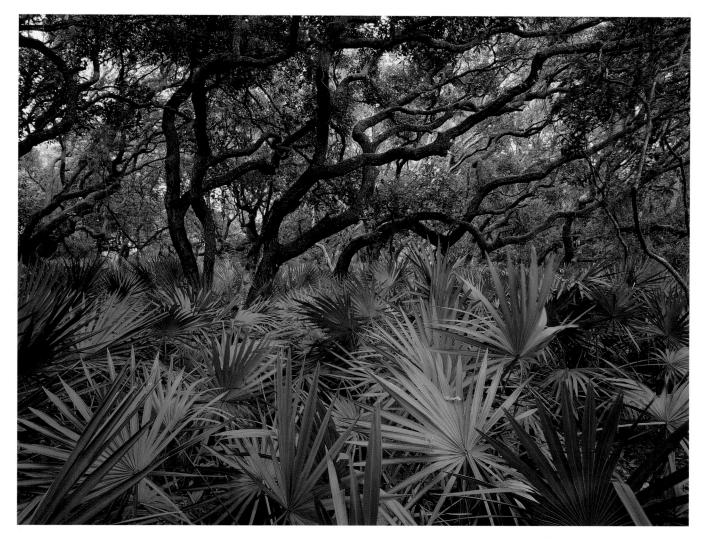

◁ Pierce Butler introduced the rice culture to Georgia, which flourished from the early 1800s to the Civil War. Today his plantation survives as the Pierce Butler Rice Plantation Historic Site. △ Seacamp is the only developed campground at Cumberland Island National Seashore. Set in the magical space of an old-growth maritime forest, spending a night at Seacamp requires reservations as much as six months in advance.

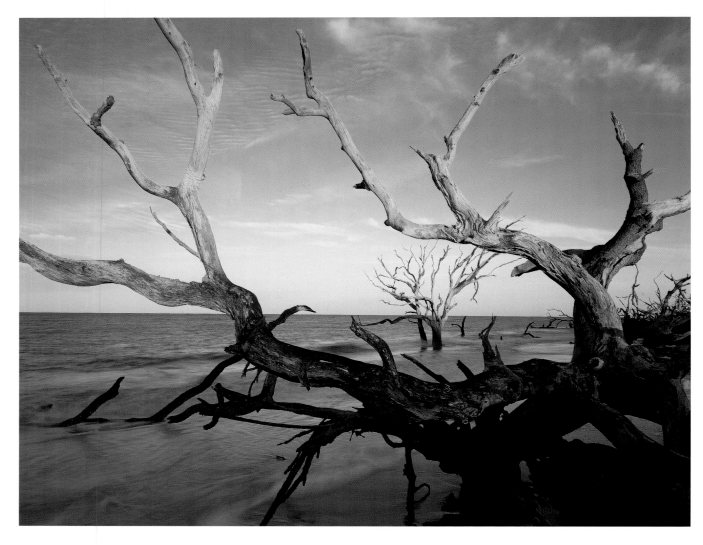

△ Blackbeard Island, now managed as a National Wildlife Refuge, once hid pirates, including the legendary Blackbeard.
▷ The Tybee Island lighthouse was the third lighthouse built in America and helped to guide British ships into Savannah. It also was a beacon to pirates, including Blackbeard, who plundered the Georgia coast and headquartered his crew in the Tybee area.
▷ ▷ Driftwood Beach is located at the north end of Jekyll Island.

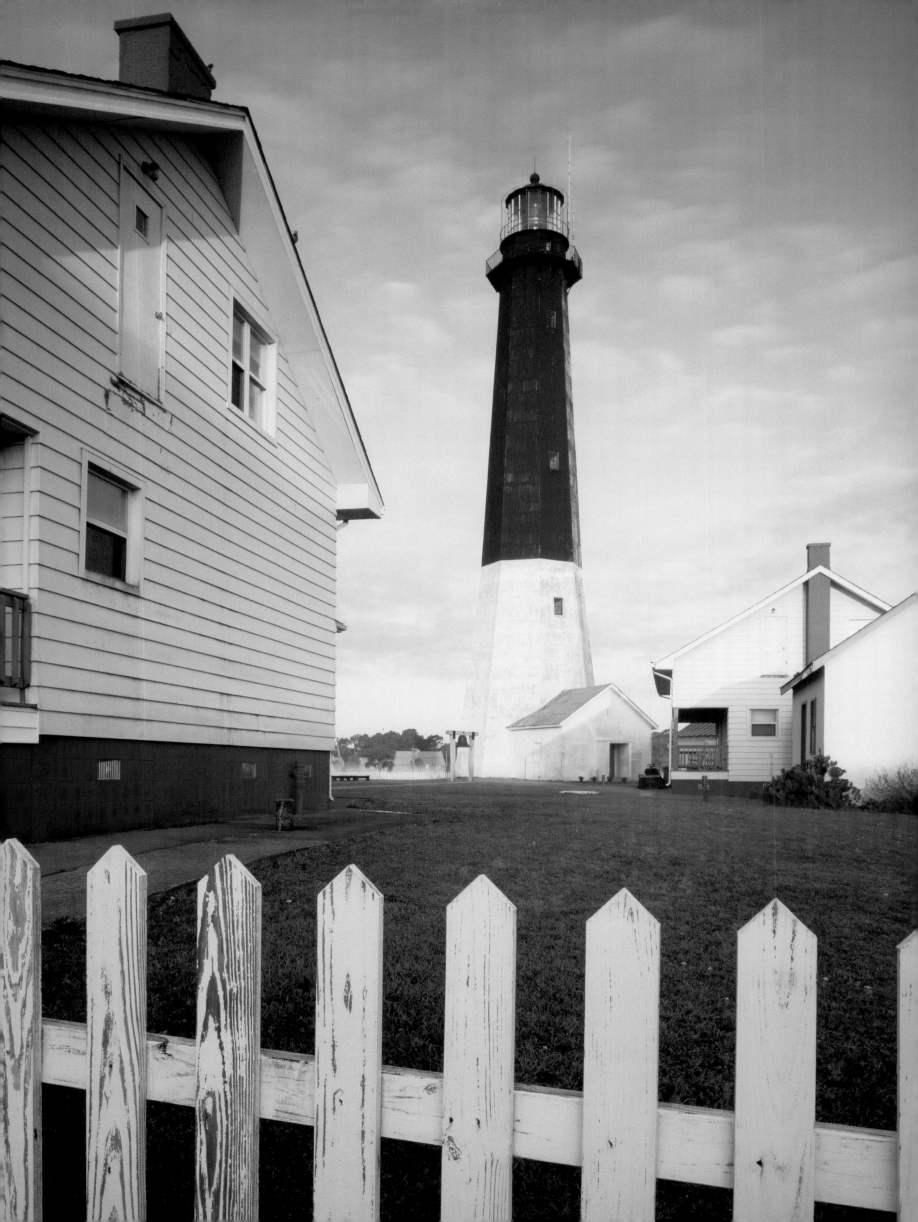

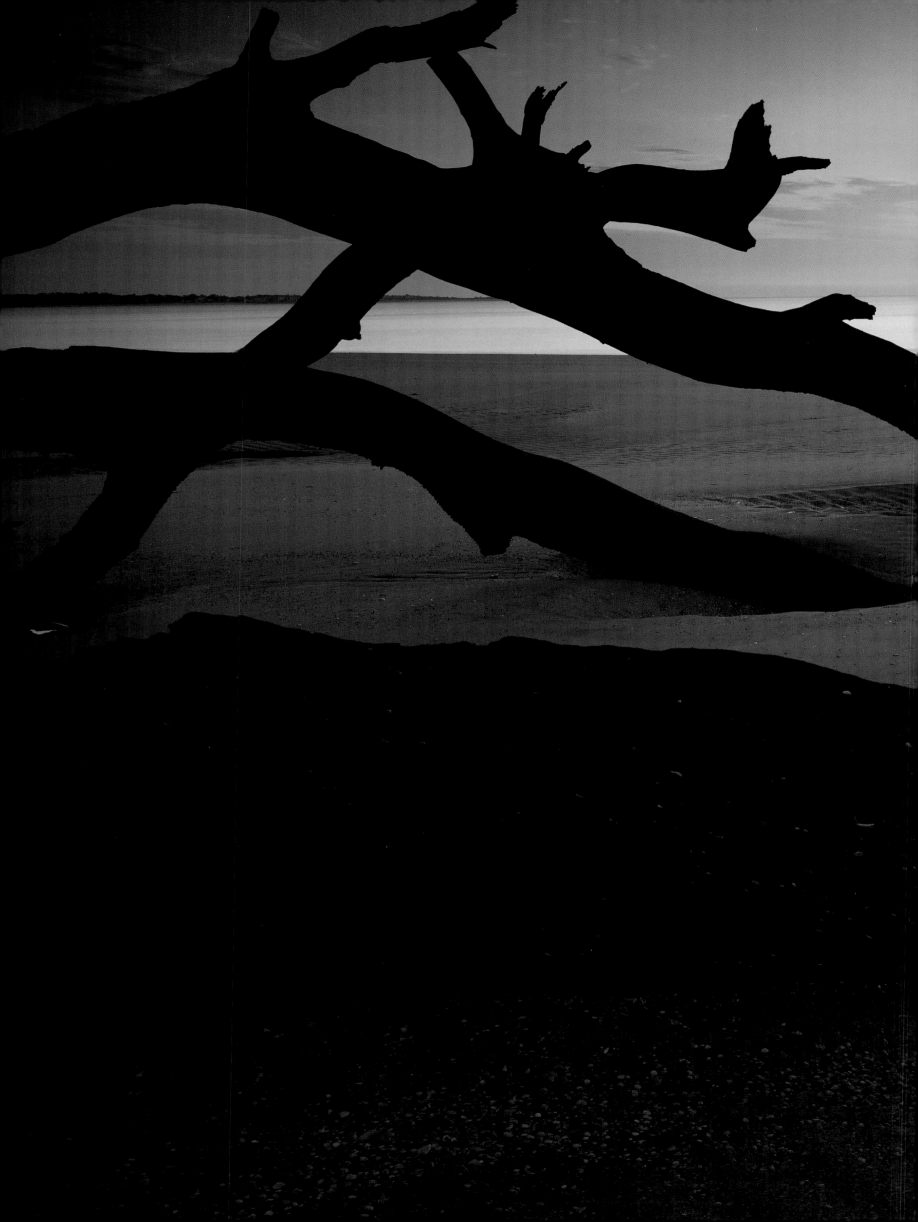

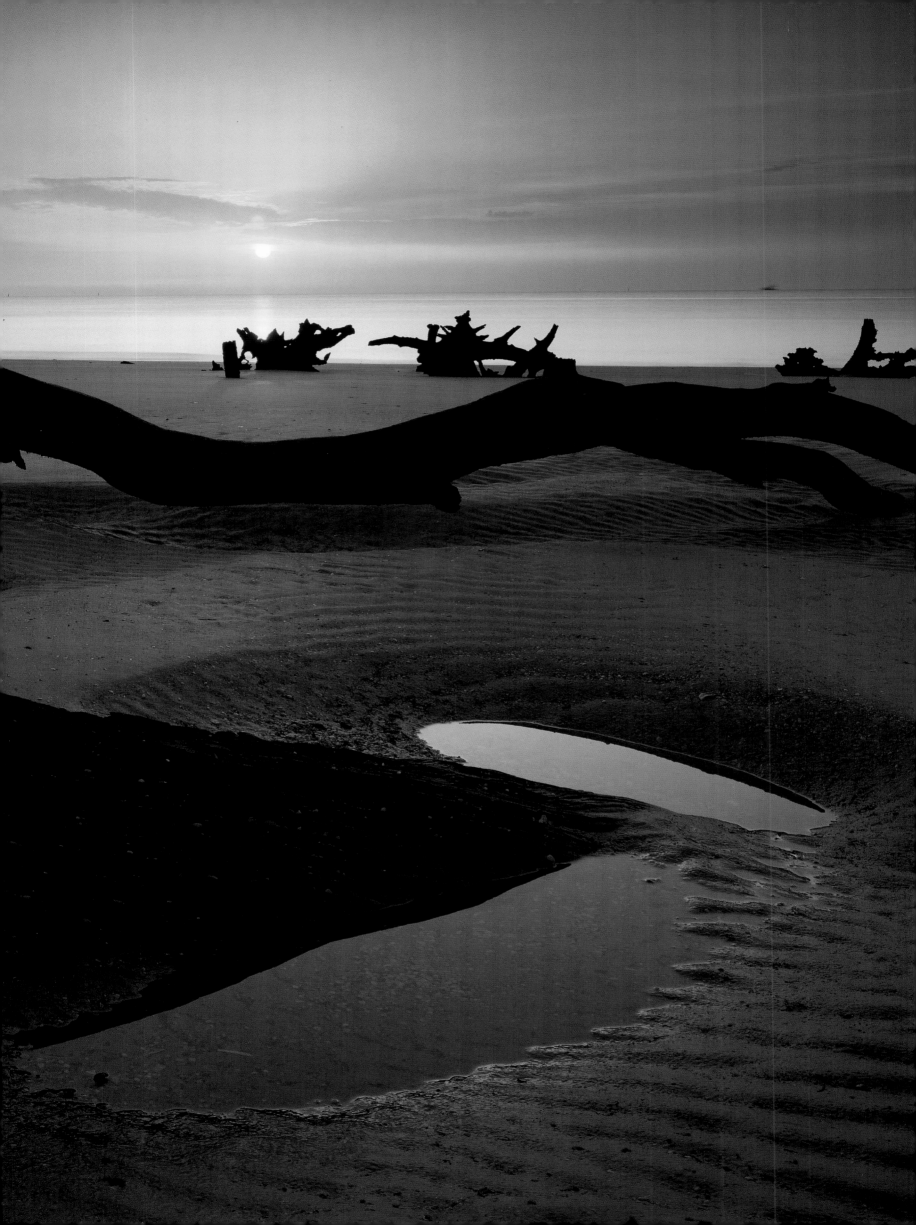

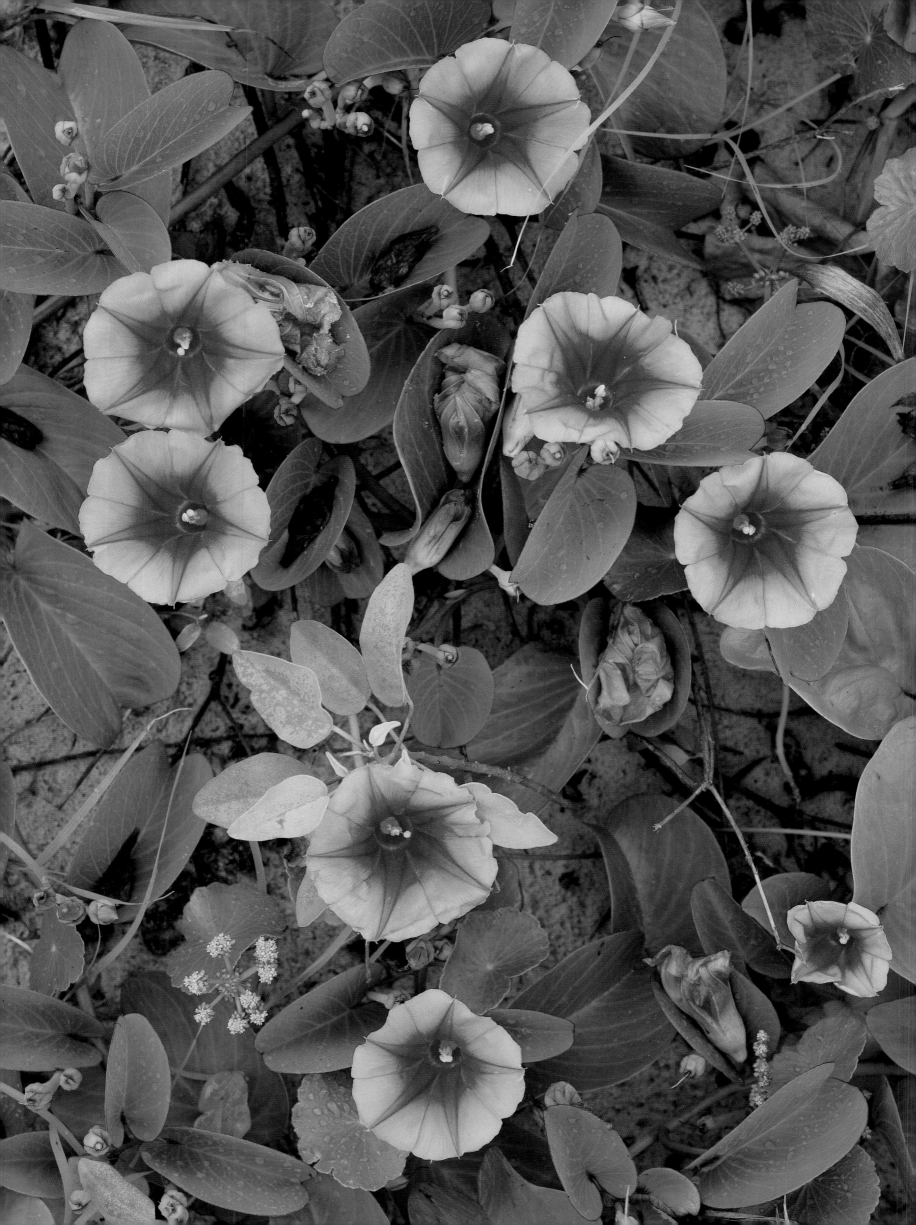

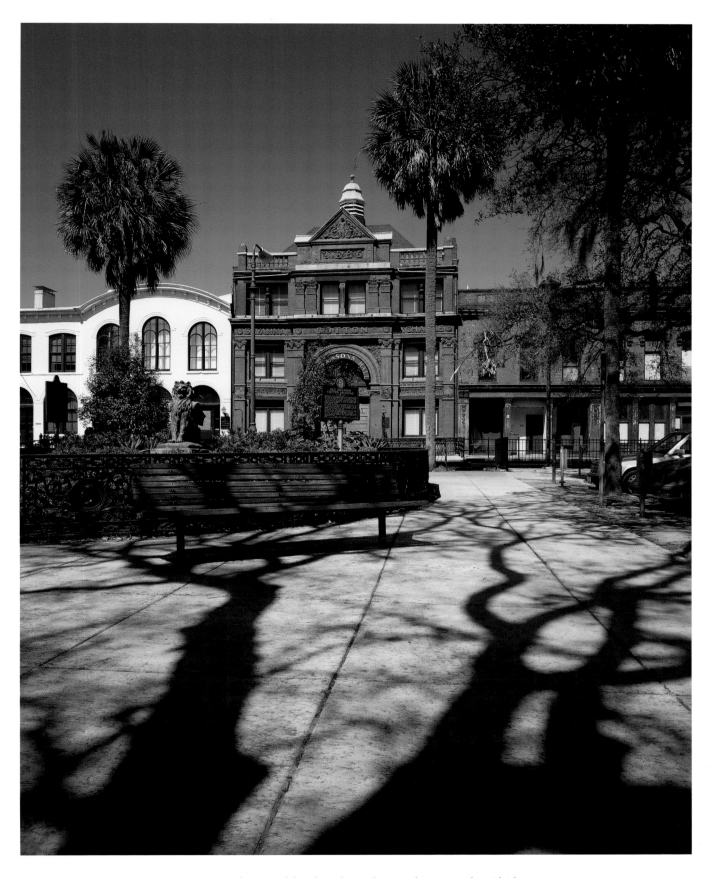

◁ Morning glories add color along the sandpiper trail at Skidaway
Island State Park near Savannah. In addition to abundant wildlife
and salt flats, this trail provides access to remnants of Confederate
earthworks utilized to defend Savannah during the Civil War.
△ Savannah's Historic Cotton Exchange building has survived
from a time when Savannah was the capital of Georgia and the
major seaport on the Atlantic Coast, and when cotton was king.

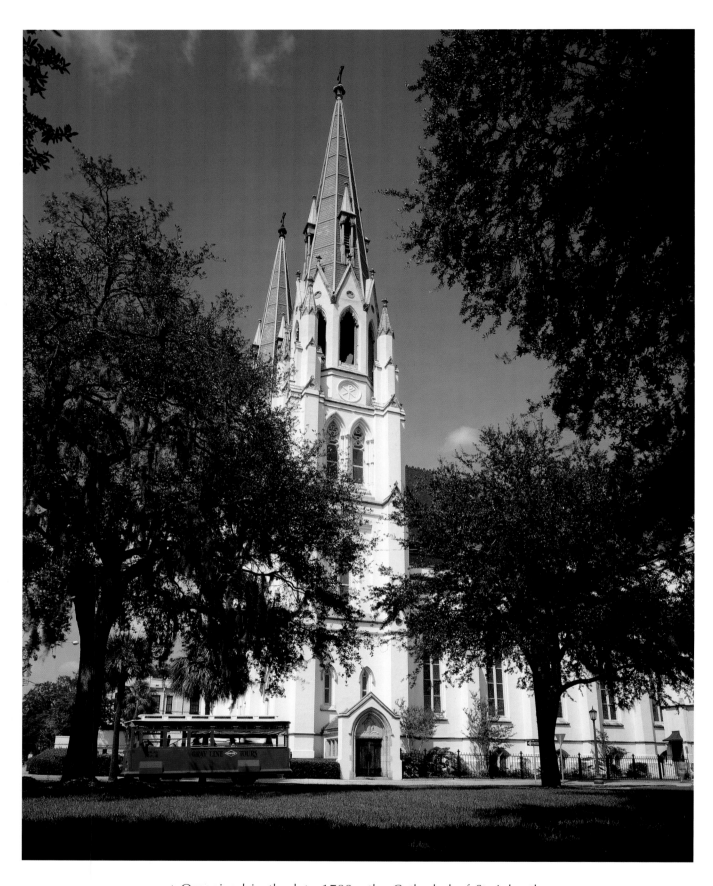

△ Organized in the late 1700s, the Cathedral of St. John the
Baptist is the oldest Roman Catholic church in Georgia. The
cathedral is a popular place to visit on historic tours of Savannah.
▷ Constructed with stones that were once used as ballast by early
British sailing ships, Savannah's River Street is now a mix of his-
toric buildings, hotels, gift shops, galleries, and restaurants. The
street is also the focal point for nightlife in downtown Savannah.

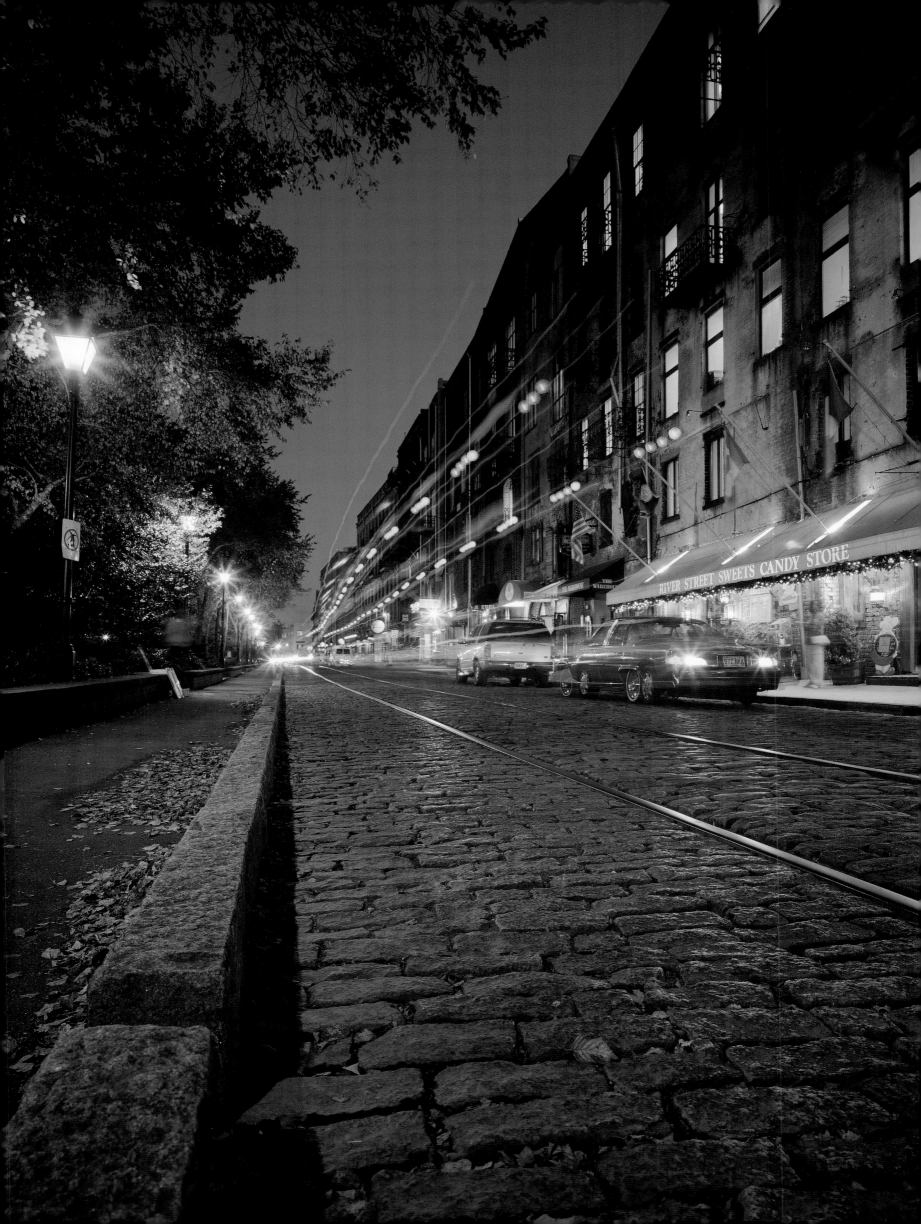

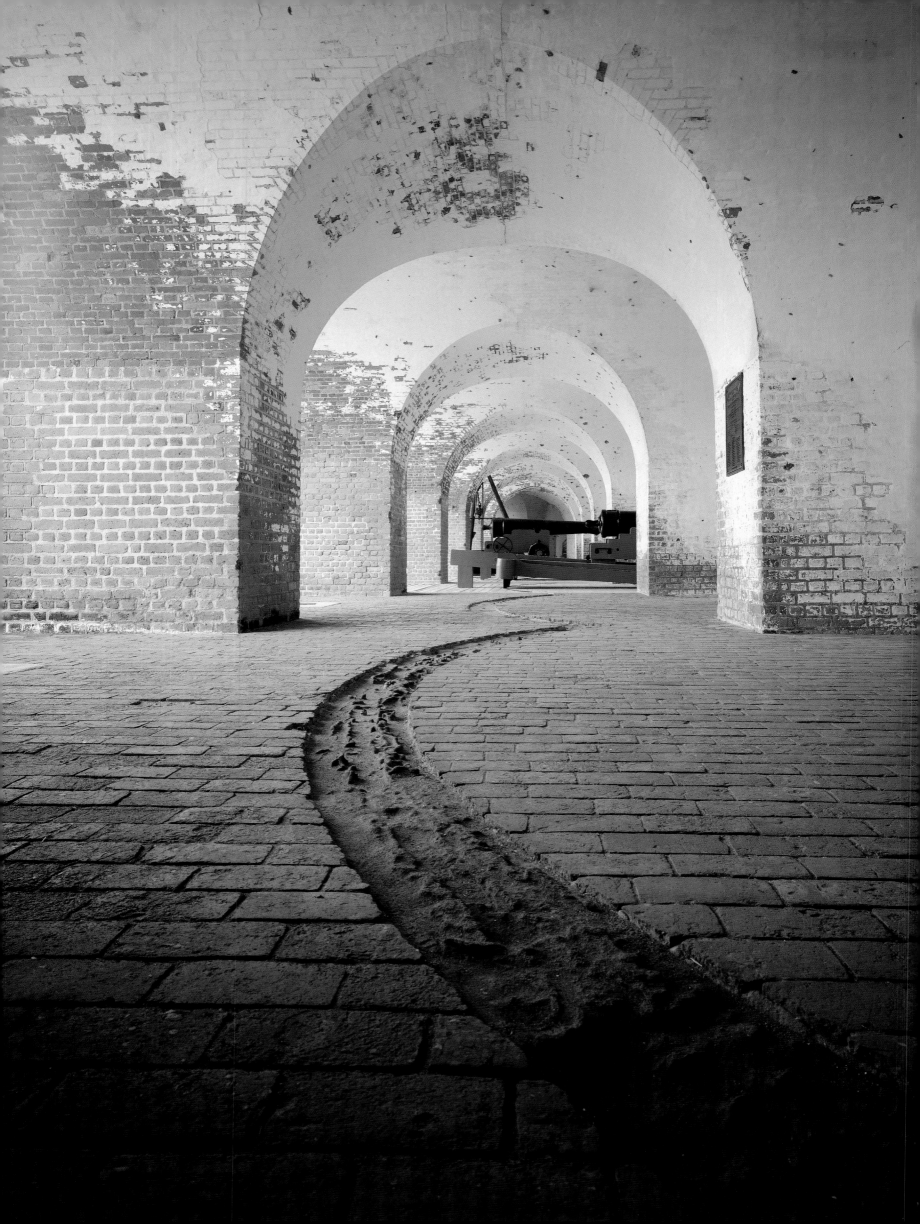

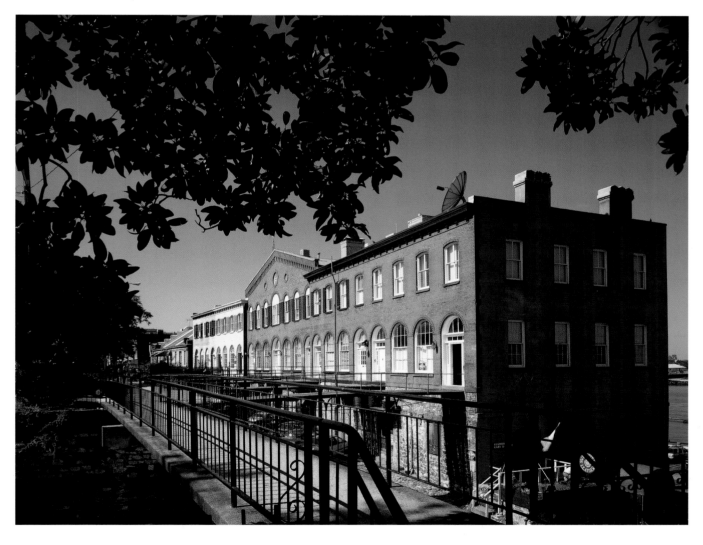

◁ Fort Pulaski, infamous for falling to Union troups during the Civil War after just thirty hours of bombardment, was originally built to guard the two entries to the Savannah River. Today, this castle-like fort is a national monument and tourist attraction. △ Historic Factor's Walk is on Bay Street in downtown Savannah. Factors, who worked in these buildings from the 1700s until the Civil War, were the brokers who controlled world cotton prices.

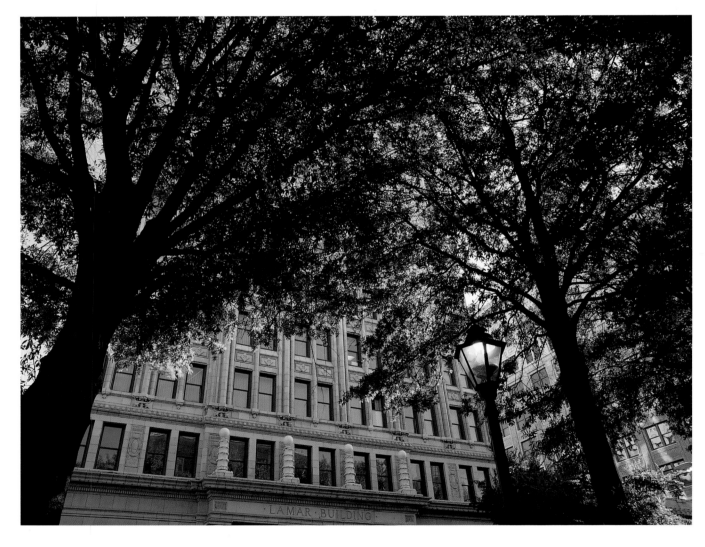

△ The Lamar Building and the Imperial Theater, seen here through the trees of the city park on Broad Street in Augusta, were both designed by famous Georgia architect G. Lloyd Preacher. ▷ Built in 1987 on the levee adjacent to the Savannah River, Riverwalk has become a successful downtown revitalization project for the city of Augusta. The area offers shopping, hotels, museums, galleries, and an outdoor amphitheater.

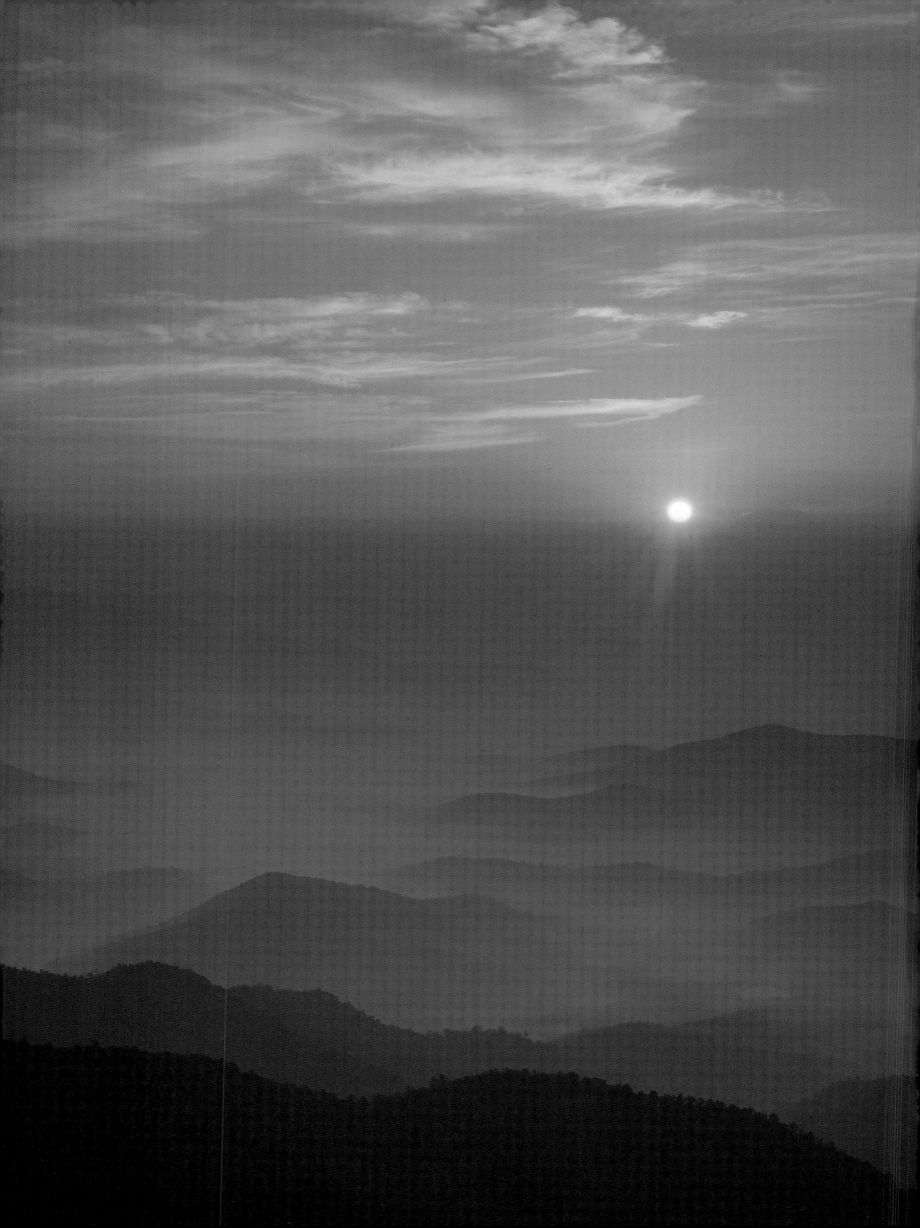

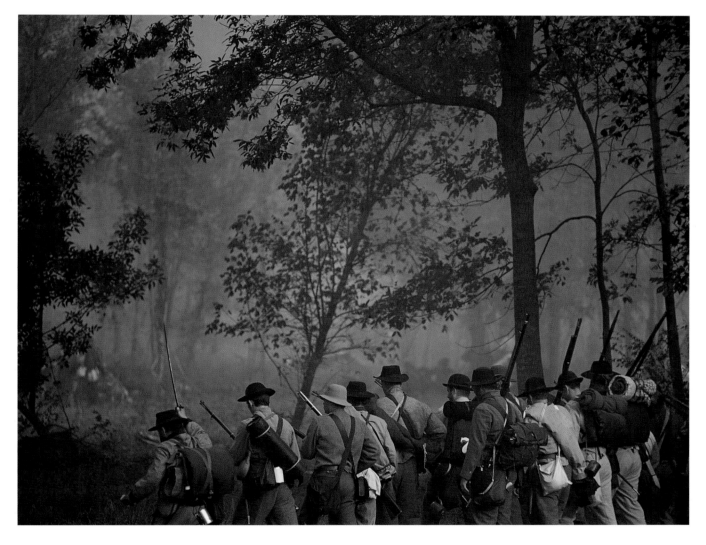

◁ On a clear day from the observation tower atop Brasstown Bald it is possible to see four states. Brasstown's name comes from confusion between the Cherokee word *itse-yi* meaning "new green place" and the word *untsaiyi*, which means "brass." △ Northwest Georgia is rich in Civil War history, including the 1862 Great Locomotive Chase and the battles of Chickamauga and Missionary Ridge. Here, reenactors stage a mock battle.

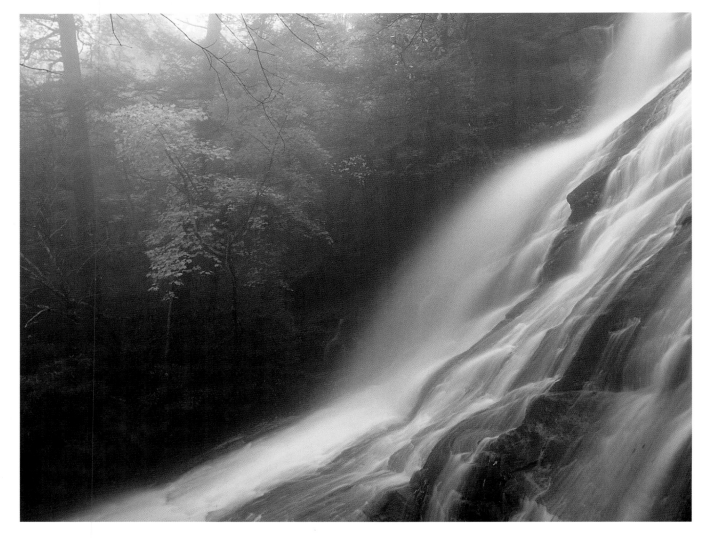

△ In the Cohutta Wilderness, Panther Creek Falls winds its way through a boulder field on the side of East Cowpen mountain. With more than thirty-seven thousand acres, the Cohutta is the largest continuous mountain wilderness area in Georgia. ▷ Rocktown, located on Pigeon Mountain in northwest Georgia's Cumberland Plateau region, is a 140-acre maze of oddly shaped boulders. Budding hardwoods dot the area with spring color.

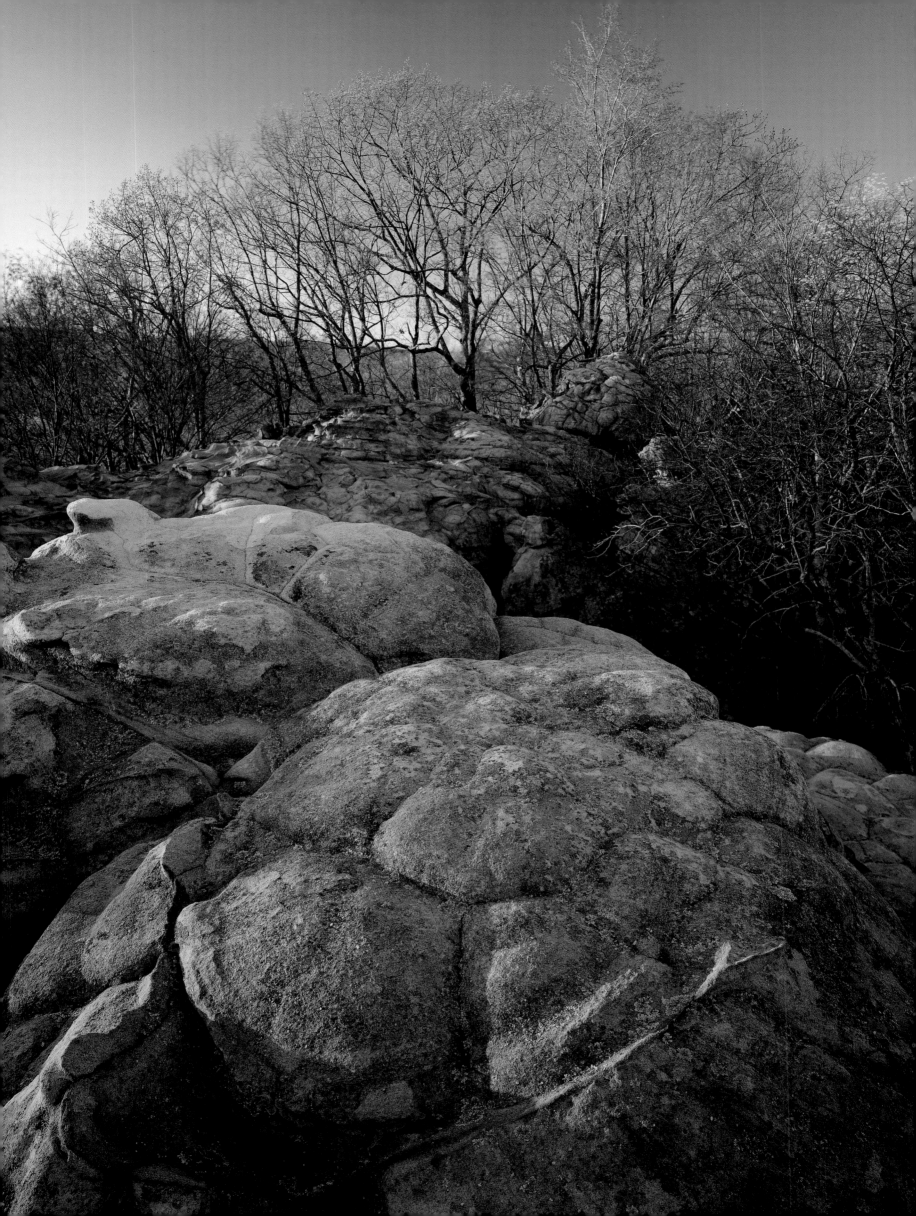

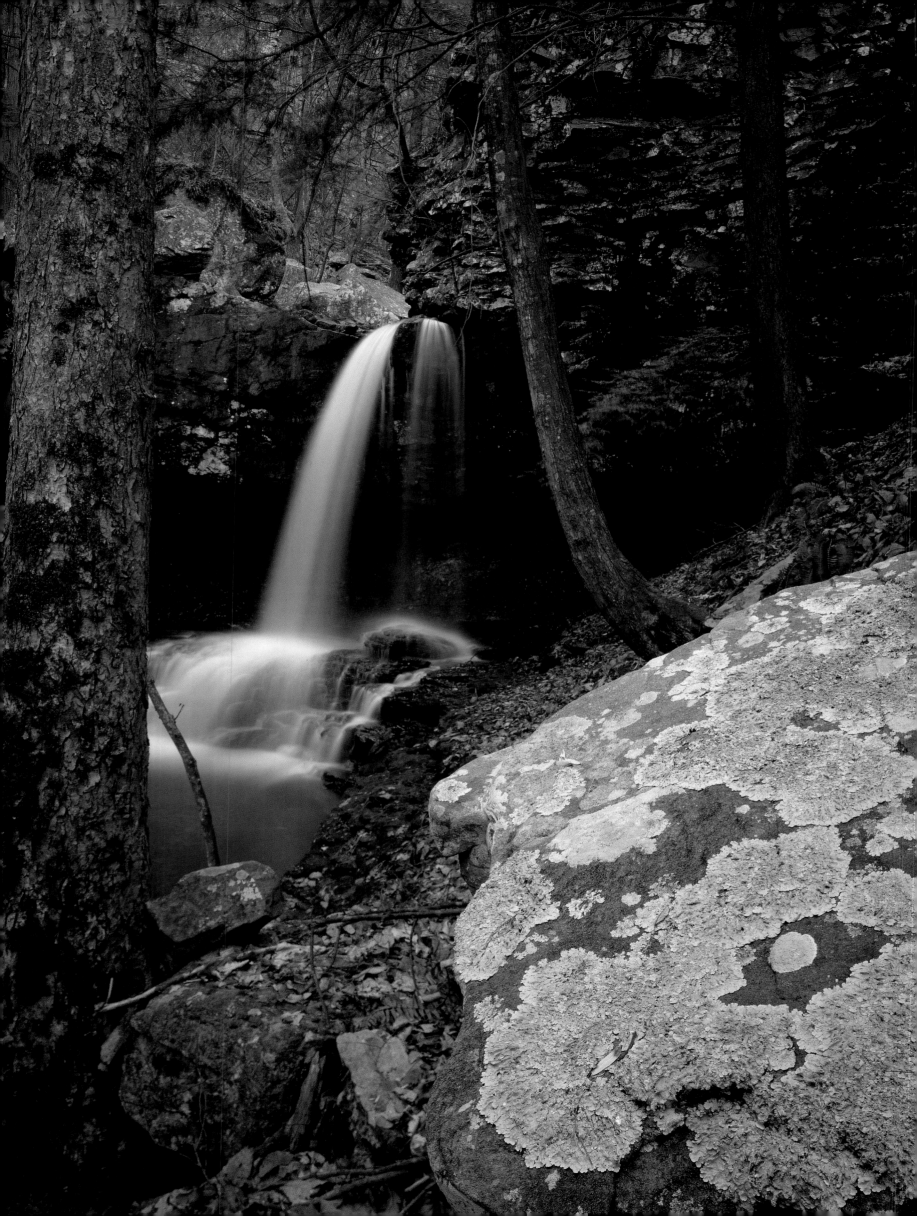

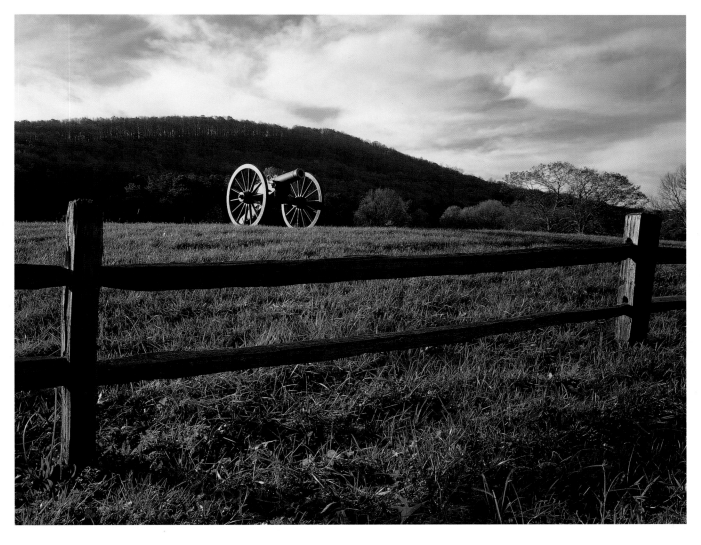

◁ Flowing through Cloudland Canyon State Park, Daniel Creek drops more than eight hundred feet in less than a quarter mile. △ Kennesaw National Battlefield Park commemorates the Atlanta Campaign of the Civil War, preserving ten miles of trench lines. ▷ ▷ Textile magnate Cason Callaway created Callaway Gardens, near the town of Pine Mountain, as a tribute to his mother. Its fourteen thousand acres contain gardens, lakes, and golf courses.

△ Sosebee Cove Scenic Area near Vogel State Park encompasses one of the largest stands of second-growth poplar in the east. The area is also known for brilliant displays of spring wildflowers.
▷ Jacks River Falls is one of the most popular destinations within the rugged country of northwest Georgia's Cohutta wilderness.
▷ ▷ Near Atlanta, the world's largest single granite outcropping, Stone Mountain, is covered by a sea of rare confederate daisies.

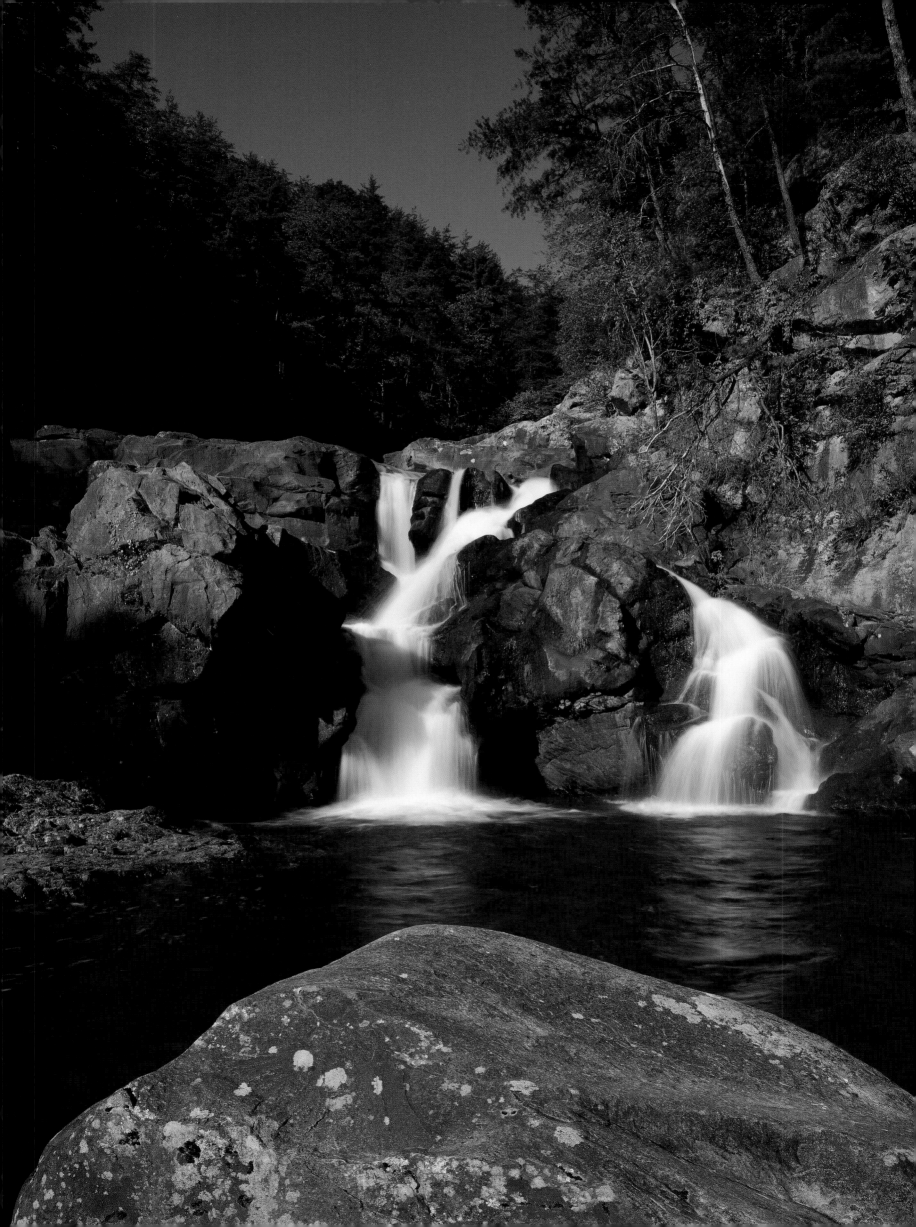

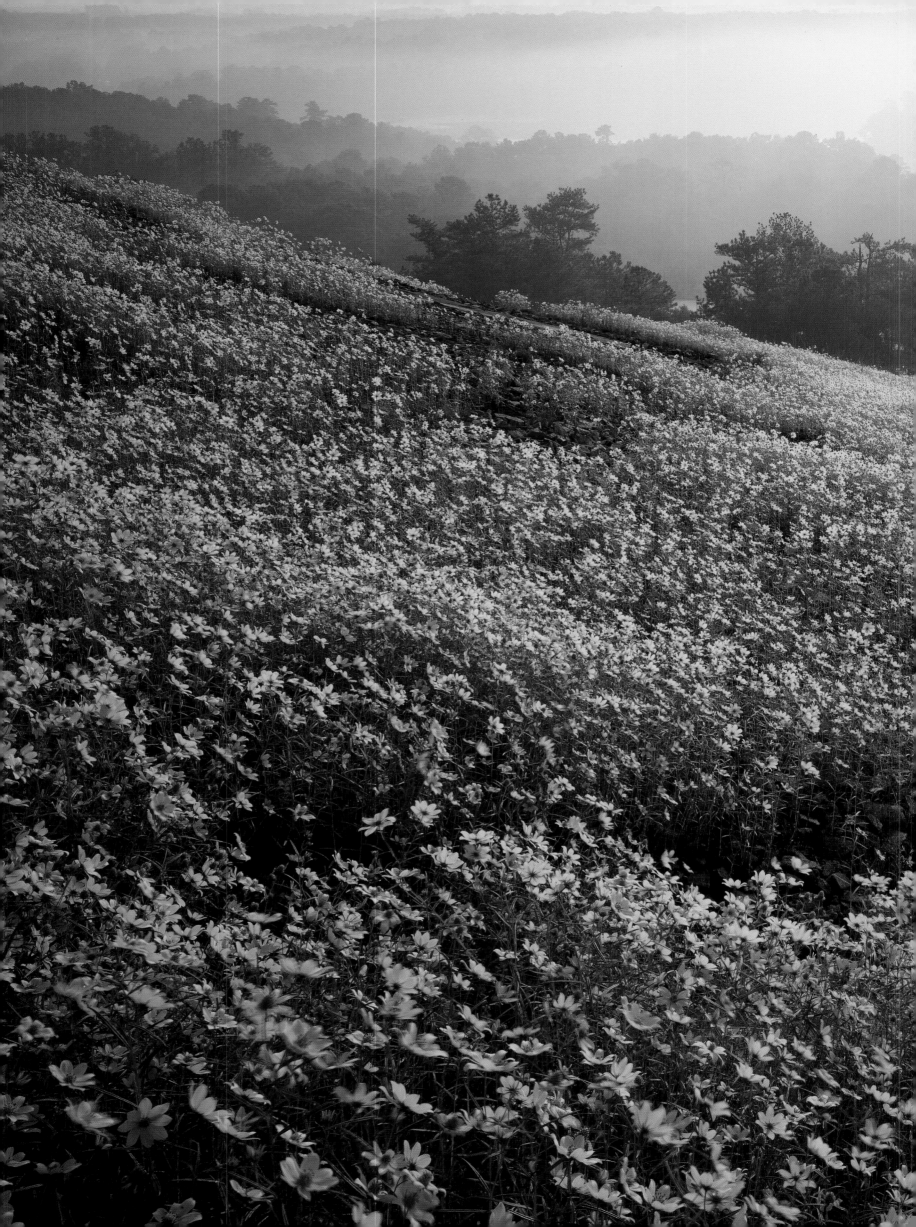

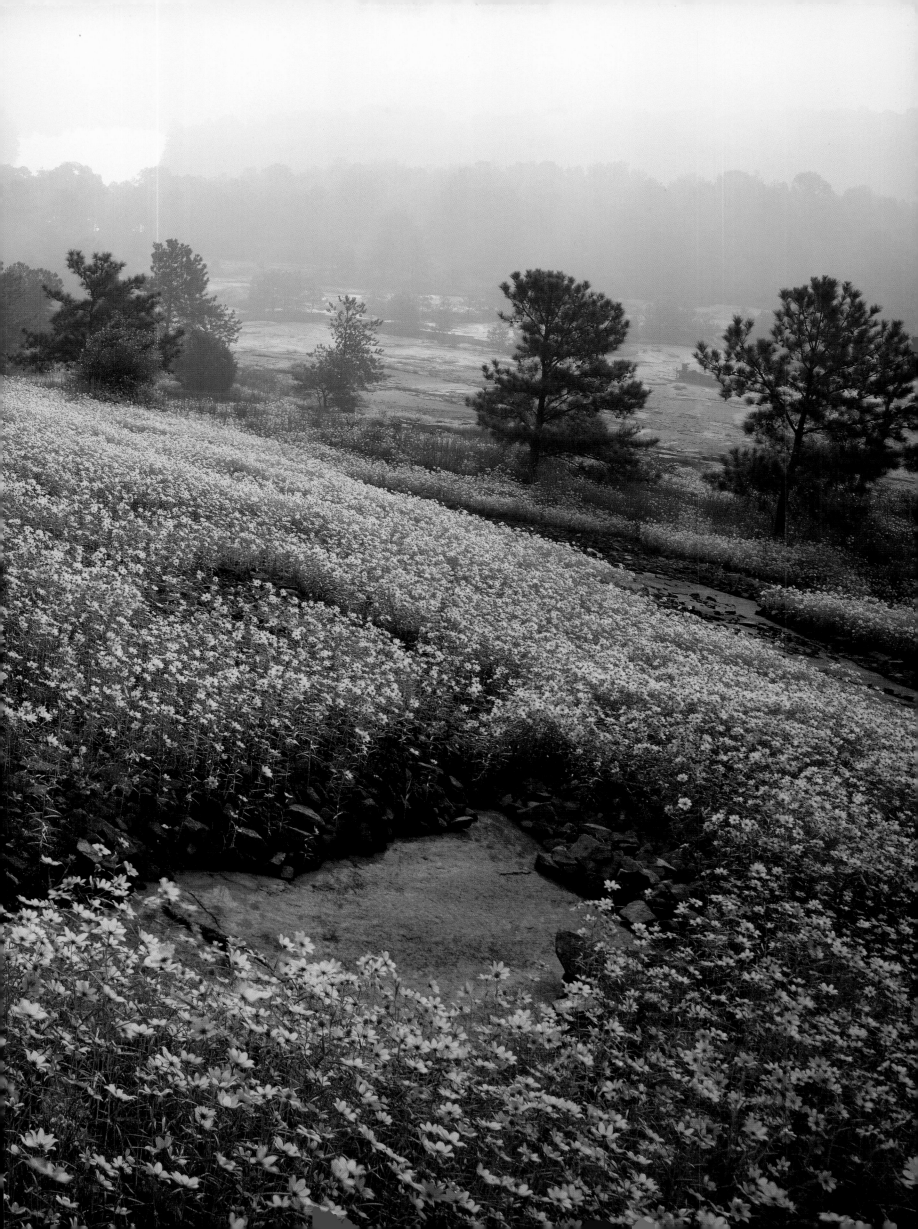

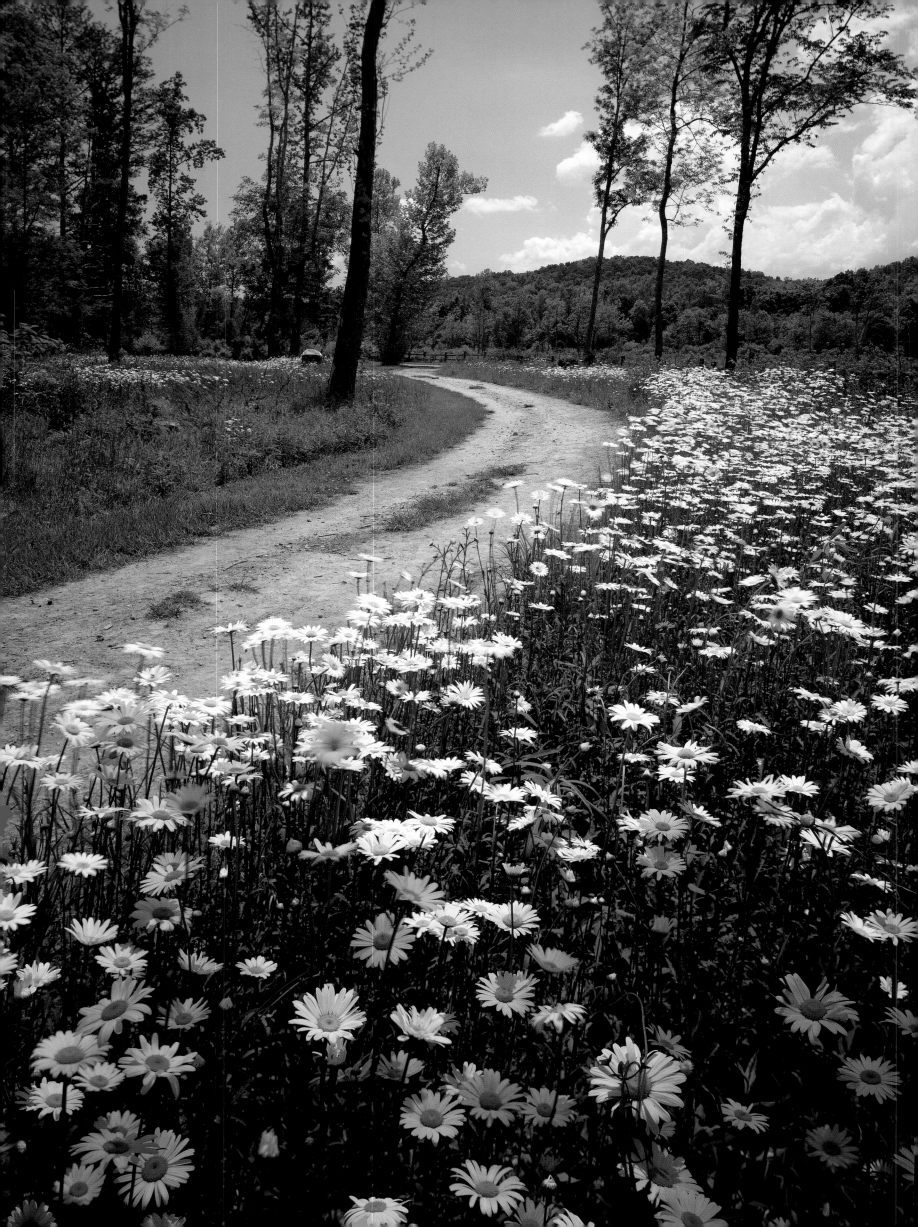

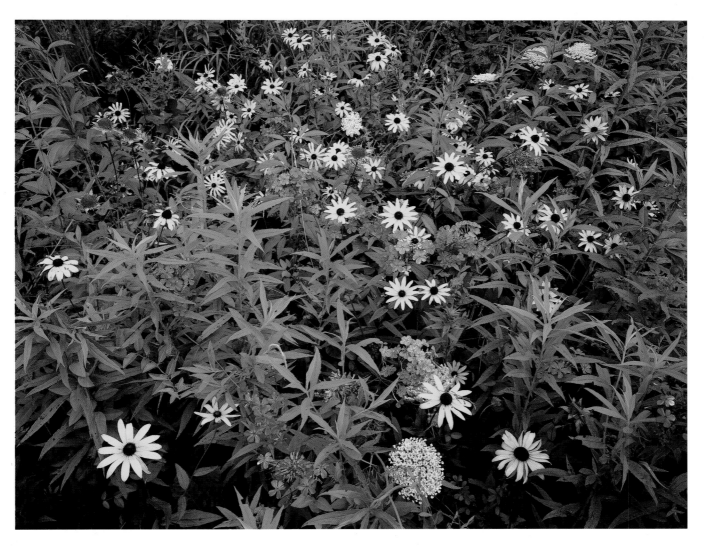

◁ Woodland daisies bloom along a country road near Adairsville.
△ Blackeyed susans, Queen Anne's lace, and purple flox create a
showy roadside display at Johns Mountain Wildlife Management
Area. The plateau-topped Johns Mountain is situated in an area
recognized as the ridge and valley province of northwest Georgia.

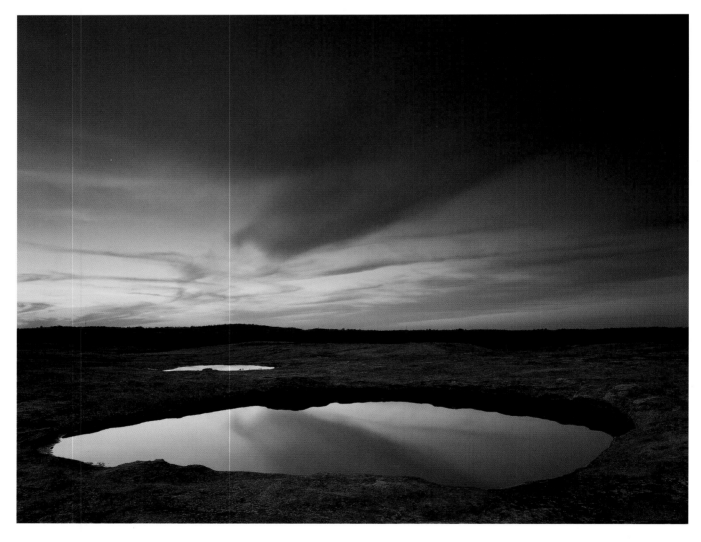

△ Evening twilight reflects in vernal pools at Davidson-Arabia Mountain Nature Preserve in Dekalb County. Endangered plants have found friendly habitat in this series of rolling granite domes. ▷ One of the finest legacies of the 1996 summer Olympics in Atlanta is Centennial Olympic Park. This rambling city park on International Boulevard is fast becoming one of Atlanta's most important cultural gathering places and most visited landmarks.

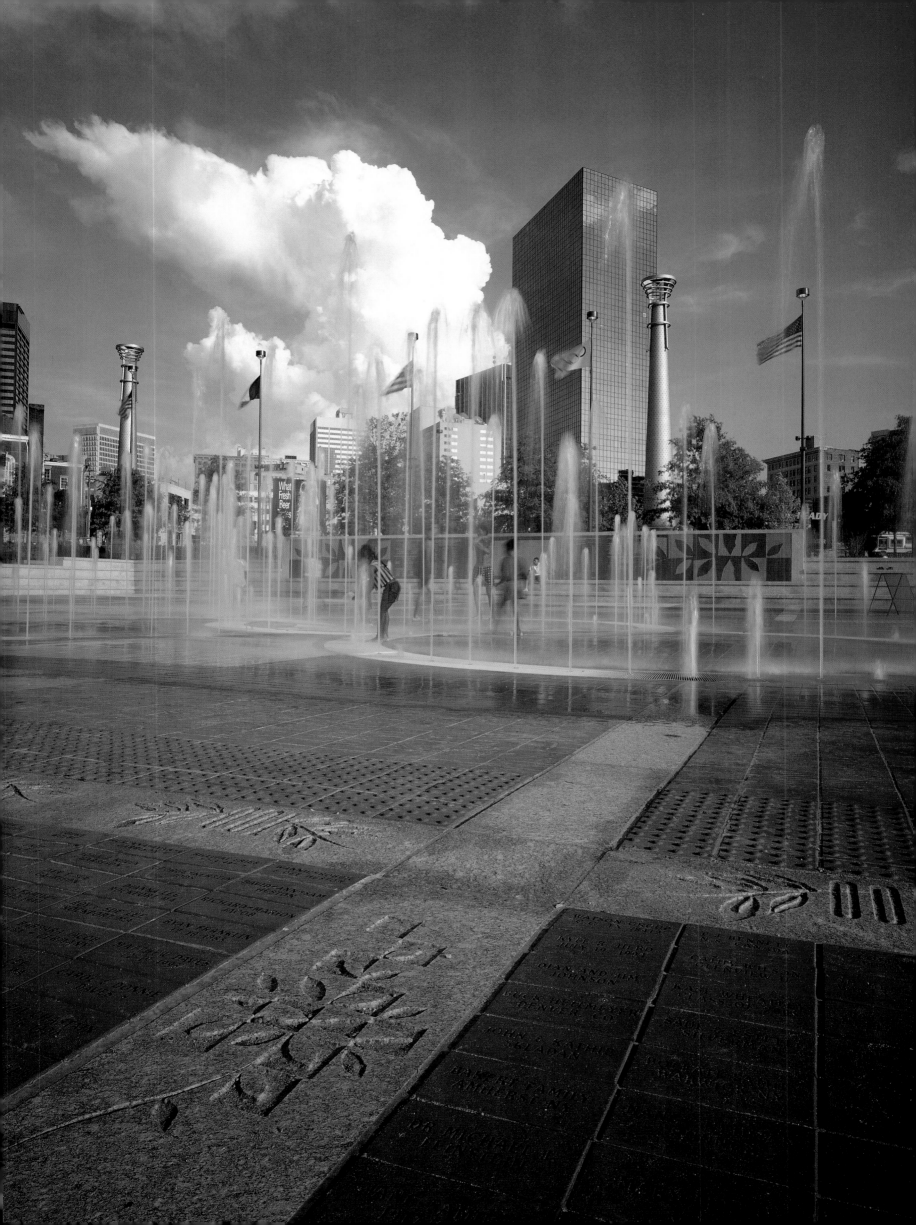

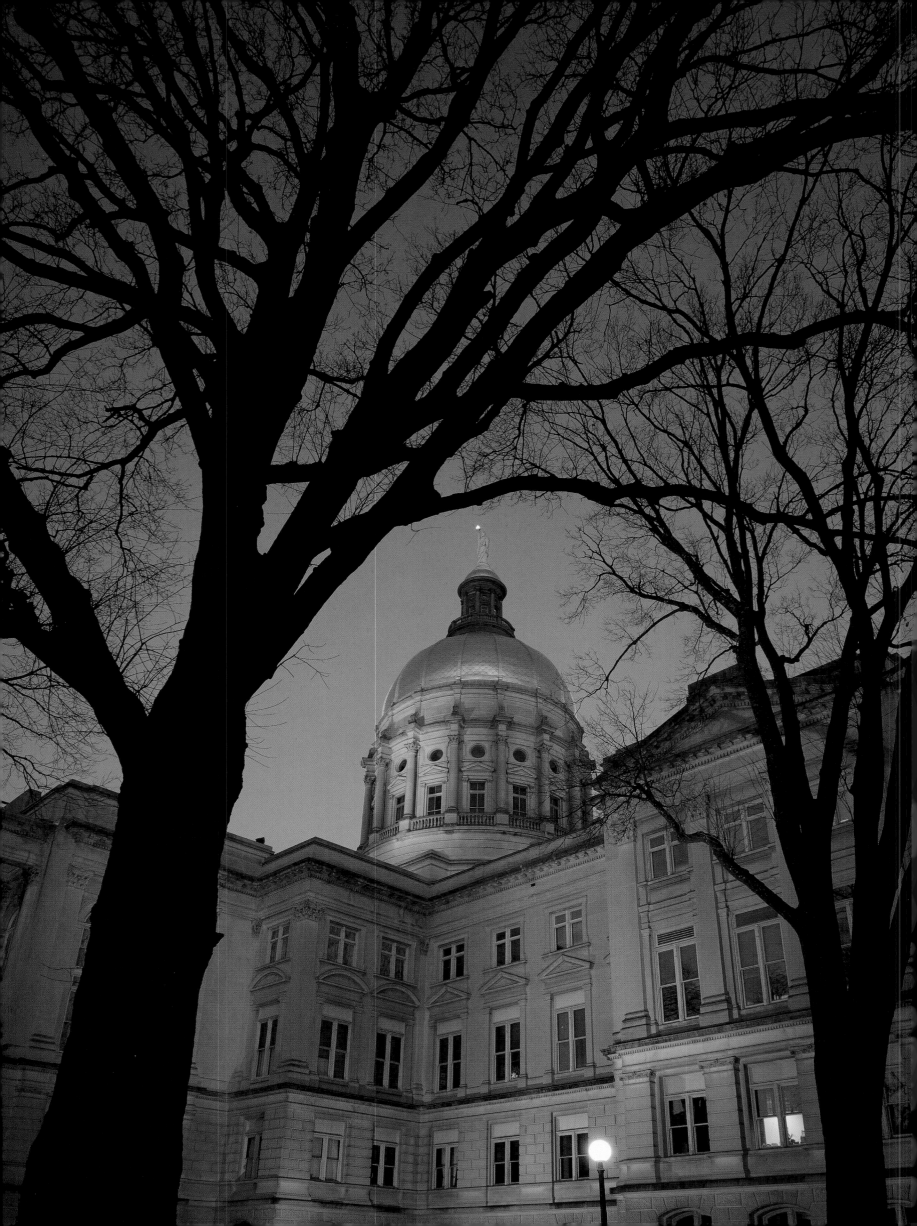

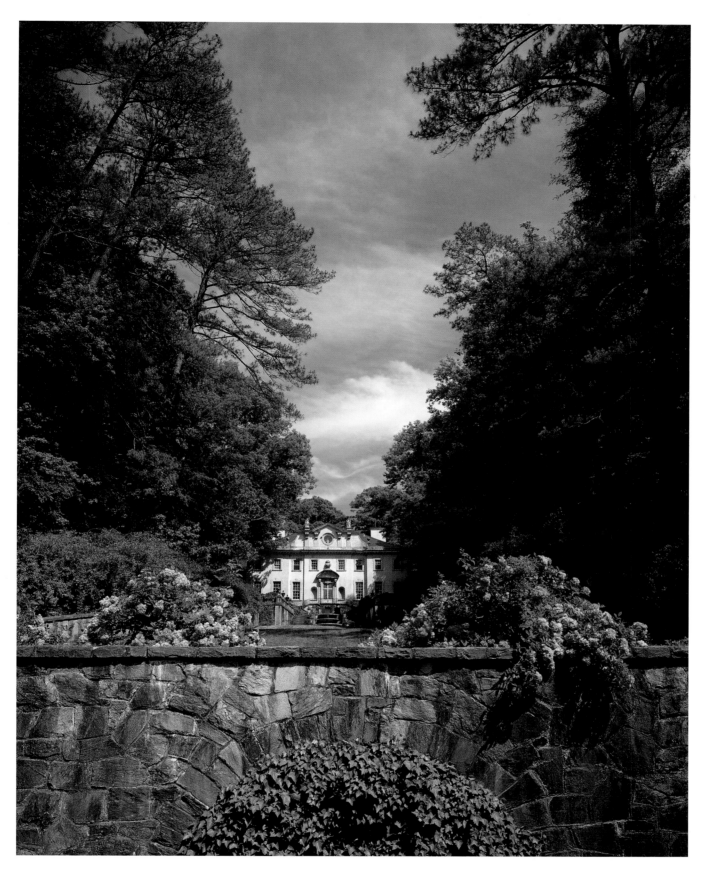

◁ Completed in 1889, Georgia's capitol building is modeled on
the nation's capitol building in Washington, D.C. In 1958, the
dome of the capitol was coated with a thin sheet of gold from
the Georgia town of Dahlonega, site of the nation's first gold rush.
△ Now part of the Atlanta History Center, the Swann House is
considered architect Philip Shutze's masterpiece. Built in the
late 1920s, it features cascading terraces and a formal garden.

△ In 1969, the Tullie Smith House was restored and moved from its original site in Dekalb County to the Atlanta History Center in Buckhead. Built in the 1830s, the house is a classic example of the Piedmont Plantation Plain style of architecture.

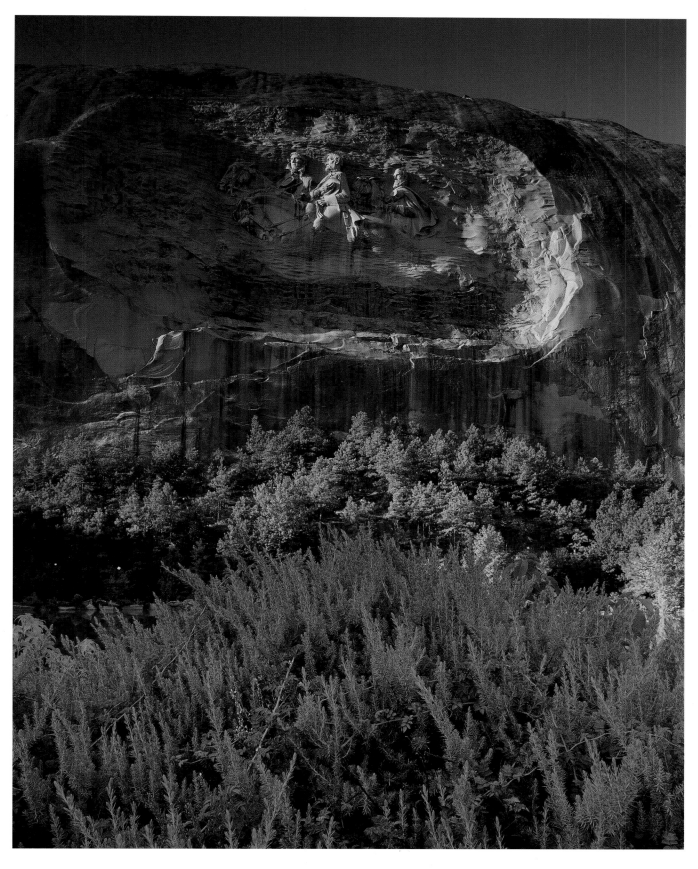

△ At Stone Mountain Memorial Park near Atlanta, Confederate heroes Jefferson Davis, Robert E. Lee, and Stonewall Jackson are the subject of the largest bas-relief carving in the world.

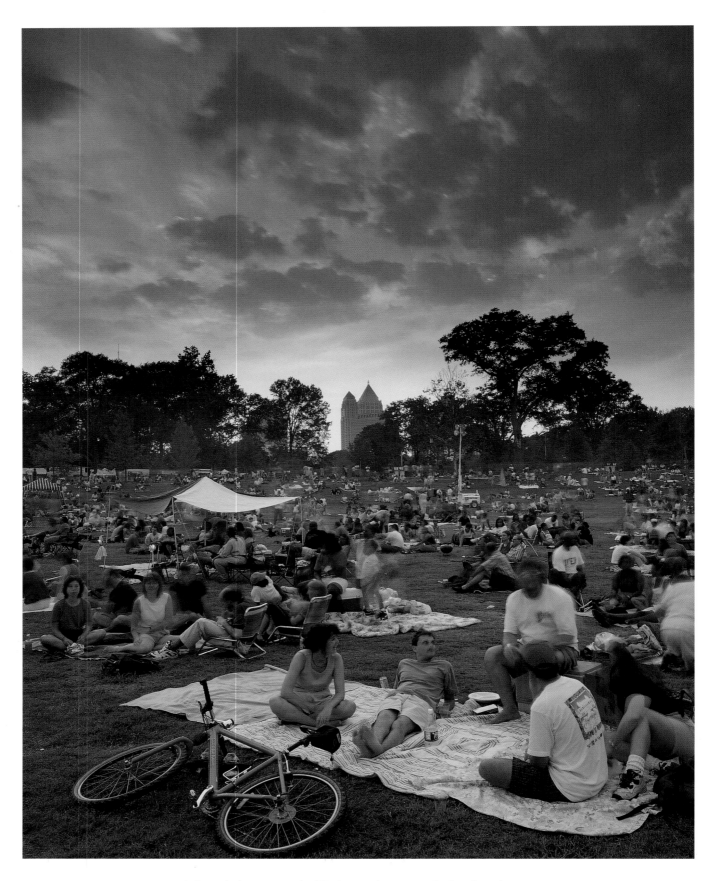

△ Atlanta's largest park, Piedmont hosts myriad cultural events. Concert goers await the start of the Montreaux Jazz Festival. ▷ The interchange of I-20 and the downtown connector crisscross the landscape just south of the center of downtown Atlanta. ▷ ▷ Beautiful geology and falling water define the landscape of the Towaliga River at High Falls State Park. In addition, the park includes a lake, a historic dam, hiking trails, and great fishing.

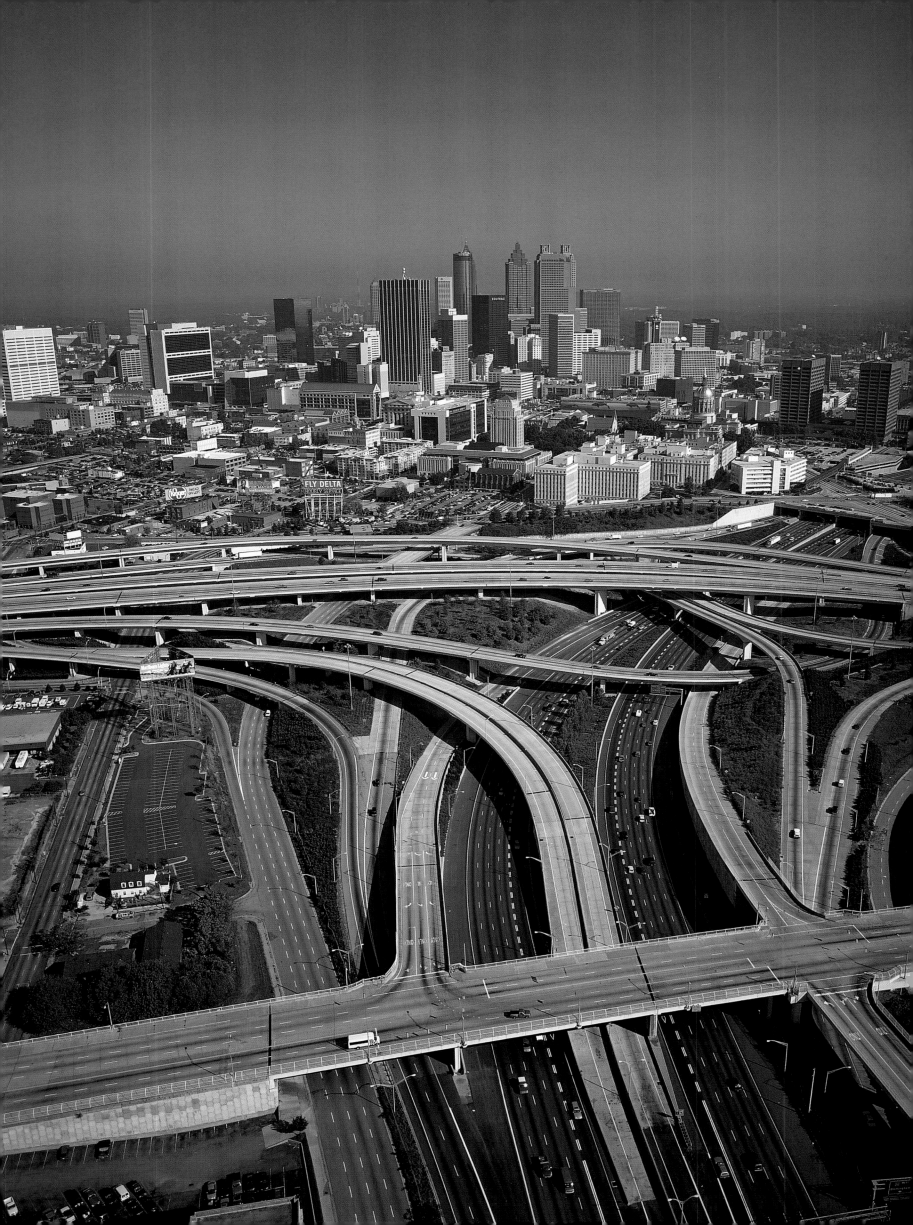

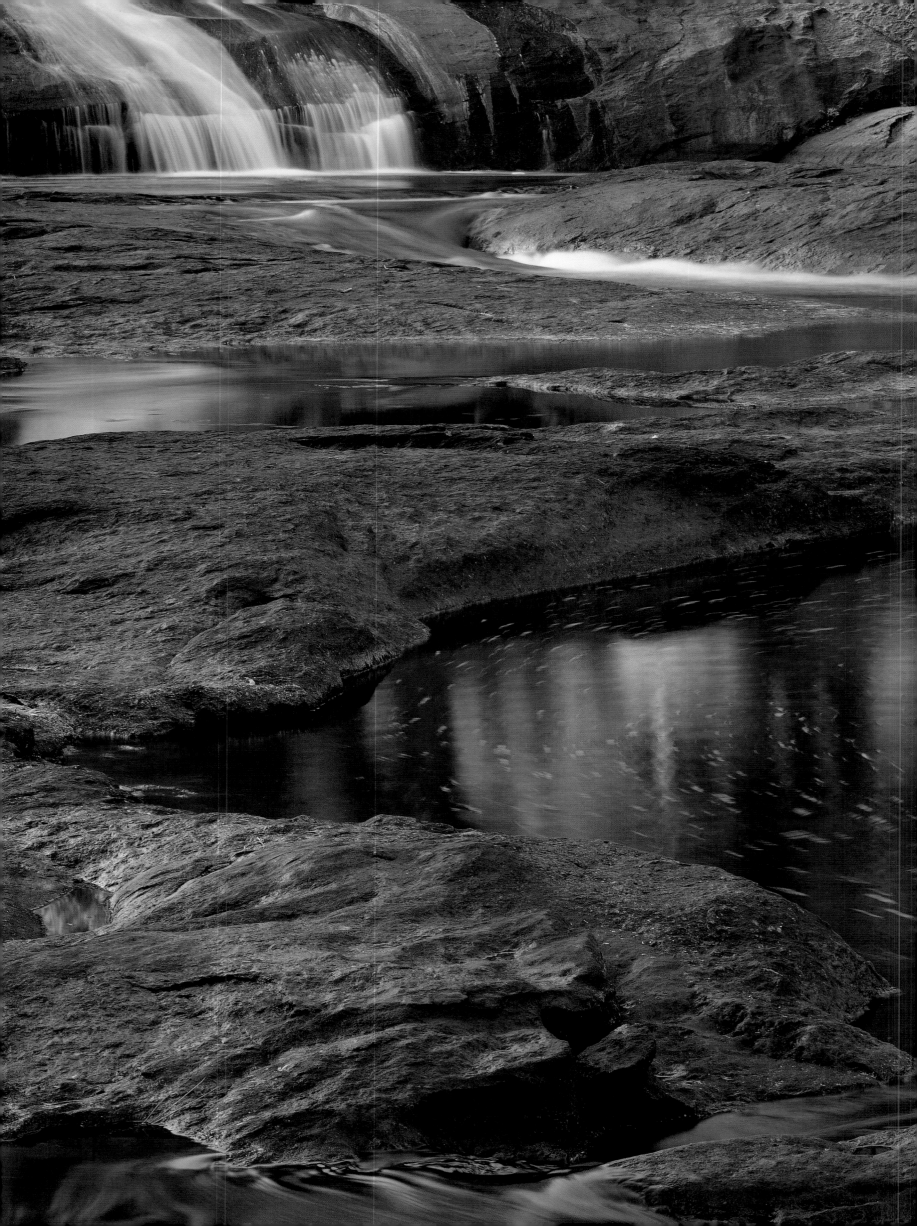

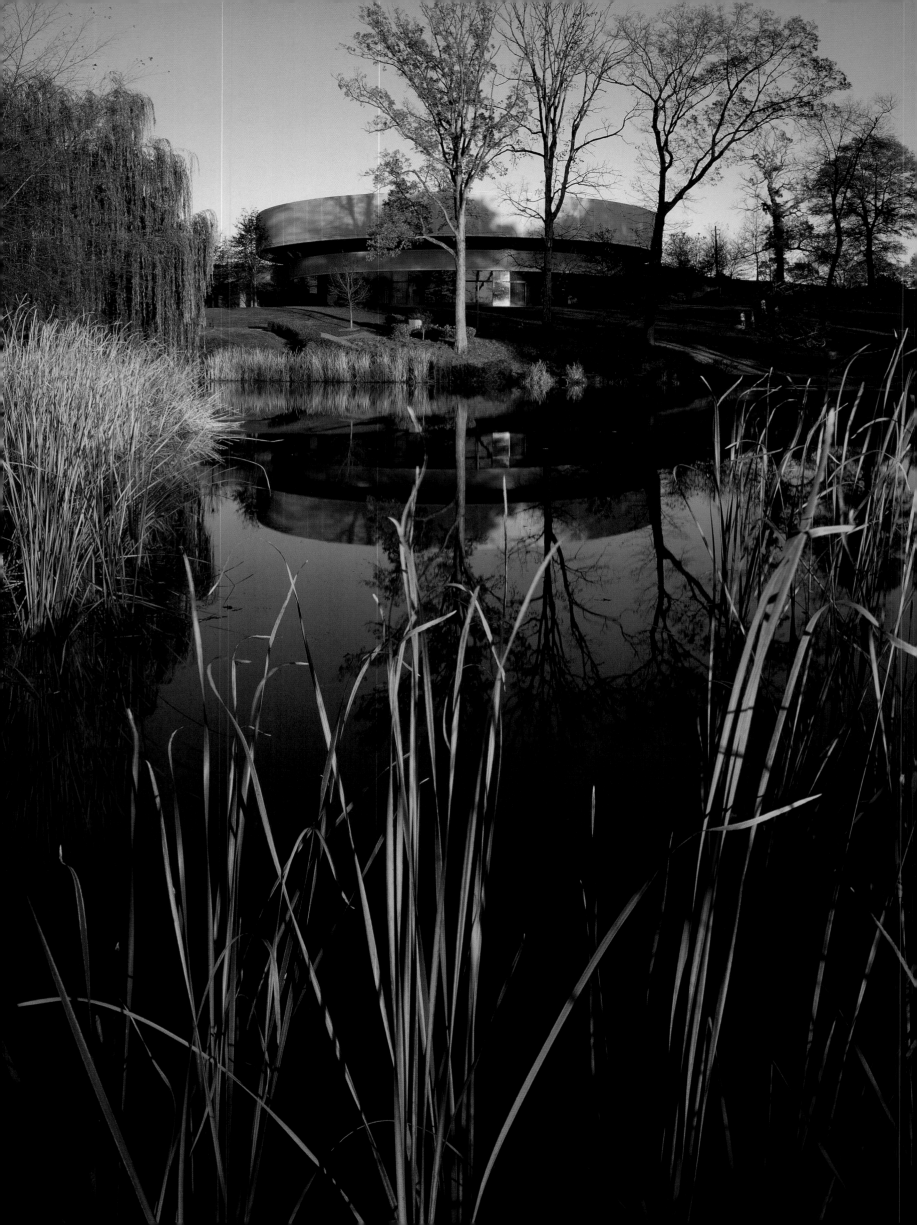

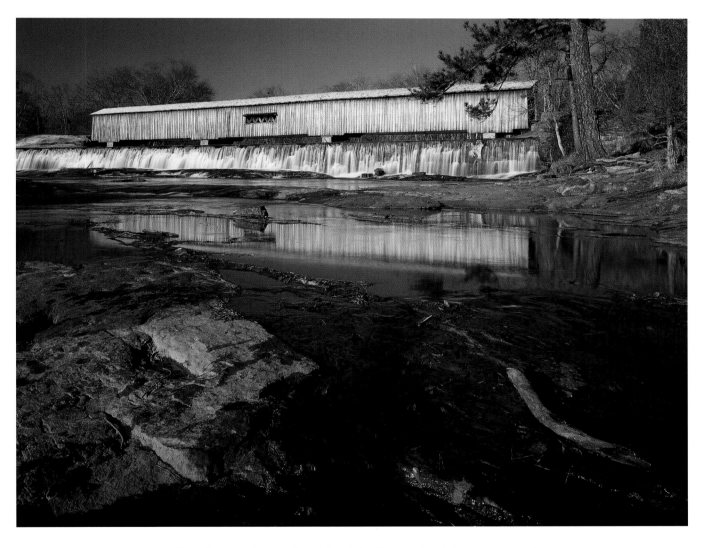

◁ The Jimmy Carter Presidential Library in Atlanta not only houses the memoirs of the Carter presidency but has become a meeting place for world leaders to discuss global challenges. △ The longest covered bridge in Georgia is situated in Watson Mill Bridge State Park. The bridge, built in 1885, spans 229 feet of the South Fork River near the small town of Comer. ▷ ▷ Autumn leaves float in Davidson-Arabia Nature Preserve.

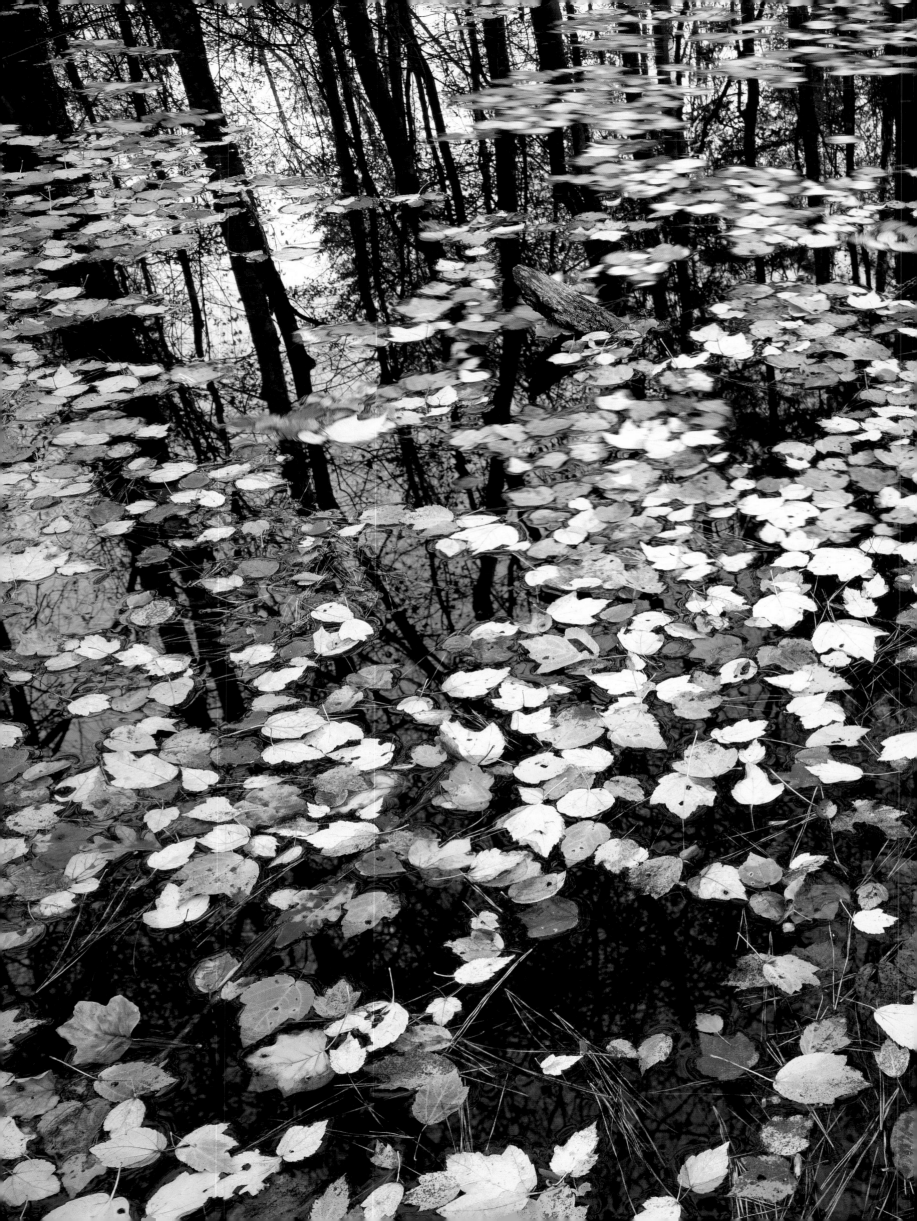

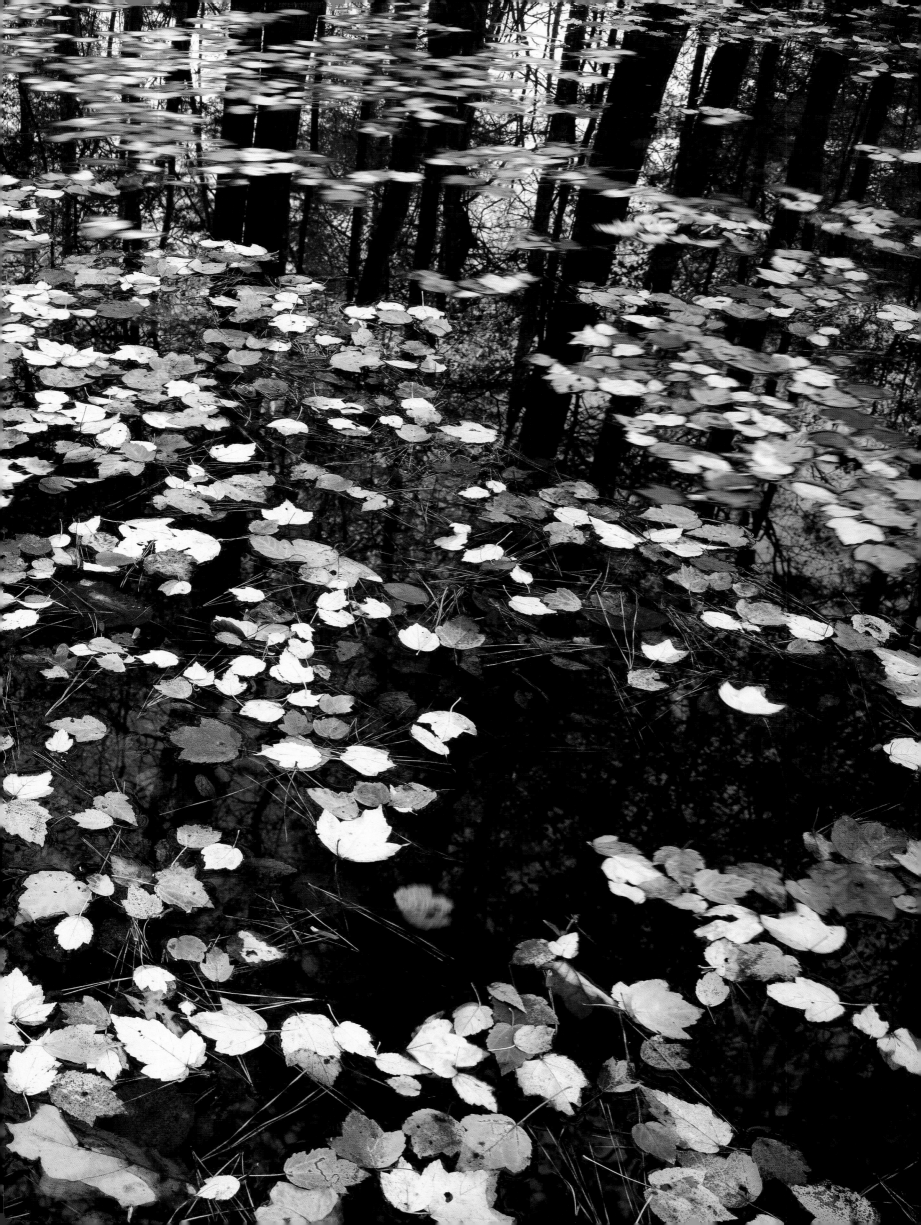

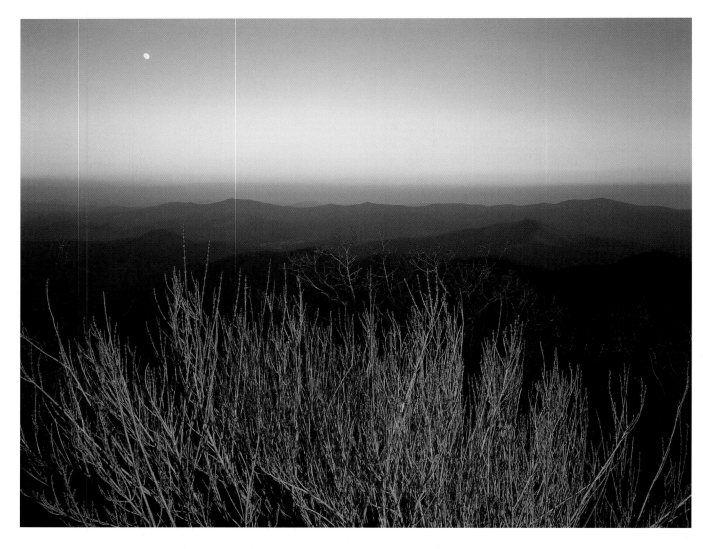

△ Winter provides the Georgia mountain visitor with spectacular, unobstructed views such as this one in the Brasstown Wilderness. ▷ Sprewell Bluff is a new addition to Georgia's system of state parks. Located on the Flint River near the town of Thomaston, this scenic park is relatively unknown outside the immediate area.

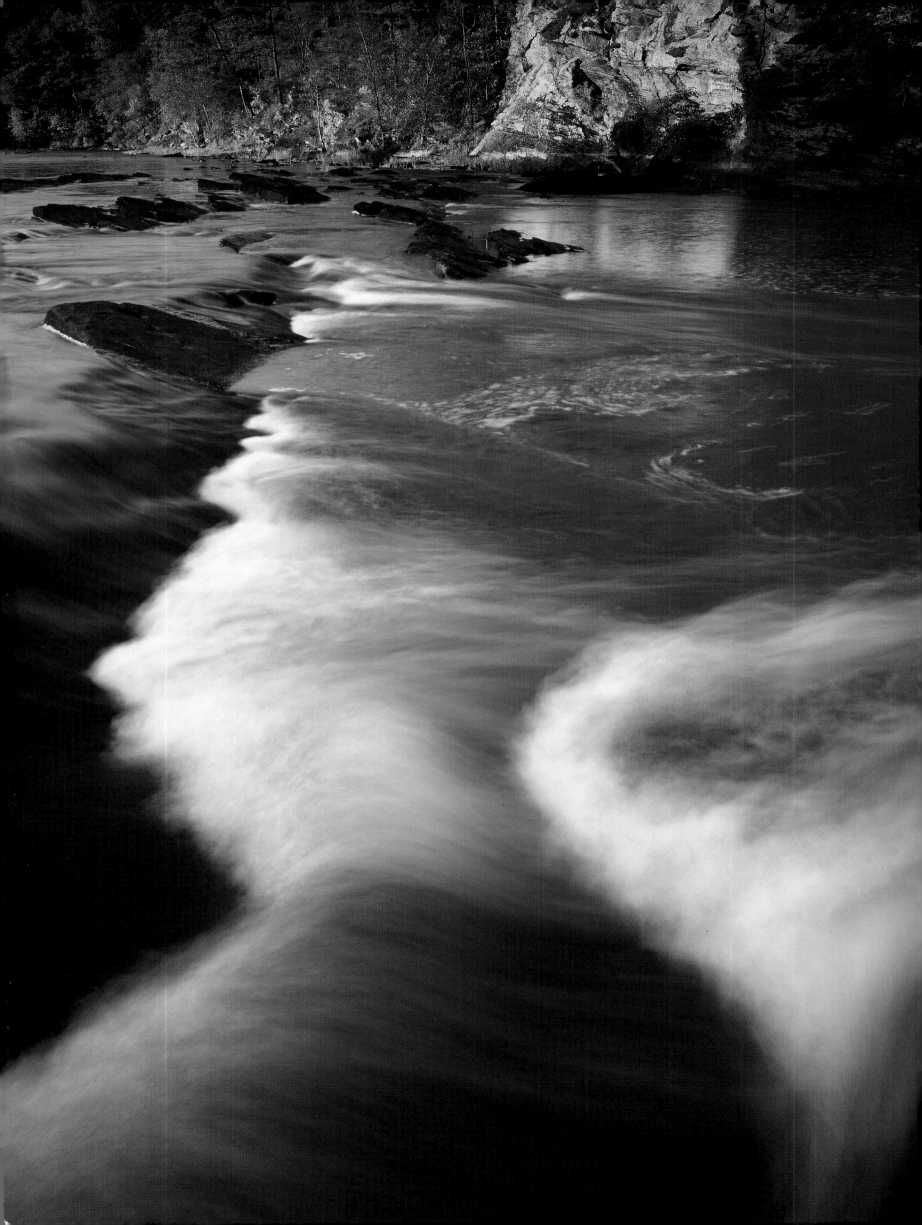

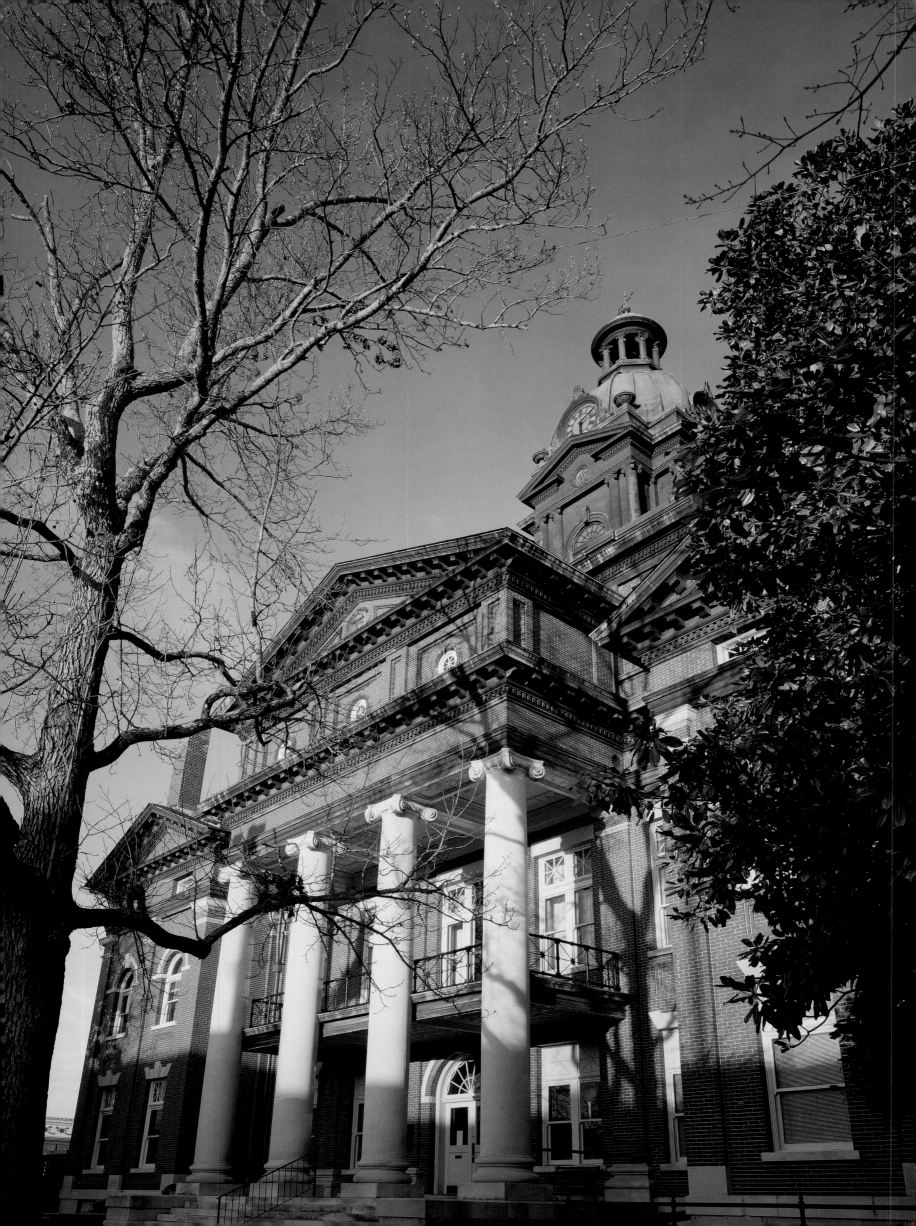

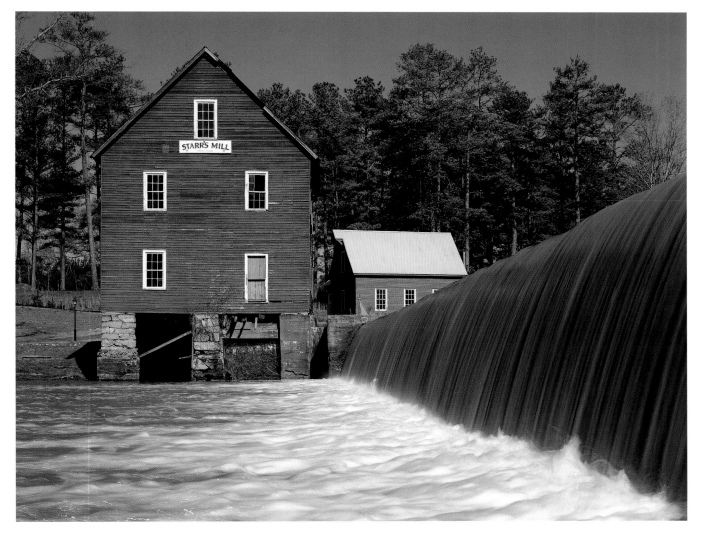

◁ Built in 1904 by Georgia architect J. W. Golucke, the Newnan Courthouse, an example of neo-classical revival architecture, is one of the most impressive courthouse structures in Georgia. △ Starr's Mill, situated on Whitewater Creek near Fayetteville, was the site of the Jones Electric, Light and Power Company, constructed in 1910 to supply hydroelectric power to Senoi.

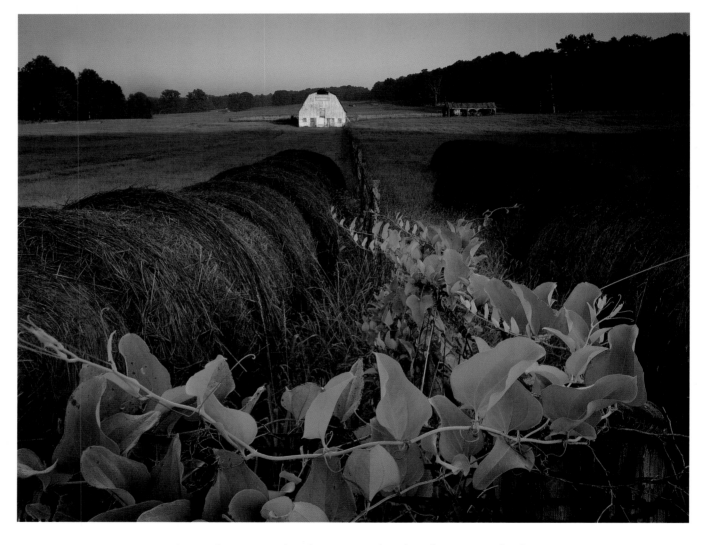

△ Near the town of Lithonia in what has become suburban Atlanta, Vaughter's Farm has survived the encroaching development to become the last working farm in Dekalb County. Efforts are being made to protect this area as a permanent green space. ▷ Situated among modern buildings near the square in downtown Decatur, the Houston House, built in 1905 by the first doctor in Dekalb County, is a quaint reminder of days gone by.

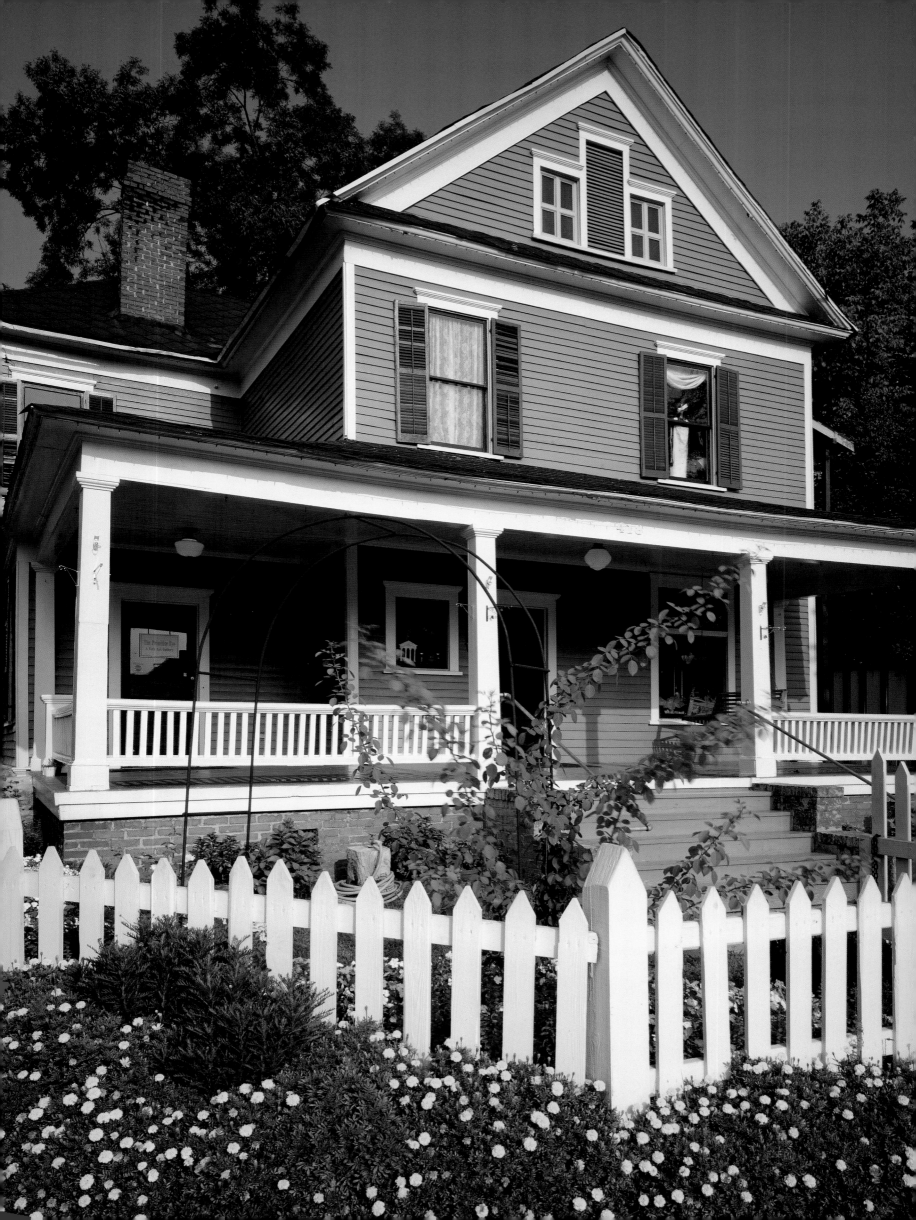

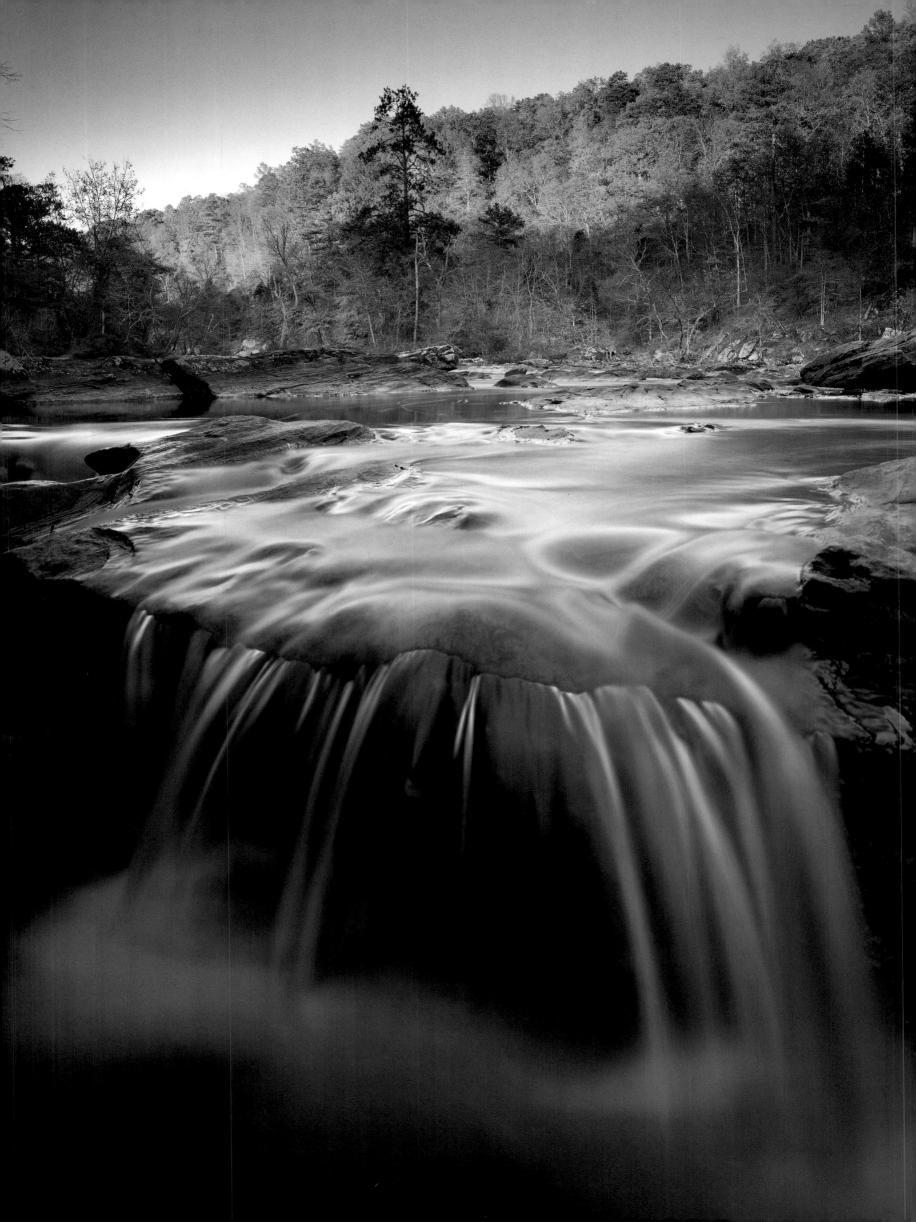

◁ Sweetwater Creek State Park contains a scenic lake and miles of hiking trails. It is also the site of ruins of a Civil War–era mill, used to manufacture soldiers' uniforms for the Confederate Army. △ The first football game at the University of Georgia took place in 1891 at Herty Field. Today, the field is preserved as part of an open lawn in front of the Candler Building at the university's historic "old campus" section.

△ The Little White House, located near the town of Warm Springs, was a second home for President Franklin Delano Roosevelt. ▷ The Ginger Bread House, now a bed-and-breakfast, is one of many Madison homes preserved because Senator Joshua Hill used his influence to persuade General Sherman not to burn the town. ▷ ▷ Banks Lake, near the southeast Georgia town of Lakeland, is a paradise for birders and fishermen.

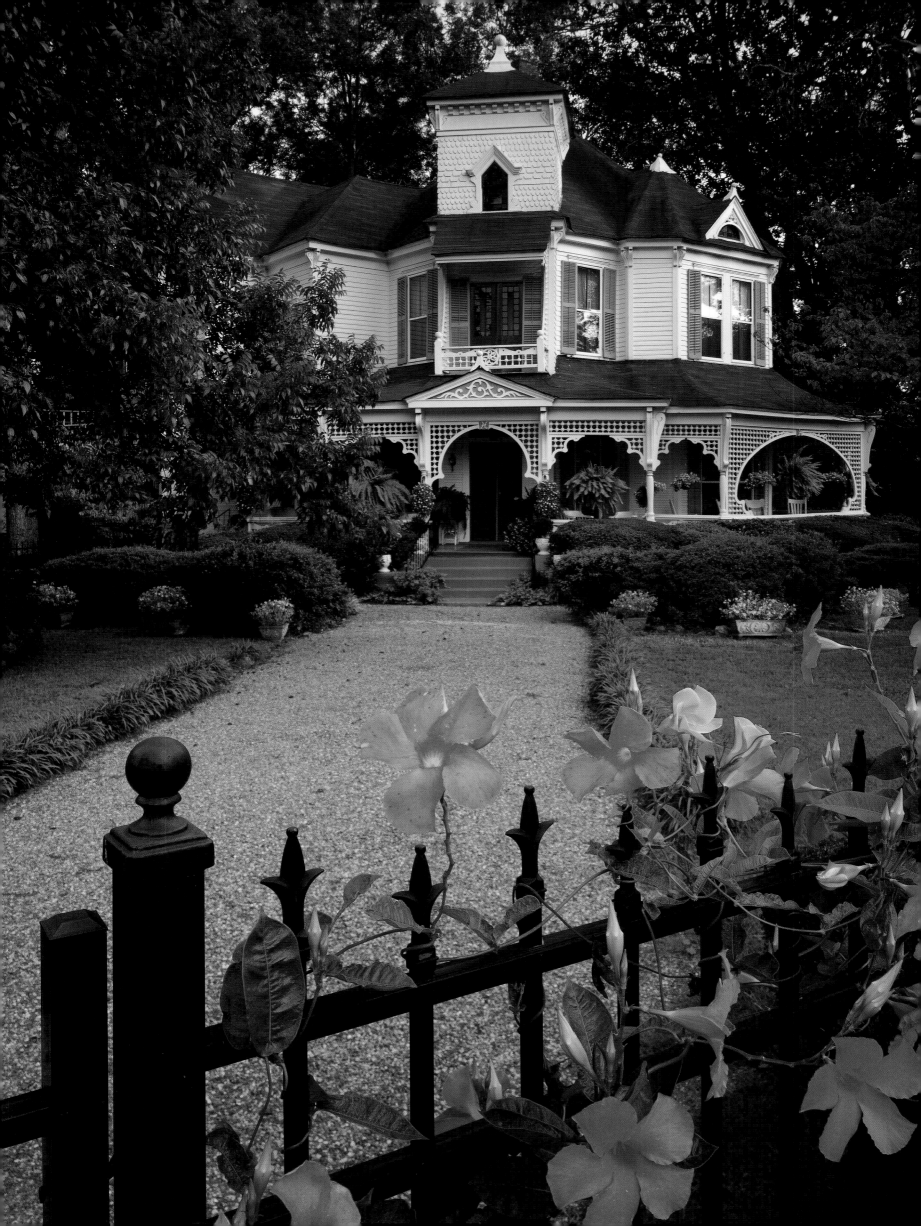

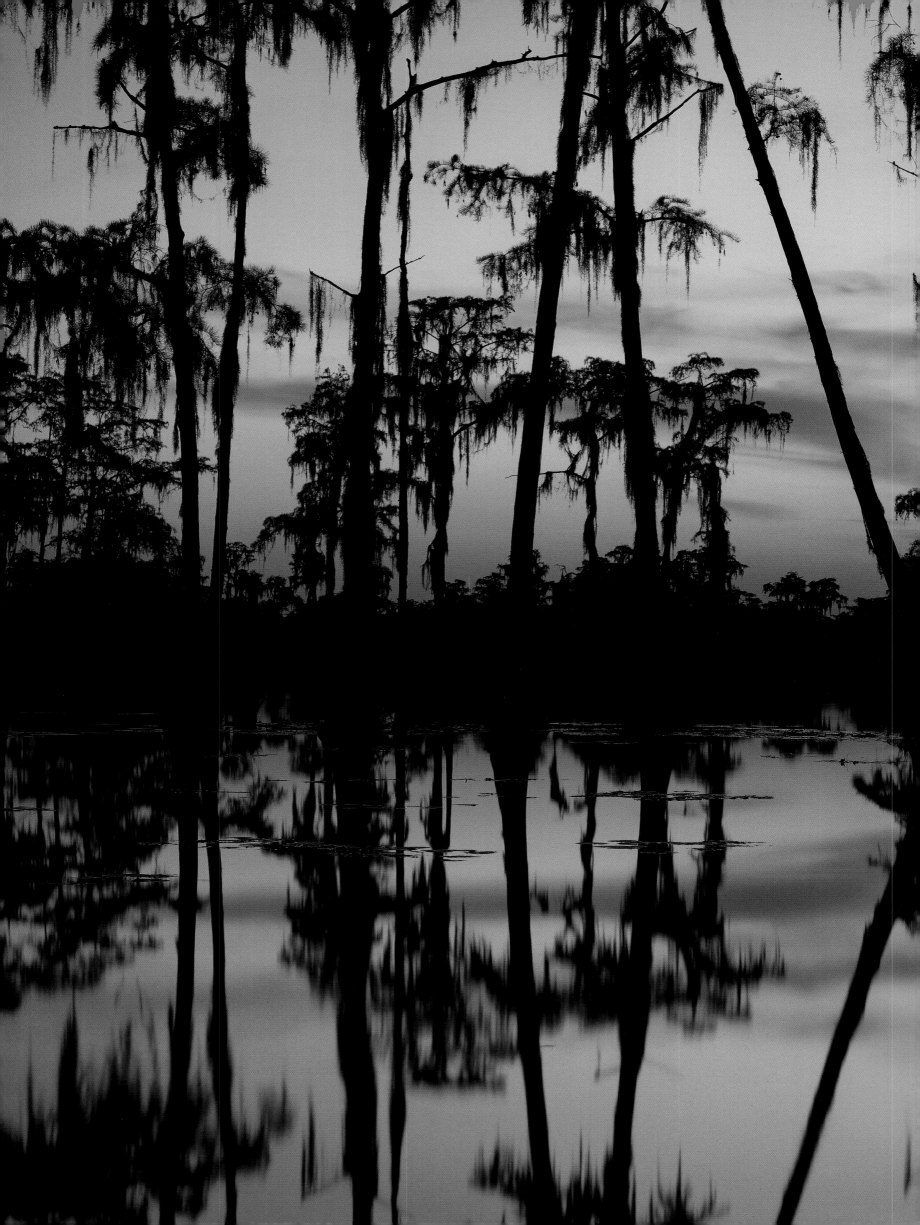

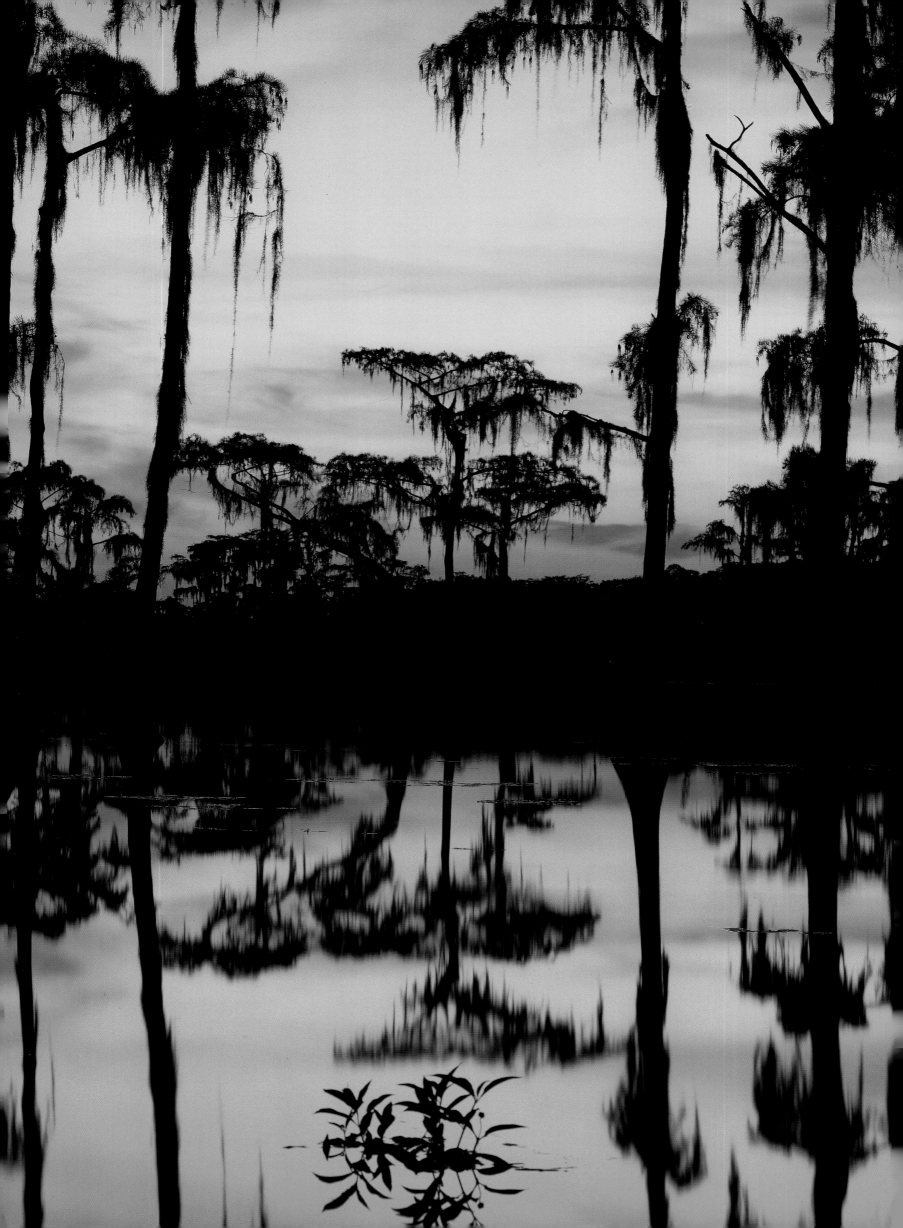

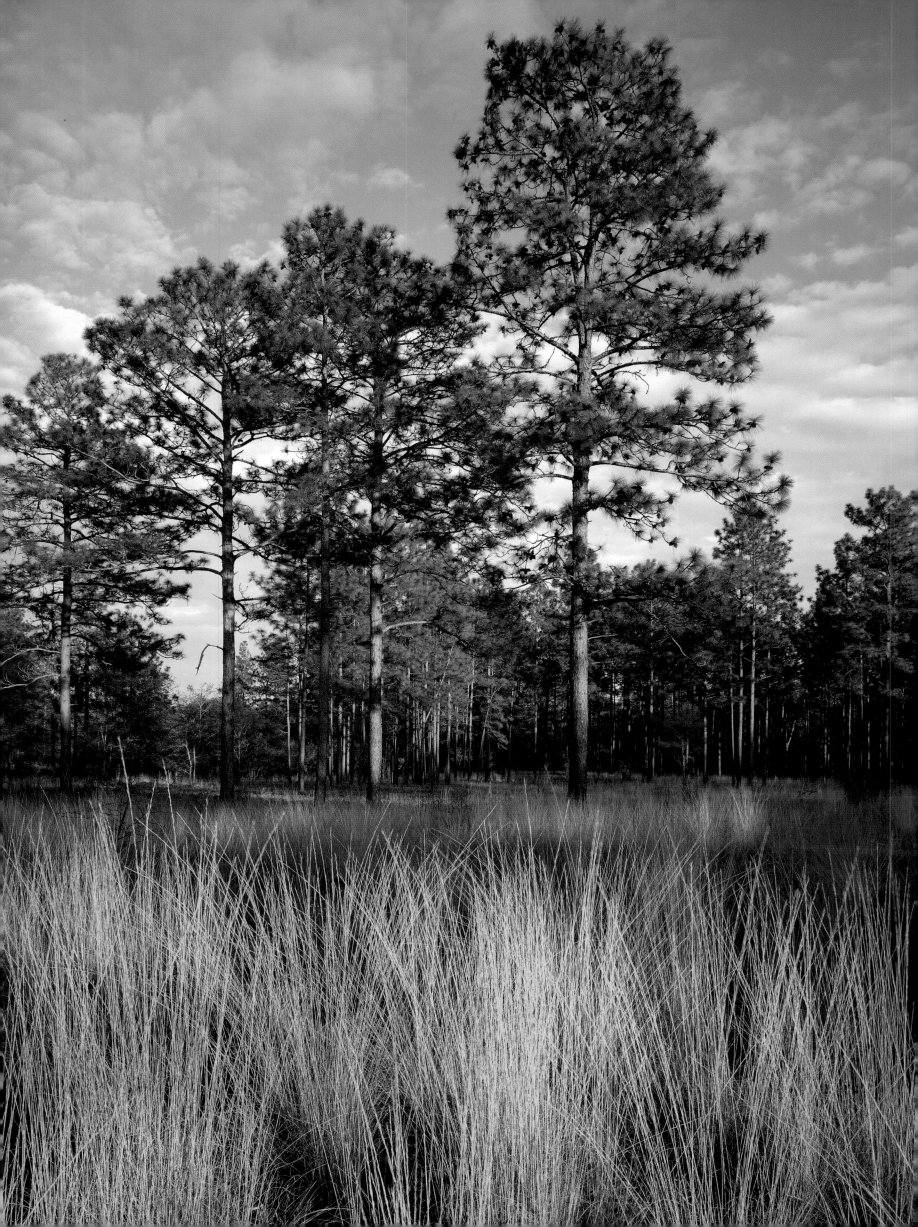

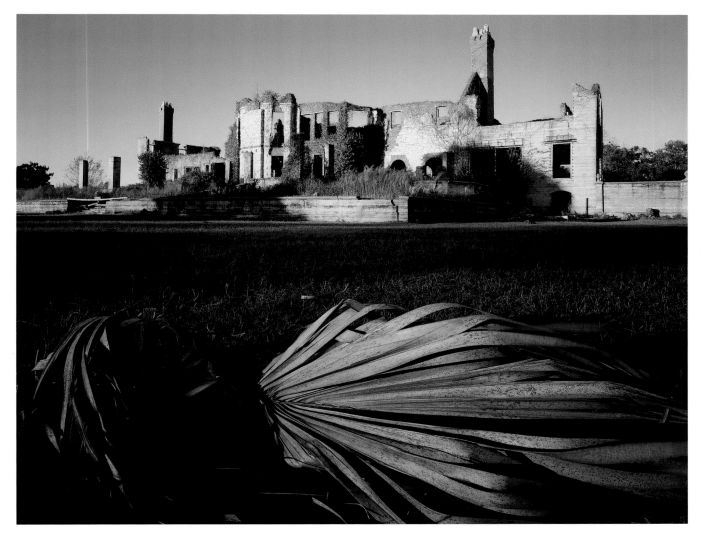

◁ Ichauway Preserve in southwest Georgia is a living laboratory
to study the ecology of wire grass and long-leaf pine habitat.
△ The burnt-out ruins of Dungeoness, once the summer home of
the Carnegie family, is at Cumberland Island National Seashore.
▷ ▷ As coastal tides flood the barrier islands' maritime forests,
live oaks succumb to the salt, creating a "live oak tree graveyard"
on beaches such as Driftwood Beach at Jekyll Island.

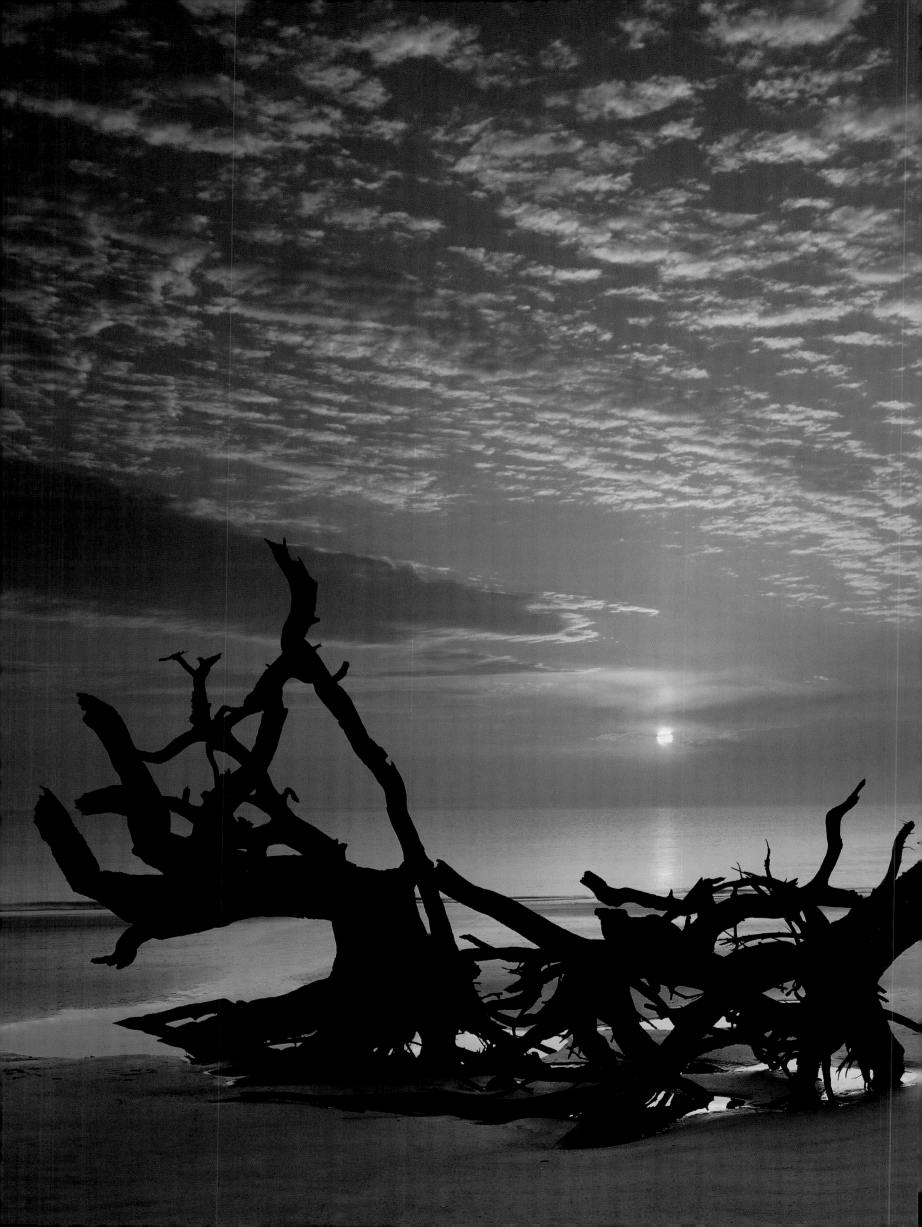

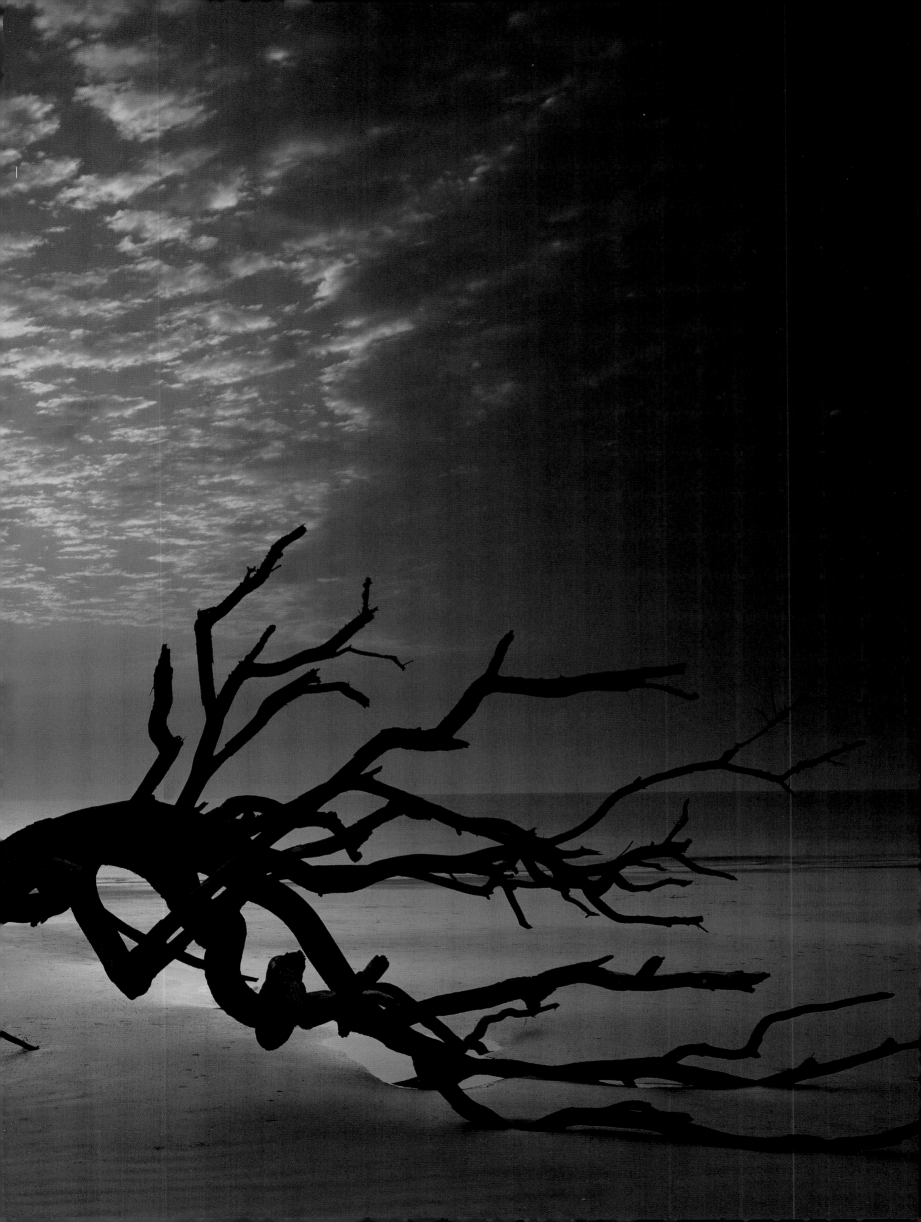

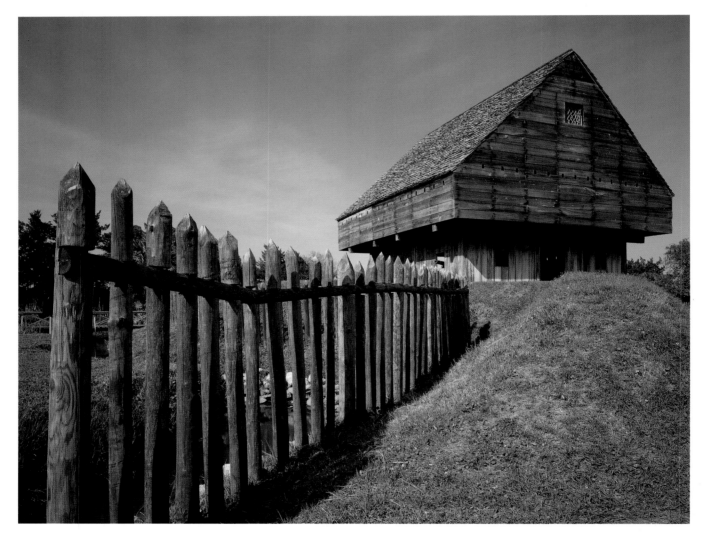

△ Fort King George, on the outskirts of Darien, is a reconstruc-
tion of a cypress blockhouse fort built by the British in the early
1700s in an attempt to keep French expansion out of the area.
▷ Like other barrier islands, Blackbeard Island faces erosion at
one end and accretion at the other, leaving skeletal trees behind.
▷ ▷ Dwarfed live oaks grow on the dunes of Roller Coaster Ridge
in the wilderness area on the north end of Cumberland Island.

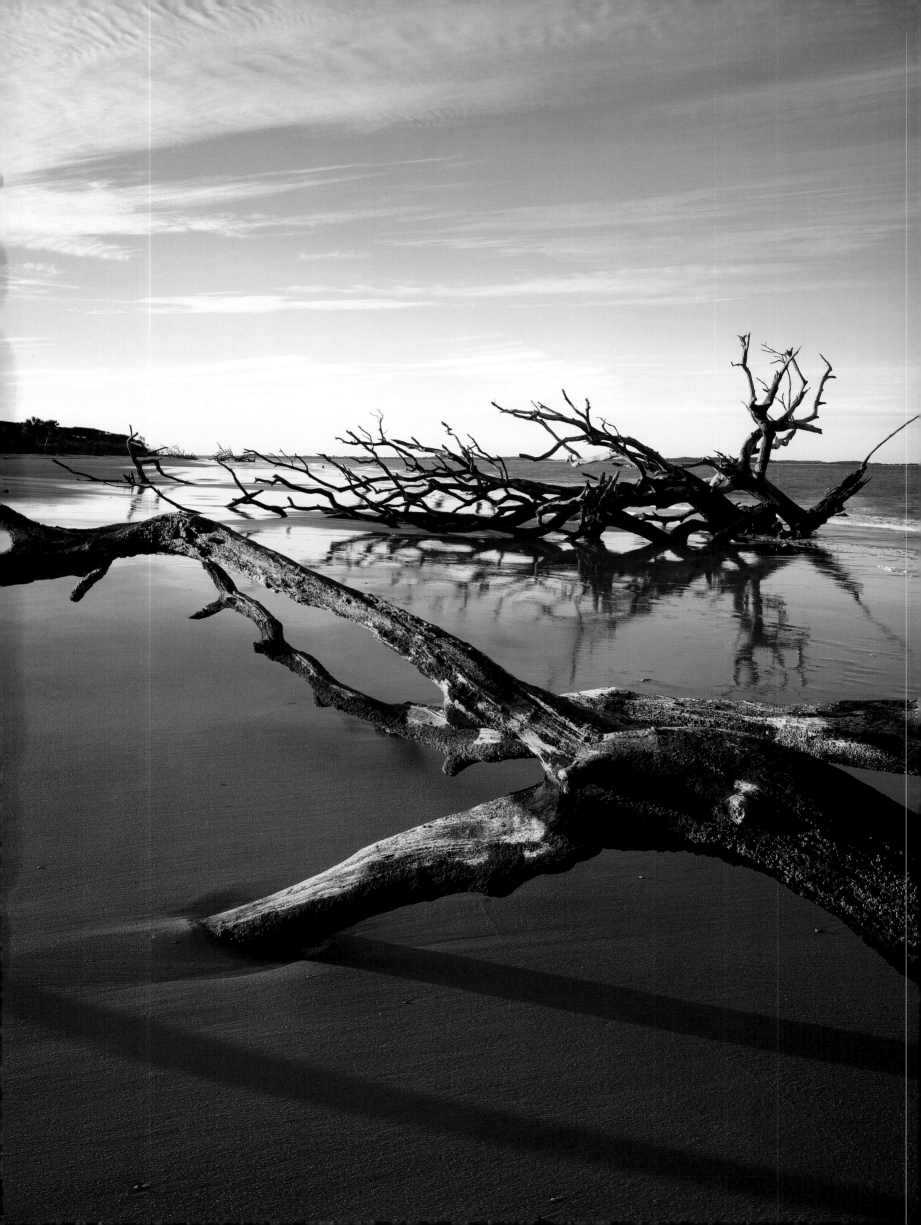

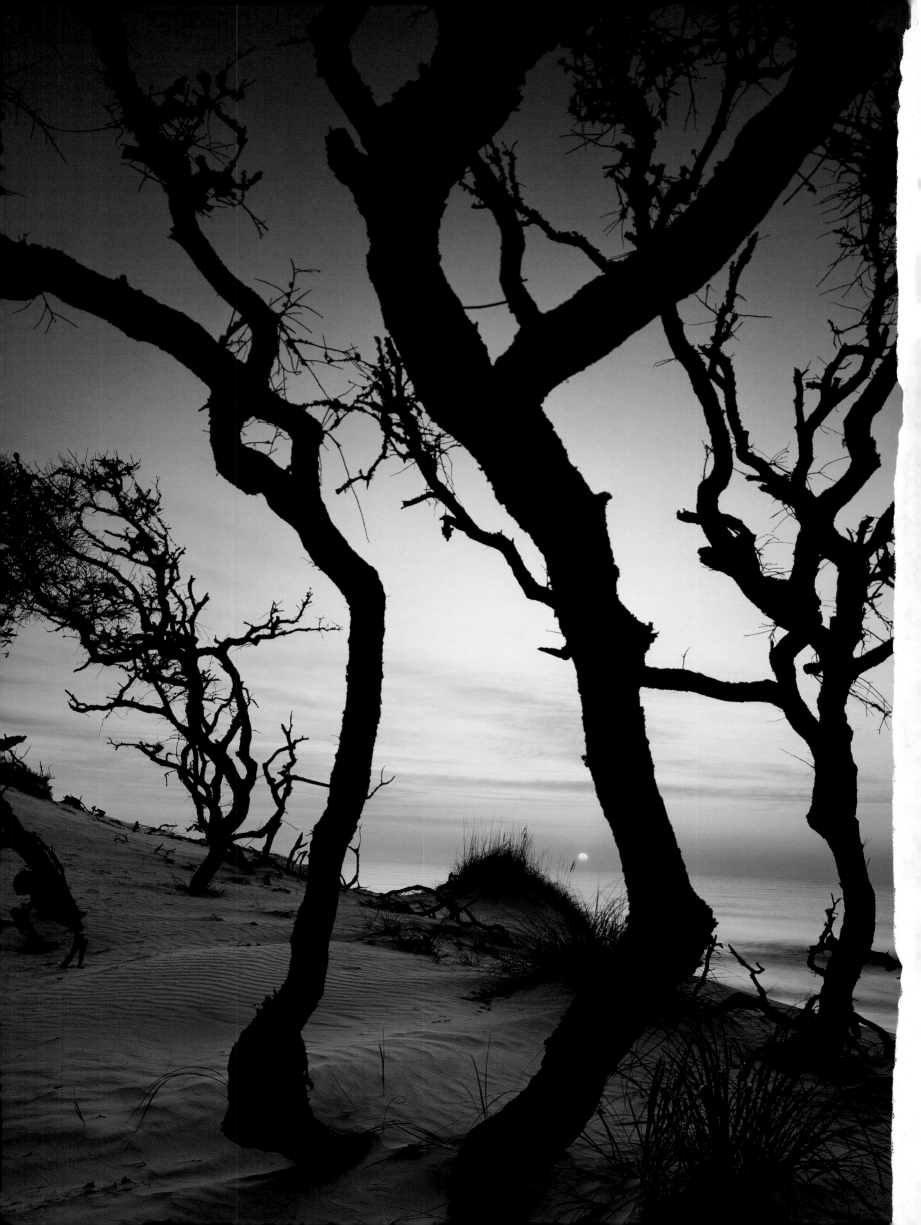